ALLEN JONES

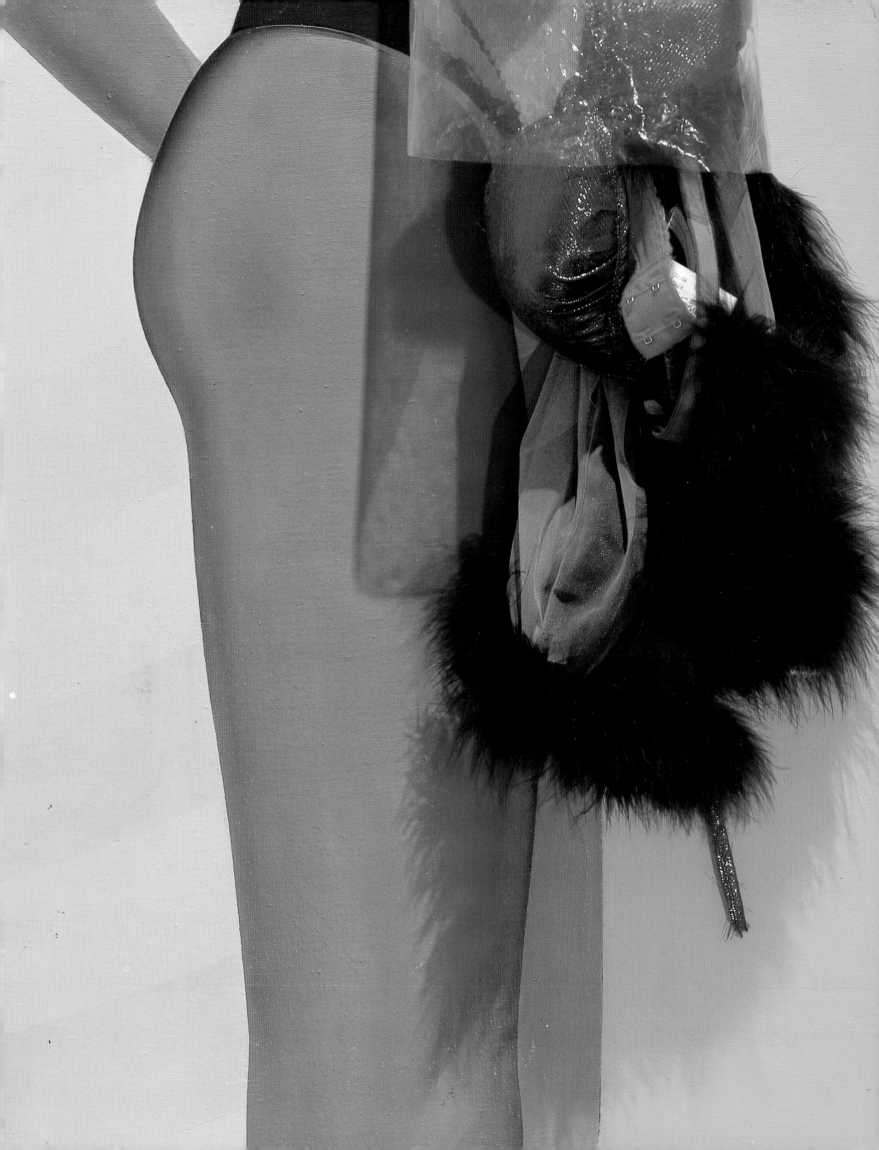

ALLEN JONES

A.D. ACADEMY EDITIONS · EN ERNST & SOHN

Art and Design Monographs
Editorial Offices:
42 Leinster Gardens London W2 3AN

Senior Designer: Andrea Bettella
Designer: Meret Gabra-Liddell
Editorial: Nicola Hodges, Natasha Robertson

Dedication
This book would not have been possible without Deirdre Morrow
who has been my model and muse *Allen Jones*

All photographs courtesy of Waddington Galleries Ltd, photographed by
Prudence Cumming Associates, unless otherwise specified

COVER: Work in progress, 1993, painting detail, mixed media, (photograph by
Nigel Haynes);
PAGE 2: Bra–La–La, 1973, 121.9 x 60.9cm

First published in Great Britain in 1993 by
ACADEMY EDITIONS
An imprint of the Academy Group Ltd

ACADEMY GROUP LTD
42 Leinster Gardens London W2 3AN
ERNST & SOHN
Hohenzollerndamm 170, 1000 Berlin 31
Members of the VCH Publishing Group

ISBN 1 85490 167 2 (HB)
ISBN 1 85490 172 9 (PB)

Distributed to trade in the United States of America by
ST MARTIN'S PRESS
175 Fifth Avenue, New York, NY 10010

Printed and bound in Singapore

CONTENTS

THE INTELLECTUAL – EROTIC – SCULPTED – PAINTINGS
OF ALLEN JONES

CHARLES JENCKS

One of the most interesting metaphysical enigmas of the universe is: 'Why did God create sex?' An answer has recently become clear as we now know that having two parents rather than one repairs, over the generations, inevitable genetic damage. But then why aren't there three or four parents and the reproductive rule an orgy? Much more importantly, why are sexual relations messed up with so many complex emotions such as love and jealousy; or, from a practical point of view, the less appetising parts of the body? If nature is so sensible a designer, how did she make such a botch of this function?

The most rational answer to that question is 'to keep novelists and psychoanalysts employed'. The truth is that sexual matters permeate every area of discourse, contaminate religion, politics, power games, family life and food; and only artists, finally, can deal with the ambiguities and overlapping pleasures this creates. Indeed the same laws apply, in the end, to the erotic and the artistic; they are both subject to the canons of beauty and communication. Today when one is found, the other is not far away, their destinies are intertwined, if not the same thing.

Futhermore, to achieve its erotic ends, art always pushes the body in unnatural directions. This sinister truth is actually a consequence of nothing more menacing than information theory, the fact that our imagination must be engaged by a subtle mixture of the familiar and the strange. The idea that the erotic and the imaginative are connected is obvious, since both depend on active participation, on provoking the viewer to fill in the gaps, to project personal meanings and become physically engaged in the pursuit of completing an interpretation.

By displacing anatomical structure and erogenous zones from their customary positions, erotic art forces the viewer to intervene in the painter's space and put them back where they belong. Rembrandt, Boucher and, more aggressively, Picasso, use this distortion and defamiliarisation – now absolutely canonical strategies for artists in every medium. We are in 'the Age of the Reader', the participant, the *opera aperta* as Umberto Eco named it, where the perceiver is the artist's other half, completing, insofar as it is ever finished, his work.

Yet calling such work erotic is much too reductive if the word is limited to 'sexual'. We are really talking about the desire to understand, decode and grasp an artefact sensually. This is the subject of Allen Jones' ostensibly stimulating sculpture: provocation through whirling movement, suggestion and vital colour – sometimes dripping-blood red or acid green. The motivation is to make us read enigmatic forms. Most public sculpture (serious bronze *gravitas* on a plinth) distances itself from active interrogation, whereas Jones' paradoxical dancers – the two-in-one figures – prod us to puzzle them out. How is it, in his *Dancing Couple* series (pp122-127), that two bodies can dance right through each other, that flat metal can jump into three-dimensions, that a man-woman dancing

can become a third thing? Paradox and oxymoron are, like all rhetorical tropes, a kind of mind-sex.

It was that celebrated American philosopher, Raquel Welch, who discovered a long hidden truth of cognitive science: '. . . the sexiest organ of the body is the brain'. It always wants to thrash out meanings that appear impossible – or extra, or even non-existent (as the most advanced experiments in artificial intelligence are showing) – and here Jones supplies it with all kinds of welcome gymnastics. The *Sungoddess*, 1987-88 (pp98-99), is a rusted steel woman whose legs run off in different directions, as do her breasts and almost her head. But as you are reassembling her fragments, she really starts to become more a dark red silhouette seen against a white background, a calligraphic flourish rather than a body. As you ponder these two quite different interpretations – and Jones' paradoxes usually have more – you can sit down on the sculpture and enjoy it as yet another thing; a seat. Some of his sculpture is even architectural – forming screens – and all of it slides into a base, or structural support, a very important continuity with the environment. This continuity is also a crossing of categories – like the *Sungoddess'* jump from Cubist art to calligraphy to furniture – and most notable in the main transformation: from painting to sculpture and back.

Having started off in the 60s with a more graphic than painterly style – with flat brash colours which were emphatically two-dimensional – Jones has moved in a more three-dimensional direction, and yet ironically with sculpture that is often two-dimensional. The paradoxes are compacted: whereas the Greeks painted sculpture that was round, here shading and depth are emphasised on metal forms that are flat

These formal contradictions tantalise with suggestion; visual counterparts of the way Jones uses parts of the body. Stiletto heel, turned up ankle, silken calf – we all know the salient parts of the body through Jones as much as mass culture (reality is never as strong as the essentialised fetish); but these explicit signs beckon us on in other unlikely directions – abstraction and structure. The oxymoron – sexy abstraction – is a major rhetorical figure that underlines a recurrent Jonesian theme, the dance: the strange fact that a dancing (or in certain cases copulating) couple is a third thing, something with a will of its own, an independent body 'greater than the sum of the parts' as they say. Put it in the cool words of systems theory, and you have a kind of Jonesian equivalent of the double-view: the passionate embrace is a 'self-organising system'. His rhetorical methods continually present such oppositions, as if hot involvement coupled with icy distanciation were a metaphysical principle.

Be that as it may his work has become more social over the years, more concerned with differences between people, their age, sex and background, and he has become involved with the mythic qualities of some contemporary situations, above all the dance hall, the confrontation of lovers, the jealousies of a party and beach

scene. In these subjects we also find the quick paradoxes, the combination of classical and pop genres, caricature and the grand tradition.

Jones' work is reminiscent of the minimalist and high-tech architecture of the 60s – it has a similar cool precision, upbeat colour and graphic quality, the kind of insistent optimism of a Norman Foster building. But there is another tone, especially in the later work, which is more nuanced, and it even turns into a kind of narrative at times: for instance the series of aquarelles which play on the subject of the pianist and his performer. In most of these hot colour-field narratives the protagonist dances and displays herself above the musician, out of reach; she is not the 19th-century Virgin on the pedestal, but the 20th-century Madonna-Temptress enslaving her audience, particularly her accompanist. In *The Blues, in Red, Yellow and Green* (pp54-55), – a sort of suppressed diptych about a 'blues' player – the pianist plays two pianos at once and buries his head between a pair of red-stretch-skin-legs which are spot-lit. These belong to the woman in charge, who, with an ambiguous gesture worthy of Madonna, turns her upper body acid yellow and green. To the left in the diptych a pair of lovers drape over the back of the piano, again a kind of two-in-one figure. Indeed, this enigmatic shape might be two women, or just one dislocated person and its formal echoes of other Modern and Post-Modern painters – Hans Hofmann, RB Kitaj and Richard Hamilton – supplies an extra provocation and query.

Does such enigmatic allegory – the suggestion of a narrative with a moral *sans* moral – signal a switch in Jones' development, like the architect James Stirling's sudden turn from Late- to Post-Modernism? I have an answer to this which seems far-fetched, but it may illuminate other truths, whatever its ultimate validity: the artist, in these sculpture-paintings, illustrates his own development.

Allen Jones' development, as I have argued, has been from a flat graphic manner to a three dimensionality made with twisted shapes that are underlined by various cues of depth. The paradox is that as he moves forward in the 80s to three-dimensionality he does so also going backwards, with flat planes of steel or wood. These shifts in form and content are sudden jumps which may come, simply, from taking up a new medium (such as paper and scissors) or a new iconography (such as dancing and embracing). These transitions in his outlook, style and career are then represented *in* the sculpture. It sounds unlikely? Well, looking for the odd accident to achieve a switch in direction is at least one of his methods:

> . . . usually my sculpture come from the act of cutting and folding paper. Typically I might cut out a female silhouette and score the paper down the middle with a random wavy line. By flexing this incised line between my fingers the paper bent into two undulating adjacent plains. One of the things that happened was that the resulting form gained a structural rigidity that took light in an agreeable manner. It provided a clue as to how I might proceed with some sculptural ideas . . .[1]

'One of the things that happened . . .' was an earthquake, and he saw where to go.

As theories of post-modern science show – Catastrophe and Chaos Theories – there is a recurrent motif of the sudden switch: the bend, the twist, the fold and the warp. These figures accompany or represent 'phase transitions': the jump from water to ice, from laughter to anger, from smooth to turbulent and from immobility to love-making. Such abrupt jumps occur everywhere in nature and if an artist wants to represent their equivalents through a physical medium then what better than the sudden bend in a steel plane, the quick roll of a curve, the wave in a piece of plywood or the twist in folded paper.

These motifs feature in the recent sculpture. It may be too much to claim they represent a jump in Jones' development, since there is much continuity between the 70s and 80s, although, of course, there is also molecular continuity between ice, water and steam. Who knows? I just know the work always invites me back to explore, and ruminate on issues which are usually outside and separated from sculpture – the erotic and machine-made, the functional and puzzling, the contemporary and historical; even chaos and failure as a sudden new order. It always recodes the way I see two people as they merge into something else, like a playful thought which divides and recouples and divides again into other wholes.

Note

1 Allen Jones in conversation, 1993.

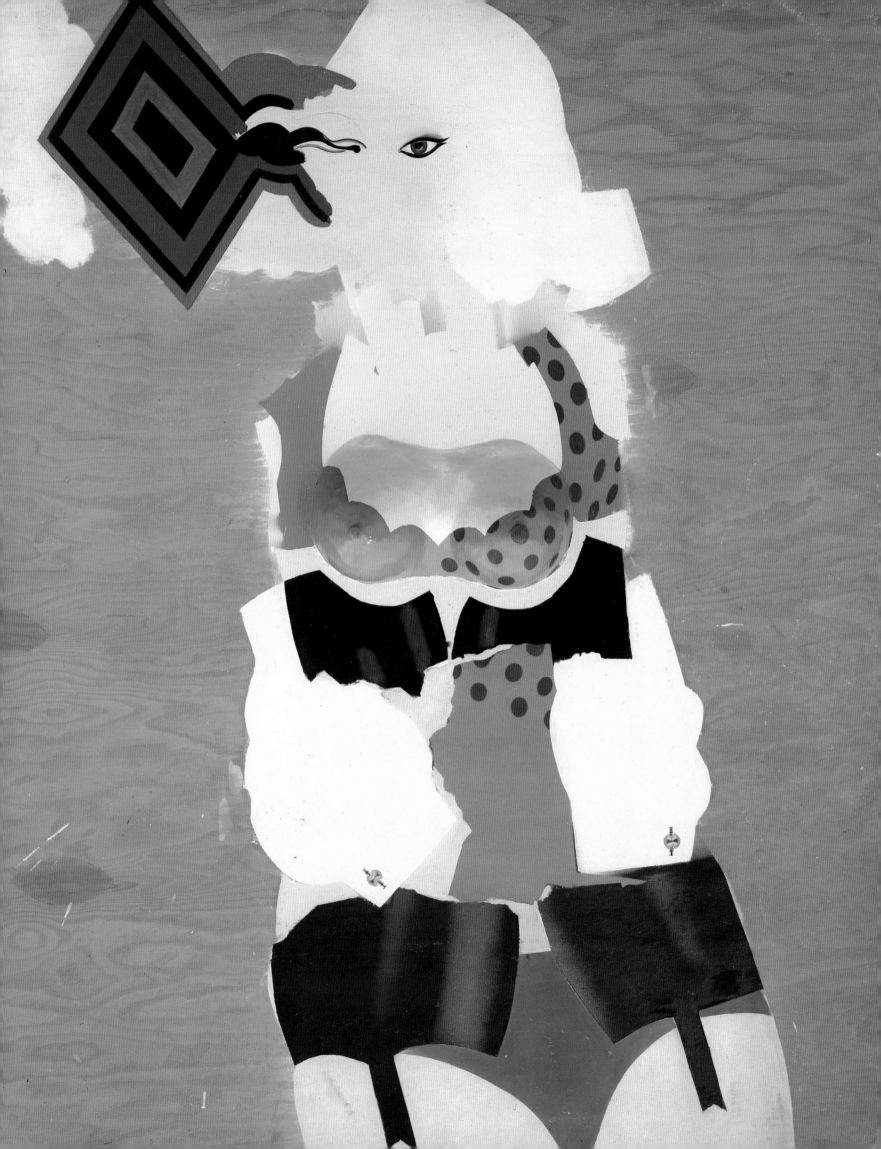

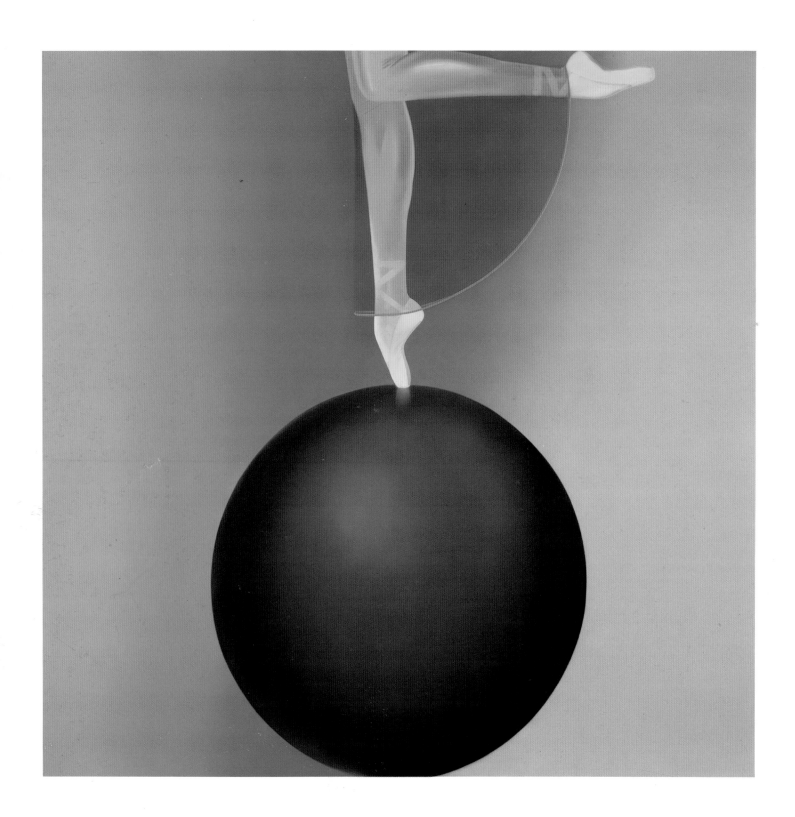

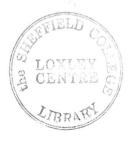

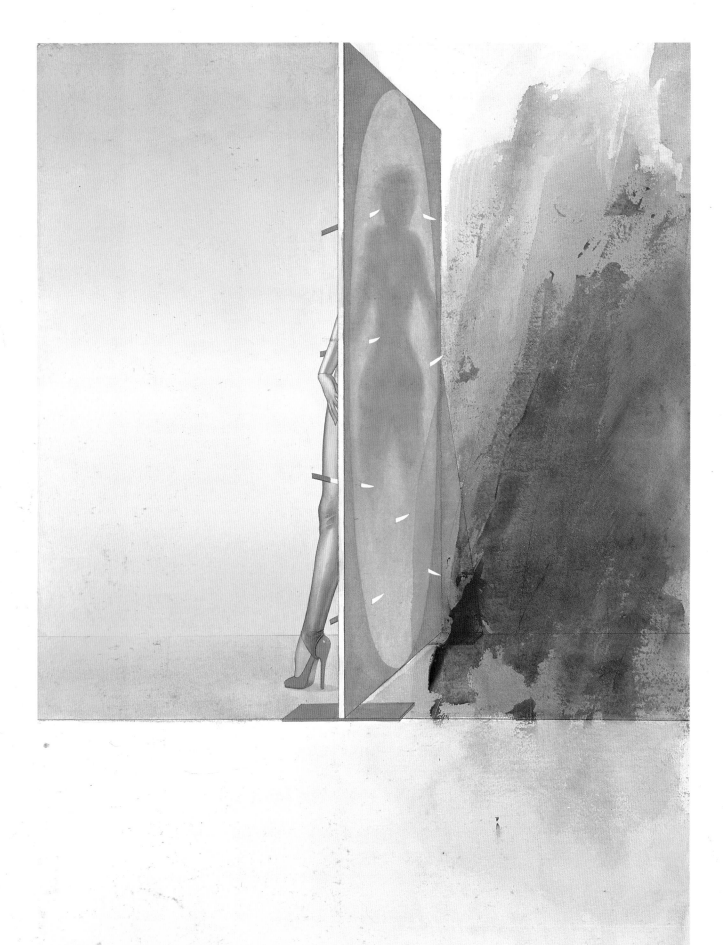

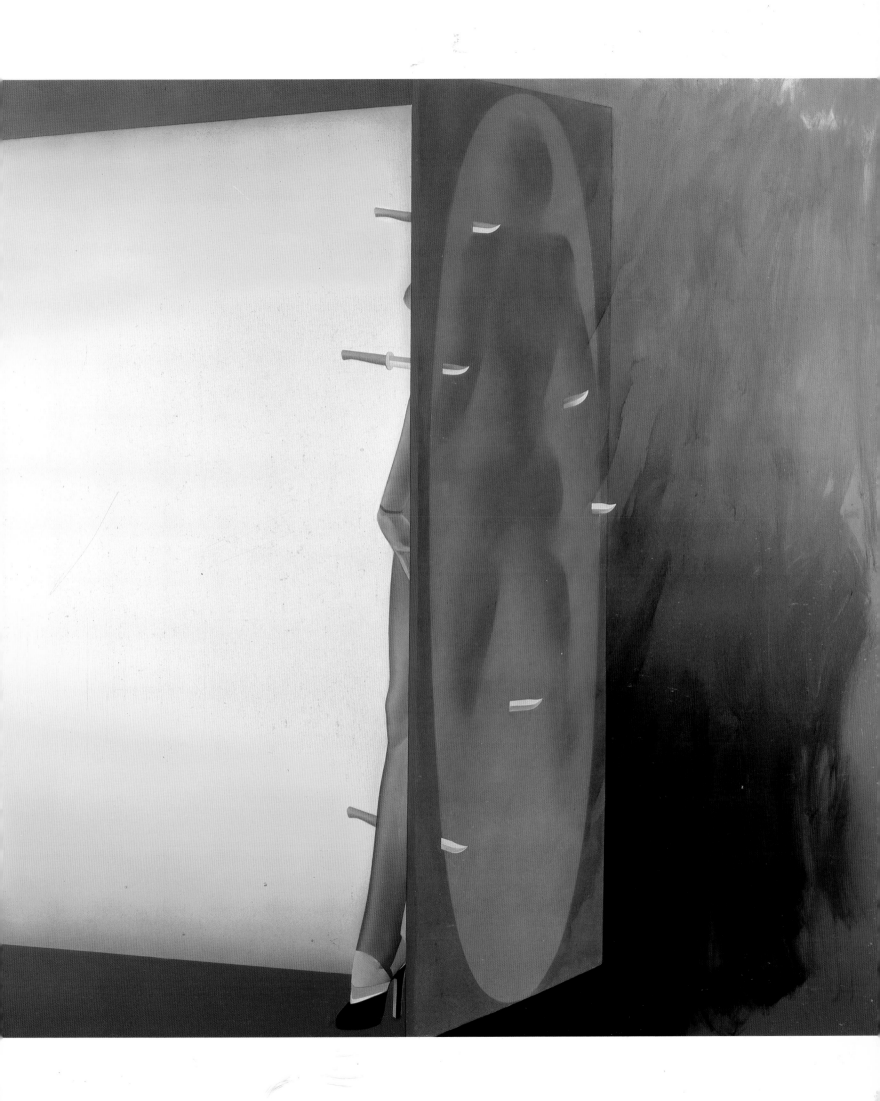

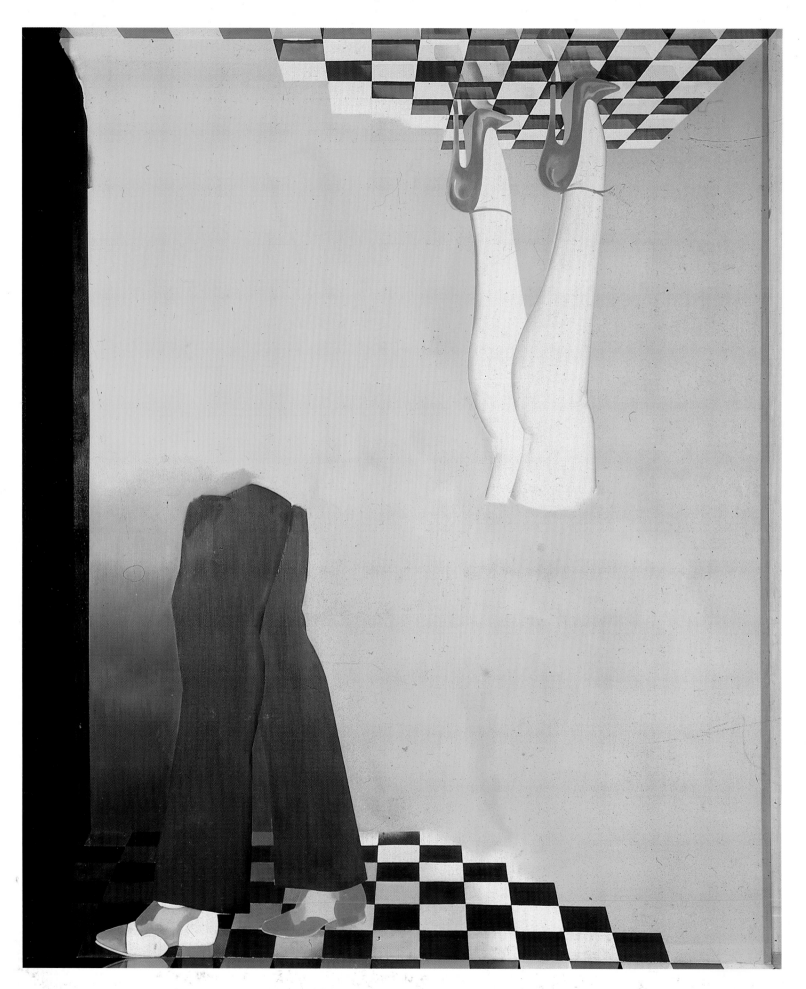

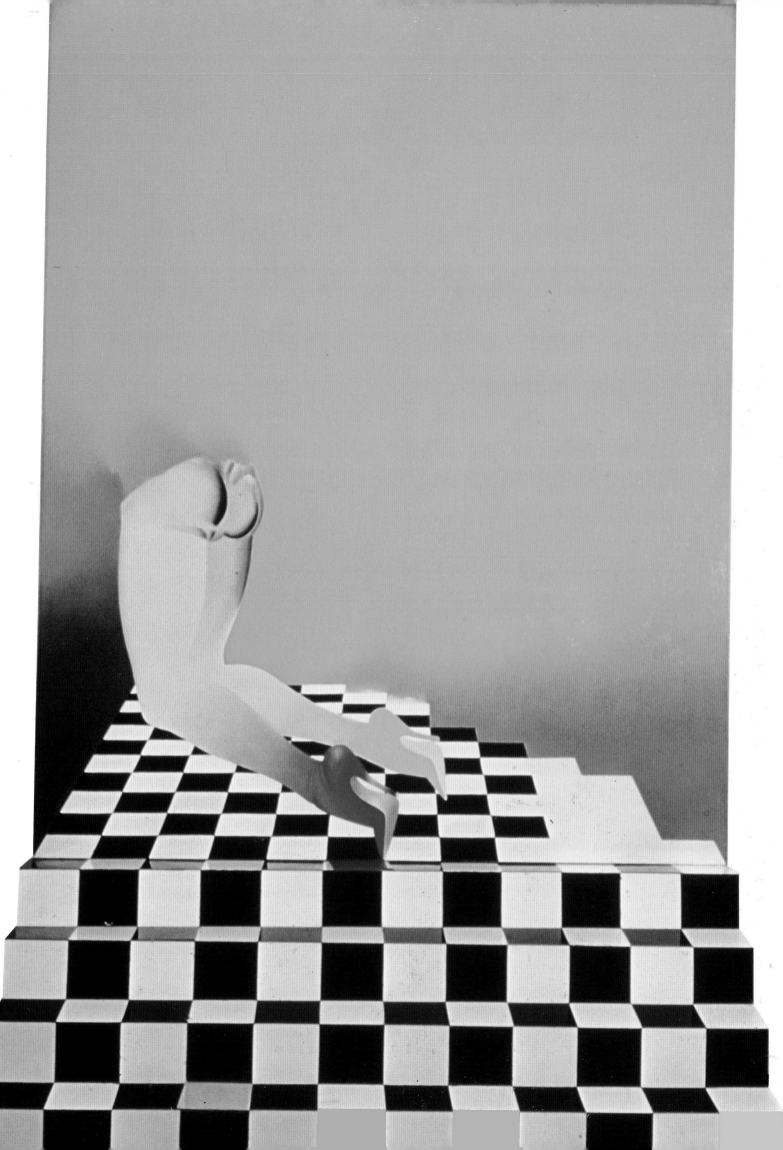

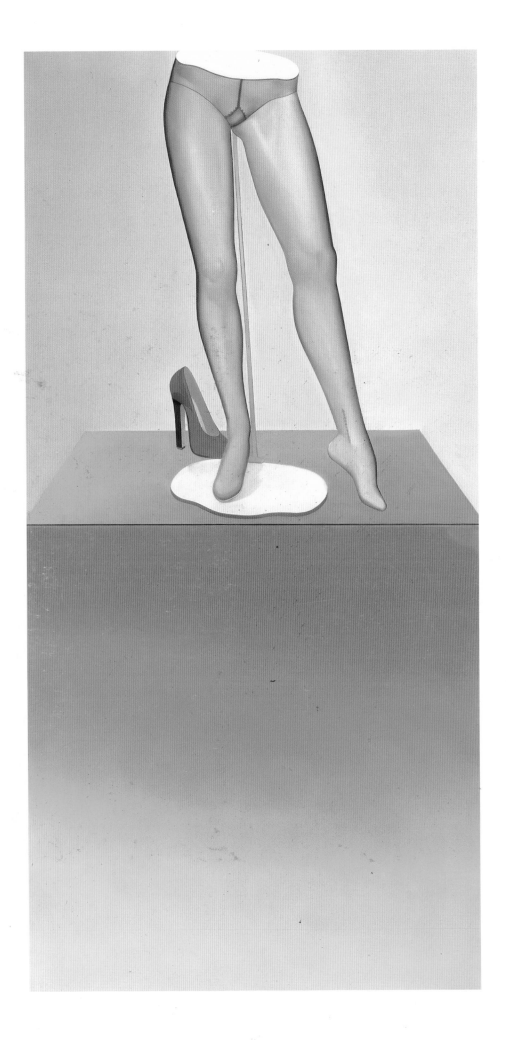

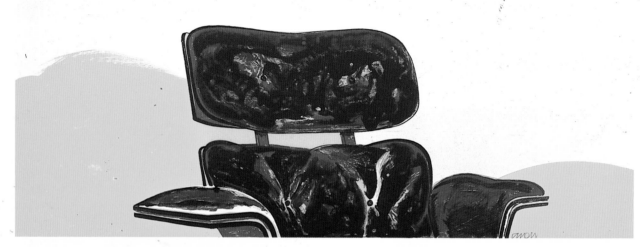

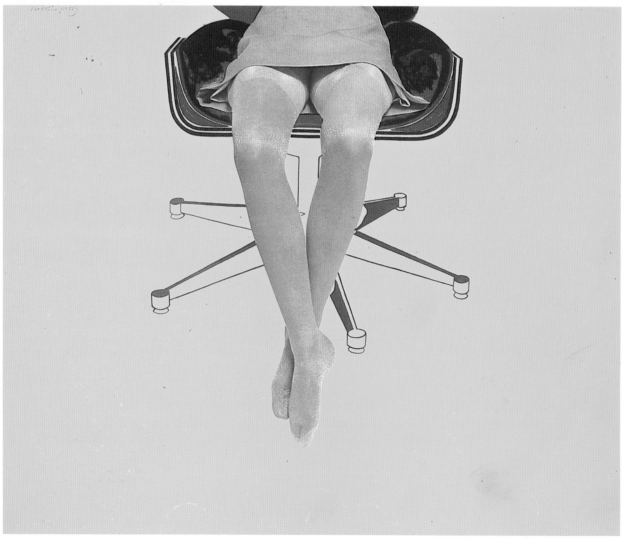

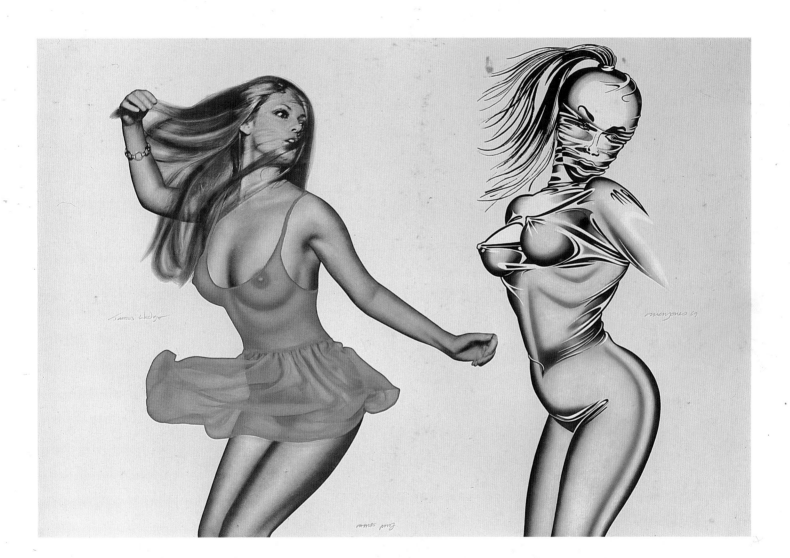

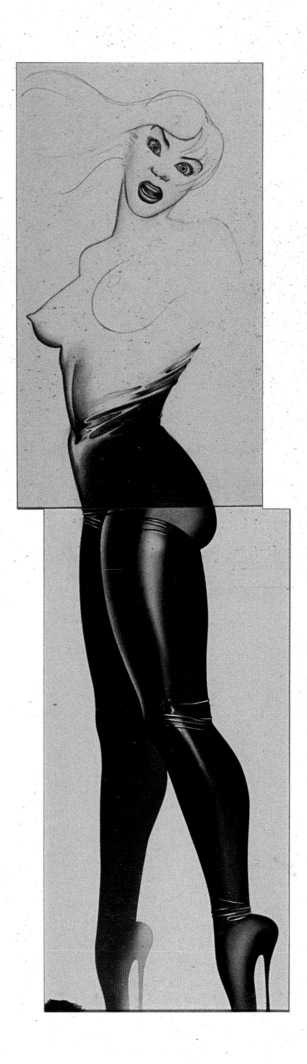

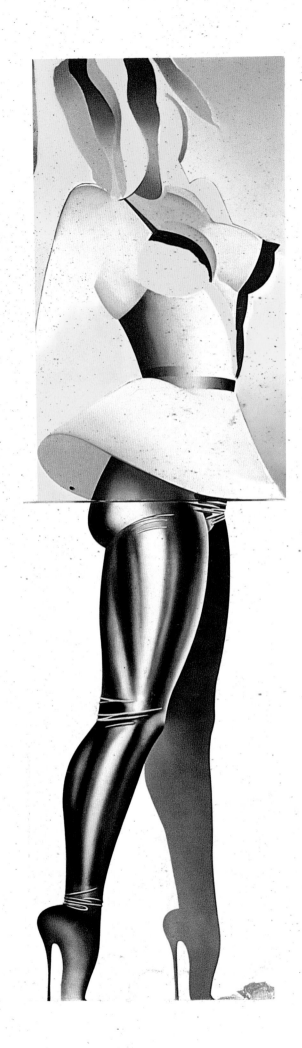

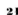

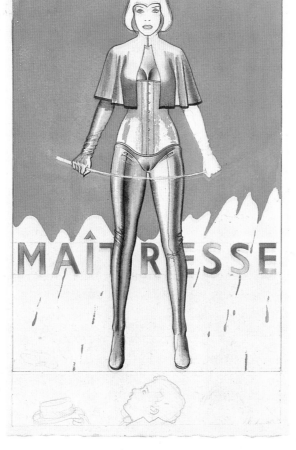

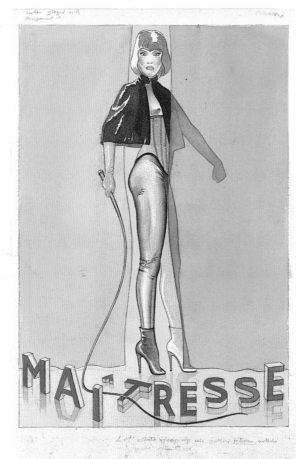

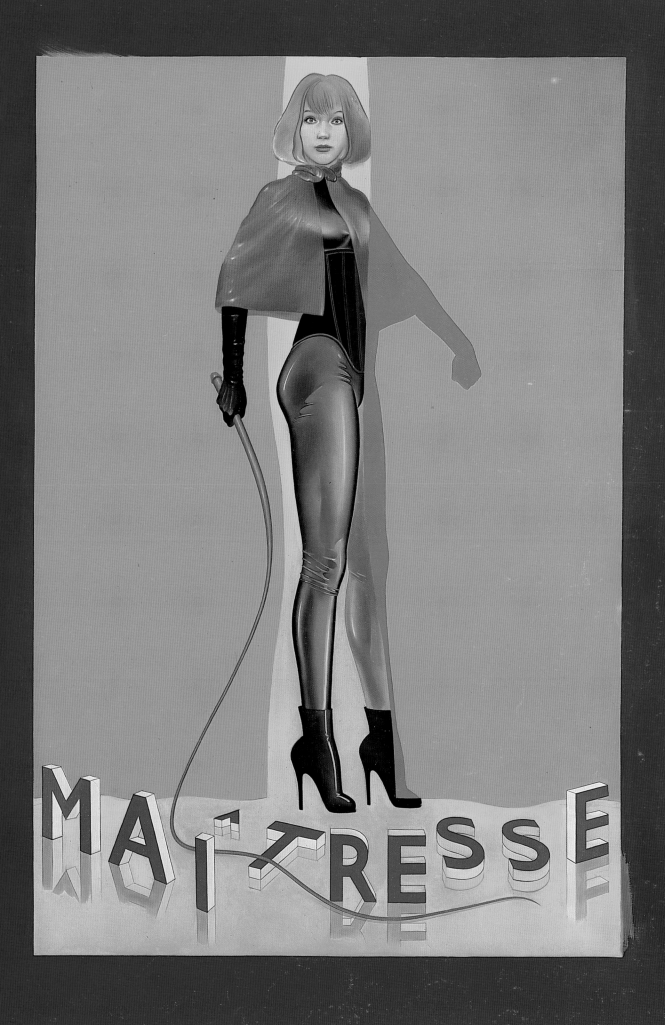

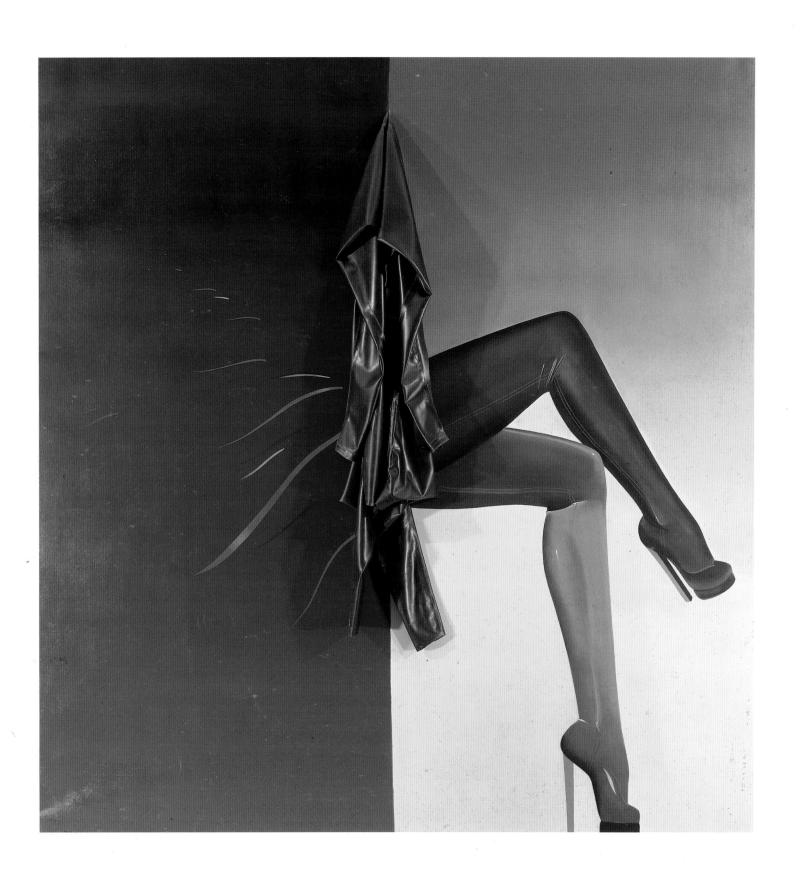

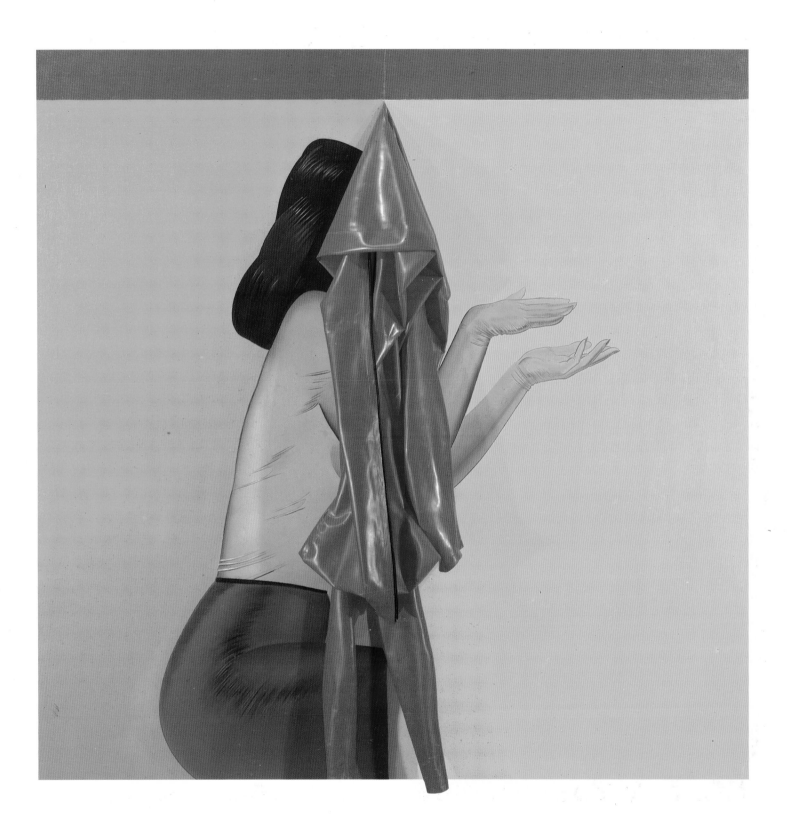

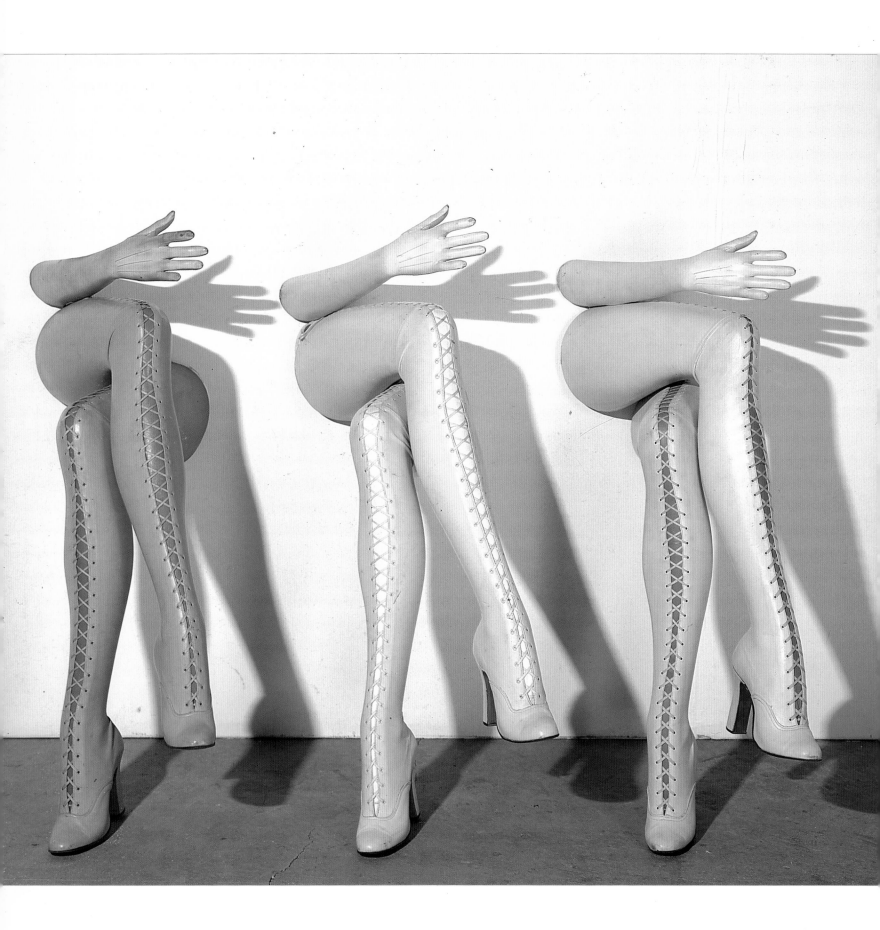

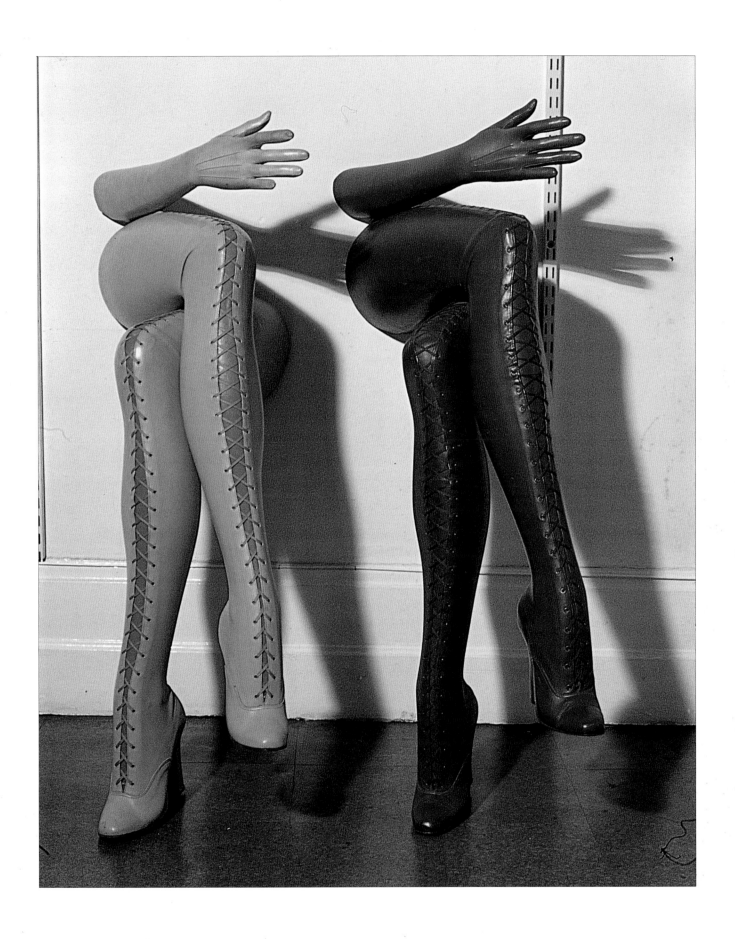

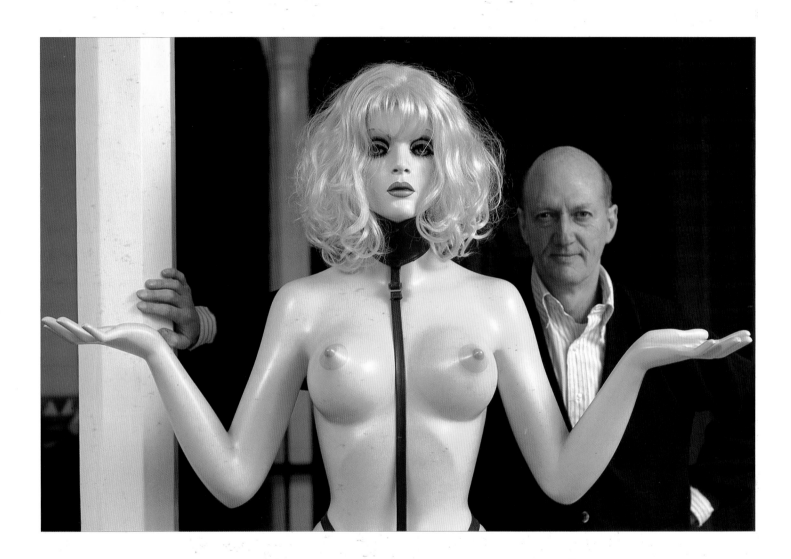

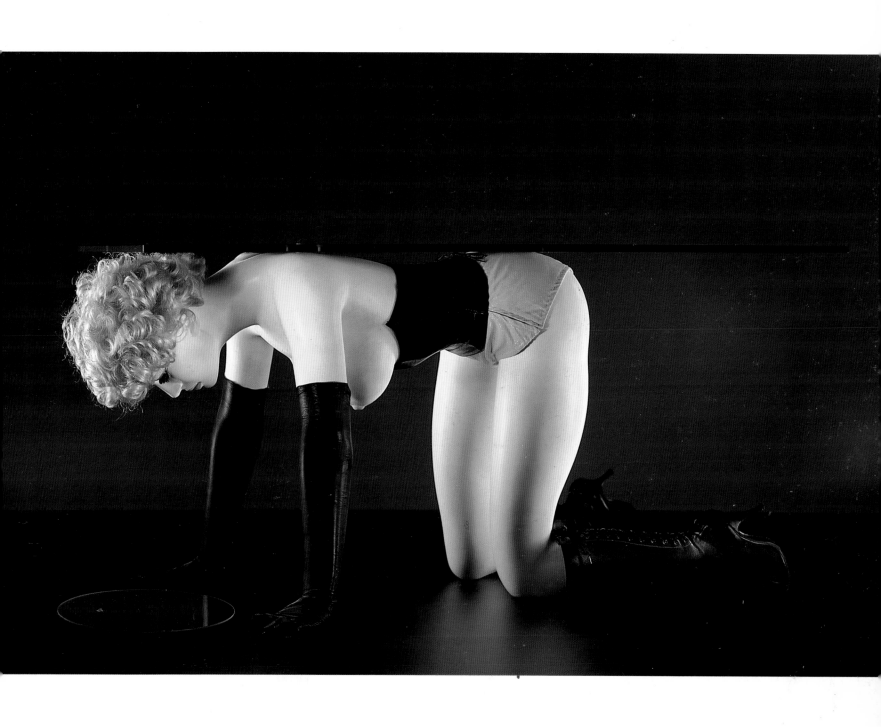

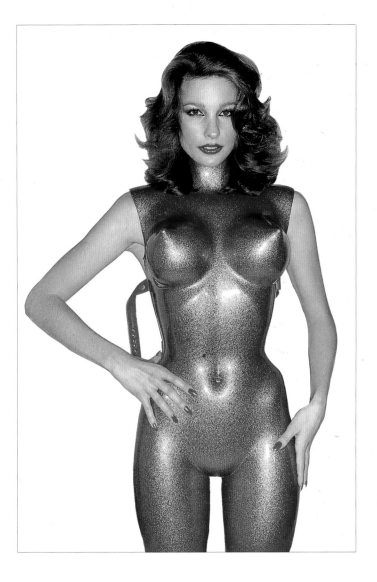

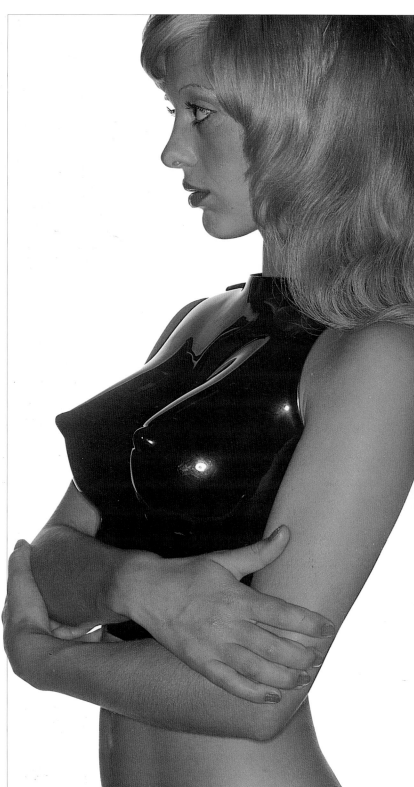

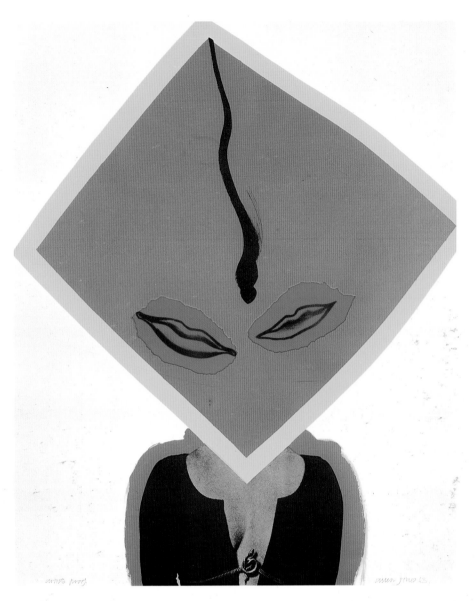

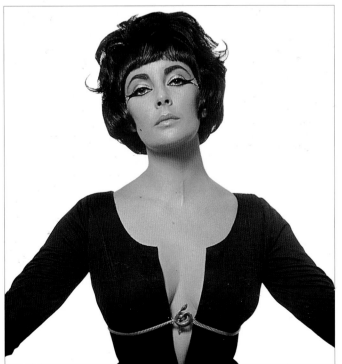

ALLEN JONES
VICTOR ARWAS

ABOVE: 2nd Bus, 1962, oil, 123 x 153cm; BELOW: The Artist Thinks, 1961, oil, 121.9cm²

Allen Jones is an urban artist, urbane, witty, sophisticated, cerebral and articulate. He can also be very puzzling, a privilege in which intellectually-based artists tend to revel. Born in Southampton in 1937, of Welsh parents, he studied painting and lithography at Hornsey College of Art between 1955 and 1959, after which he entered the Royal College of Art alongside RB Kitaj, David Hockney, Peter Phillips and Derek Boshier. Though each of these artists pursued his own vision in his own style, it was clear that not one of them was prepared to give up this independence and meekly follow their tutors' instructions. They were therefore regarded as a group of troublemakers, and each was at some point threatened with expulsion, though it was Jones who, at the end of his first year at the Royal College, was expelled as an example to the rest of them. Jones had at the time expectations of a teaching career, and graduation from the RCA would have been an entrée into the better teaching jobs, so the expulsion assumed near-catastrophic proportions. He returned to the Hornsey College of Art to take a Teacher Training Course after which he taught lithography at Croydon College of Art, then drawing at Chelsea School of Art. His future, however, was to be as an artist, not a teacher, though he enjoyed teaching, was good at it, and was to return to it periodically: visiting teacher at the Hochschule für Bildende Kunst in Hamburg, 1968-70, guest professor in the Department of Painting at the University of South Florida in Tampa, 1969, guest teacher at the University of Los Angeles at Irvine, 1973, guest teacher in the Painting Department of the University of California in Los Angeles, 1977, visiting tutor in Painting and Drawing at the Banff Centre School of Fine Arts in Alberta, Canada, summer, 1977, and guest professor at the Hochschule für Künste in Berlin, 1982-83.

His images come out of his obsessions, and he explores them obsessively, sometimes returning to them after an interval of years. One of his earliest subjects was the buses he commuted in when first teaching, executing a series of paintings in 1962. Using Paul Klee's *Pedagogical Sketchbook* as one of the bases of his teaching, he had also set his students the problem of relating the subject of the painted canvas to its identity as an object to ensure that the formal qualities support the content. He wished to convey the 'arrested moment of universal motion' as he wrote in his lecture notes at the Royal College, but did not favour the solution of the Futurists, who attempted 'to create movement (action) itself', or for that matter the method of Robert Delauney.[1] 'Whatever the ostensible subject of a picture . . . itself must be visually still,' he wrote.[2] His solution for the buses was to paint them on rhomb-shaped canvases, which gave the feeling of the moving bus. The circular wheels at the bottom of the canvas were then transferred onto two little canvases appended to the bottom of the larger rhomboid canvas in some of the bus paintings. The massive presence of the bus in each of the paintings was balanced by the depiction of the passengers as suits, later treating them in increasingly abstract ways, reducing them further into just hints of flesh or cyphers. He returned to the buses in 1964 with a huge painting, *Buses*, which is a multi-coloured patchwork of bus-blobs which instantly convey the slow movement of an incipient traffic jam.

Another recurrent subject is the self-portrait, beginning with a student effort in 1957, but which in the early 60s became schematised into 'a hieroglyph or shorthand'.[3] In the 1960 *The Artist Thinks*, the self-portrait is reduced to a small square at the bottom of the canvas containing the image of his face from the top of the head down to just his nose. Above the head the rest of the canvas is taken up by an enormous cartoon-style 'think bubble' in which a large red space is invaded by swirling shapes and colours, a depiction of the artist's unconscious at a time when he was deeply involved in Freudian textbooks, the Surrealists' use of automatic drawing as pure expression of thought, and his fascination with the work of Jackson Pollock. The 'hieroglyph' head reappeared in other paintings, but *Understudy* in 1972 comes as an unexpected visual likeness of the artist at work, merging into another of his recurrent subjects, legs. Unlike, say Rembrandt, who went on exploring the gradual collapse of his features, Jones has, as he says, clinically chronicled his receding hairline.[4]

That quip is on the battlement of the defensive structure which surrounds Jones' oeuvre. Inspired by Nietzsche, Jung and Freud, he has studied the work of painters of the past and those of this century, aligning himself with those who use the language of abstraction without abandoning figuration. It is ex-

tremely difficult to analyse his work because he has already done it himself, and expressed this intelligently and coherently. His works, abstracted, totally figurative, or a mixture of both are always recognisable because he early developed his *griffe*, a French word which means 'signature' or 'style' but which also means claw, or talon.

Allen Jones first made an impact on the London art scene in 1961, when the 'Young Contemporaries' exhibited at the RBA Gallery. Peter Phillips was president and Jones secretary that year, and other exhibitors included Derek Boshier, Patrick Caulfield, David Hockney and RB Kitaj. Jones was a prizewinner and this led to a commission from Courtaulds Ltd for a very large mural painting, *City*, designed to hang in the restaurant of the firm's headquarters in, of course, the City. This and a group show at the Institute of Contemporary Art led to his being taken up by Arthur Tooth & Sons, an important London Gallery where he first exhibited in a mixed show in 1962, then had one-man shows in 1963, 1964, 1967 and 1970. Though Jones, championed by one of the directors, Peter Cochran, was obviously a critically and financially appreciated exhibitor in the gallery, the managing director, who heartily disliked contemporary art, managed to be out of town whenever there was a Jones exhibition. He only slipped once, coming in accidentally when a Jones show was still on; avoiding looking at the works on view, he steeled himself to mumble a few words to Jones before disappearing into his office. Jones also exhibited at the Paris Biennale in 1963, where he was awarded the Prix des Jeunes Artistes. In 1964 he moved to New York with his wife, Janet Bowen, and lived for a year there at the Chelsea Hotel, before going on an extended tour of the United States by car.

He had begun exploring erotic imagery with such paintings as *Bikini Baby* in 1962, in which only the relevant top and bottom polka dotted bikini halves appear floating in front of a door, with a barely outlined head above and footsteps below. As the date of his wedding approached, he became more adventurous: *Marriage Medal*, 1963, consisted of a rectangular, striped canvas (the ribbon) above an octagonal canvas with the clad torsos of a woman and a man (the medal), based on Nietzsche's concept of marriage as 'the will of two to create the one who is more than those who created it'.[5] The juxtaposed canvases suggested a marriage of styles. Now Jones went further, and began to merge the figures of man and woman. Like Nietzsche, Jung considered that the creation of a work of art was dependent on the integration of the male and the female aspects. Man's male aspect, the outward 'persona', and his feminine aspect, the 'animus', combined to make the complete individual; the woman's male aspect was the 'anima'.

Hermaphrodite and *Man/Woman* (both 1963) are very much a separate male and female figure in the process of fusion, thereby creating an entity that is 'more than those who created it'. The following year's portfolio of eight colour lithographs, *Concerning Marriages*, explored the theme further in a joyous explosion of colour and alogical conjunctions of male and female limbs crowned with hats. The poster for the portfolio represented a collage image of a woman's svelte torso ensconced in an oversized man's coat and hat, her body ending in a brightly patterned tie.

That tie, which echoed the brightly patterned ties Jones wore in those days was itself becoming a feature in his imagery. It reappeared in several of his self-portraits, becoming what he described as a 'phallic totem image' not part of 'a popular iconography'.[6] *Mis-ter*, 1964, had his self-portrait head metamorphosed into a diamond shape supplied with a choice of facial features, with tie below: the diamond-shaped head became a mandala he used over and over again. *Curious Man*, 1964, has his torso sporting a particularly elaborate confection of a superimposed wooden tie surmounted by an exploded head, floating features topped by the mandala. The pair to this, *Curious Woman* (p9), 1964-65, similarly painted on wood with part of the surface showing the wood grain, the face differentiated solely by one perfectly made up blue eye, the other just a point which slithers leftward to become an elaborate mandala in red, black, blue and green, additionally had two further features he was to develop later. One was the three-dimensional breasts, epoxy-filled transparent plastic falsies encased in his then favourite painted green polka-dotted dress, which were to evolve into sculpture; and curiously detailed and highlighted items of lingerie, corset, girdle, panties, which along with bras and sheer stockings have made regular appearances in his work.

Working in the United States firmed up the strands of his obsessions. His painting became more hard edged, his imagery more explicit. David Hockney visited Jones in New York, and pointed out to him similarities between his hermaphrodite paintings and some illustrations in fetish magazines. In a 1973 interview published in *The Image*, issue 9, Jones said:

David thought he'd found my source material. In fact he opened the door on such a fund of information, I nearly blew my mind on the 6th Avenue book shops looking at all this drawing. I began to appreciate the vitality of this kind of drawing of the human figure, which had been produced outside the fine art medium. So I started to collect as much of the stuff as I could and began going through mail order catalogues. The point is if you're doing a drawing to sell a product, like in the *Fredericks of Hollywood* catalogue there is no way that the product would sell if the drawing didn't come to the

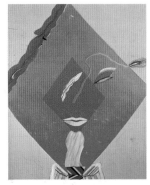

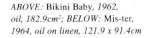
ABOVE: Bikini Baby, *1962, oil, 182.9cm²; BELOW:* Mis-ter, *1964, oil on linen, 121.9 x 91.4cm*

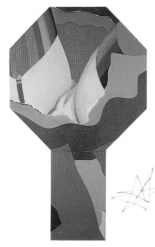

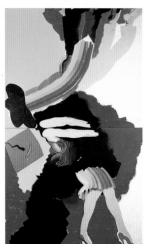

point. There was no extraneous line or information ... There is a charge I get from such a direct way of dealing with the figure and I like to use that 'charge'; the commitment a person has to make to a cube is less than that to a figure. I wish to strike some chord which threatens the person in some way so that they have to make a decision which has nothing to do with art history. I recognise this charge and I feel I should utilise it somehow or other.[7]

He began to collect fetish magazines such as *Exotique*, *Bizarre* and *Bound*, featuring the work of Gene Bilbrew, Eneg, Jim and Stanton, highly stylised images of the relevant fetish. Each fetish had its own specialised publication and its own specialised illustrators. They included rubber, shoe and leather fetishes, lingerie, transvestism, bondage, domination and submission, sadomasochism and any other that catered to the human imagination. Within their stated parameters the magazines, often filled with fan letters and amateur drawings, display a touching innocence. The catalogues display their offerings to fetishist readers as glamorously as possible. There is courage and more in offering size 13 court shoes with six inch heels. Some of these magazines date from the 30s, but their heyday was the 40s and 50s.

Although the sexual act of congress is clearly equated with the act of artistic creation in Jones' work, there is no explicit imagery. The closest he has come to explicitness is *Falling Woman*, 1964, in which he reverses the order of the *Marriage Medal* canvases, placing the octagonal one on top and the rectangular one below to depict the simplified fork of a tumbling girl, echoing the near-Surreal description of a girl falling off her bicycle in Georges Bataille's *L'Histoire de l'Oeuil*. This shape of canvas, which he also used for some 'parachute' paintings, suggested a keyhole, a self-portrait with tie and even male genitalia. But all such interpretations are only in the eye and mind of the viewer, and sometimes in the artist's replies to direct questions, and he has been known to mock the occasional interviewer by leading him on.

Jones conceived a group of free-standing sculptures in England shortly before leaving for New York, and had the wooden forms of the first of these prepared before his departure. These were then assembled, painted and added to in New York. They were all extensions of the self-portrait with tie and were all male figures except for the last, which was hermaphrodite. The ties had turned into totem poles capped with a head, the column shaped and painted, with its cut plastic top. The *7th Man*, like the *Hermaphrodite*, was entirely of transparent plastic, partly painted, and with a curiously sinister rope dangling within it. Had these sculptures been executed in England, the plastic would have been Perspex. Executed in the United States it was Plexiglas. *Hermaphrodite* also had a collage.

In 1970 Jones decided to destroy *Hermaphrodite*, as its technical quality no longer satisfied him. Wanting to keep a record of it, he decided to make a life-size painting of it; the phallic rope, piercing through the horizontal panel, ejaculates flecks of paint which shower down the perfectly gradated colour of the background, while the dual sexuality of the Heraphrodite is emphasised by the addition of a finely modelled pair of female legs, wearing stockings and high-heeled shoes in lieu of collage. The painting is entitled, logically enough, *Painted Sculpture*, 1970-71. *Hermaphrodite* also appeared in his lithograph *Young Lady Contemplating Modern Sculpture*, 1969.

Female and Male Diptych, 1965, painted in New York, consists of two canvases identical in size, one being totally female, from red mandala-face with glossy lips, spectacular cleavage encased (just) in blue, striped knee-length skirt and a handsome pair of legs in green shoes; the other male, hat at top, down-swooping striped phallic torso, trousered legs, shod, with just a hint of tight buttocks seeming to ooze out of the trousers. The separation of the sexes is, however, not total. A female arm has penetrated the male domain, almost but not quite parallel with the arm in the female domain, implying, perhaps, further invasion of territory, but also visually seeming to bring the two halves closer together by either sliding them over each other or bending them at an angle to each other so that the arms would merge. A closer look at the painting reveals more invasion. Standing on its male side the dark-trousered legs are framed not only by a red-trousered pair of male legs, but also by two legs in fetching pink trousers, one wearing a stiletto-heeled shoe, the other a flat-heeled tan shoe. And that extra floating parallel arm seems to make perfect sense, stretching forward in the throes of a Latin-American dance, torso thrust back. Well, perhaps. But placed on the floor on either of its short sides, Jones observed that feet, painted to the very edge of the canvas, shared the same space on which he was standing. On his return to England he began a series of pictures in which shoes, painted to the very edge, were given a real surface to stand on by the addition of a narrow shelf at the base. 'Because they are physically there in real space, the shelves emphasised the fact that the painted image is phoney and not a substitute for real life,' he said.[8]

Real life provided him with inspiration for many images. A photograph of a group of Cardin models in a newspaper led to his lithograph *Exciting Women*, 1964. A photograph by Bert Stern of Elizabeth Taylor (p33) with plunging neckline and Egyptian eye makeup showing the scar of the cut in her throat made to enable her to breathe when she had fallen ill while filming *Cleopatra* was transmogrified into *Woman* (p33). This is a colour lithograph with collage in which the face is replaced by a diamond-

shaped mandala with a twin set of lips surmounted by a serpentine squiggle, with just a shadowy mark that seems to echo the scar. Stern commissioned a five-panel *Painted Screen*, 1965, from Jones, who produced a wide dark horizontal storm cloud with two diamond mandala heads above and several women's legs and shoes below.

The shapely leg of a woman was another theme pursued by Jones. Taking a quotation from Nietzsche in *Thus Spake Zarathustra* as a starting point, he executed a variety of paintings which express his love of dancing, music and the theatre with considerable humour, *joie de vivre* and sly composition.

> Lift up your hearts my brethren
> higher and higher!
> Neither forget your legs!
> Lift up your legs also ye good dancers
> and better yet if ye can stand upon
> your head.[9]

Neither Forget Your Legs, 1965, has five legs skipping joyfully, *A Figment in Pigment* and *Sinderella*, both 1969, show the lower halves of couples dancing, more thigh-to-thigh than cheek-to-cheek, both using the device of the pyramidal spotlight to shape the composition. *Duet*, 1971, depicts two singers, each in her face-effacing spotlight; the one on the left grasps her microphone in her hand in a way that might make the lazy viewer leap to the wrong conclusion and take it for a whip. It is another Jones trap. *Command Performance* and *Tall, Average, Petite*, both 1975, and *Curtain Call*, 1975-76, depict performing legs on stages seen from the theatregoer's perspective, framed by sitting knees and up-gazing faces.

In *A Dream to Dance to, II*, 1974-76, the red-faced spectator may well be the artist (with tie), but the performer has become a swirl of colour dominated by the artiste's artificial smile. That same smile graces the face of the female spectator of the couple looking at the girl on stage playing the maracas against a curtain drawn by an elegant green glove in *Downbeat*, 1975, and free floats in *Command Performance*. *Strange Music* has a dancer centre stage and another almost totally concealed by a curtain, while the conductor's hand wields his baton from the pit in front. The apotheosis of conducterdom is *Overture*, 1977-78, a triumphant semicircle of outstretched arms extracting a symphony of colours ranging from cool to flaming: but is there not another piece of whimsy and is the conductor not Jones himself?

Fatal Footstep, 1966, introduced the exquisitely modelled leg following his introduction to fetish magazines, but it is somewhat tentative, not yet committed to the subject, and the words WOMEN and MEN are superimposed on each other, fixed to the wood panel over the knee. Interviewed by Peter Webb for his pioneering book on *The Erotic Arts* in 1975, Allen Jones explained:

I wanted to paint a picture free from the ideas about picture-making that had become almost a dogma whilst I was living in New York in 1964. I wanted to paint a pictorial affront. Whereas before the subject was enmeshed in painterly gestures I now wanted to insinuate it upon the viewer. The choice of a leg for my image meant that I had to consider shoes; to consider a shoe is to consider a style and I did not want to date my pictures in that way. I wanted the epitome of a shoe just as I wanted the epitome of a leg. The high-heel black shoe became an inevitable choice. From Freud to *Fredericks* it is the archetypal shoe. In retrospect I can see how the fetishistic content must have been important, and I can recognise the Freudian implications of the high heels.[10]

Wet Seal, 1966, was the epitome of leg and shoe. A single garment hugs bottom, thigh and leg, so tightly it wrinkles at the ankle and the back of the knee; becomes a shoe with stiletto heel so steep the foot is almost on point. The left leg reflects light with high polish. But the hyper-realism of that leg is countered by the right one, painted a flat, unreflective black culminating in a barely outlined shoe, the paint thickly dried on the laminated wood shelf at the bottom of the painting. The background is a very softly gradated flesh tint. This 'was an extreme stance holding in check my natural instincts for colour etc. Black and white/extremely modelled legs/erotic overtones of stance and black material rubber/leather image taken straight from a mail order drawing by Eneg ... all these points were extremes for me, at home with colour and ambiguous form' he wrote in a letter quoted in the catalogue of the touring exhibition of his work organised by the Walker Art Gallery, Liverpool, in 1979.[11] A group of leg paintings was exhibited at the Tooth Gallery in 1967.

Leg pictures became increasingly adventurous. *First Step*, 1966, contrasted a pink and a silvered leg, hobbled by a transparent narrow skirt which was somehow also part of the stockings, with a spectacular golden yellow background. *Hot Wire*, 1970-71 depicted the legs of a tightrope walker, graceful in an immensity of geometric colour fields. *Automatic Shift*, 1968, and *High Style*, 1970, each join two canvases of equal size, the legs in the upper canvases, the first lower canvas painted with a hoop, the second with a sphere. In *Automatic Shift* the feet, in strapless sandals, are simultaneously standing on the central plane bisecting the painting and apparently about to use the hoop's edge to take off into space, an illusion sustained by the backward flapping skirt. In *High Style* the legs, in a sturdy pair of shoes, stand squarely on the edge of a yellow plane seemingly balanced on the sphere, a clear impossibility. The chromatic spiral of *Sheer Magic*, 1967, is a dazzling centripetal force whirling into its

centre out of which a shod leg dangles its reflective surface like a tassel. It is a serious joke or a witty manifesto, combining the nearly hermetic explorations of colour of Seurat in his *Application of the chromatic circle of Mr Charles Henry and the Portrait of M Felix Fénéon* in 1890 with the Pop Art Target image, proffering an enigma as a solution, the transformation of the flat colour plane into the three-dimensionality of the modelled leg.

Towards the end of Jones' year in the United States his friend Peter Phillips, there on a Harkness fellowship, turned up with a car, and the two men with their wives went on a 20,000 miles round trip. Jones spent some time in Los Angeles, where the Feigen-Palmer Gallery gave him an exhibition, and he fell in love with it: 'I go back at every opportunity,' he said in *The Image* interview.

I think Los Angeles is the only metropolis which has something going on in the way of cerebral activity and also sunshine. The other thing they have is a great sense of humour and I think humour is an important part of my work. What I like is that they know what I'm doing.[12]

In 1966 he went back on a Tamarind Lithographic Fellowship. He executed individual lithographs such as *Daisy Daisy* and *Subtle Siren* at the Tamarind Workshops, as well as two major portfolios, *A Fleet of Buses*: five lithographs with title page and portfolio, and *A New Perspective on Floors*: a portfolio with title page and six lithographs. The fifth lithograph represented a tiled floor with a rug on it and an electric plug and cord. The other five were leg images on various floor surfaces. All were designed to be framed with a front fold to simulate a shelf.

The tiled floors were also used in a new series of paintings in which the basic shelf was replaced by aluminium steps covered in plastic laminate tiles completing the painted floor on the canvas. The first two had flirtatious titles, *Come In* and *You Dare* (both 1967), the legs now extending up with skirt to the waist, but placed to the side of the painting, revealing an almost uninterrupted, subtly gradated background to the powerful, gaudy, chequerboard floor. Jones had sought to offend the complacent acceptance of current academic conventions, and he clearly succeeded. Ira Licht, writing in *Studio International* (July-August, 1967) argues that the indication of depth by the use of floor tiles painted in perspective was 'thoroughly discredited' and 'vulgar', while the tiled aluminium steps as a device for entering the spectator's space was 'almost unspeakable'.[13] This encouraged Jones to paint *Two Timer*, 1968-69, a chequerboard perspective step picture in which previous sombre colouring was replaced with the jarringly luscious colours of Mexican sugar-dolls, pinks and mauves and oranges and greens with another wide expanse of masterly, gradated colour framed by two pairs of female legs. In *La Sheer*, 1968, he changed his own

conventions, and centred a pair of shod legs that were no more than fully modelled stockings, apparently enclosing no more than air. This was a device used sometimes by lingerie catalogues to display stockings, corsets or bras, and has been wittily used by Jones from time to time, as in *Sale, Save*, 1972, *Or Perfecto*, 1969. *Double Take*, 1969, brought the series of chequerboard perspective step pictures to a close, the tiles occupying the lower half of the picture, the upper half an uninterrupted vista of gradated pinks, the 'human' element just two little squares on the steps, harking back to earlier images, each with a diamond mandala head with a *Pathway* feature: mouth/eye with protruding tongue/ snake/squiggle over a rudimentary torso.

Every Allen Jones image is the culmination of a multiplicity of drawings, sketches, watercolours in sketchbooks and in the form of cinematic storyboards, in which he works out every problem, from placement of elements to complexities of colour. Some pictures are inspired by the very existence of a visual or conceptual problem.

Photography had long intrigued him, and over the years he has taken many thousands of photographs, all neatly filed and catalogued in his studio. He now approached the problem of integrating photography in his work. In 1968 he published an album entitled *Life Class* containing a title page and seven colour lithographs (p18). Each lithograph was cut horizontally across the centre, simulating his painterly use of two canvases. Each depicted a seated female figure (though plate II has a pair of fleeing male legs and plate III amalgamates the female legs into a besuited but headless male figure). The lower halves depict attractive 'pin up' legs using photographic images as their basis. The upper parts are treated in various painterly styles, some using fetish imagery, others echoing earlier Jones imagery, the torso replaced by a framed image, a barely sketched portion, or even replaced by the back of a modified Eames chair. It is also possible to shuffle the pack and substitute some images for others. In *Miss America*, 1965, one of two lithographs he had produced for the Philip Morris sponsored Album *11 Pop Artists* he had used a photographic postcard of a cowgirl flipped through a landscape with cactuses, and an even earlier lithograph *Self-Portrait*, 1963, had incorporated a treated photograph of Brigitte Bardot; *Thrill Me* (p19) joined a dancing figure entirely encased in a transparent space age outfit, lithographed by Jones with a matching photo-mechanical image of the lovely Pat Booth by James Wedge.

Inspired by an image in one of *Fredericks of Hollywood*'s catalogues depicting trousered legs fanned out in a circling line and ascending size, he executed a set of five pictures, the first, *What do you mean, what do I mean*, more than twice life-size, followed in descending order of size, by *Man Pleaser*

(p21), *Brazen Beauty*, *Desire Me* (p20), and the final untitled one less than a foot high, all 1968, the first three oil paintings, the last two pencil and ball point pen on paper. Executed in two halves, the leg portion of each was a photographic reproduction of *Wet Seal* printed on the canvas unchanged except for some airbrushing to ensure it was in focus. Feeling that other artists who used photography with painting subordinated them to the painted surface, so that, say, Andy Warhol would deliberately mis-register the image, while Rauschenberg would either use only a fragment of the photograph or print it only in monochrome, Jones chose to use the photographic image complete and untouched, its original power at full strength, but of course the photograph was of a subject he had painted in the first place. Talking to Sally McLaren and Peter Daglish in the *Inprint Printmakers Council Magazine* he admitted that a photographic image printed on canvas 'is artifice, but on paper, as a printed surface, it has reality'.[14] *Florida Suite*, published in 1971, took his use of photography to the ultimate, his choice of four images printed, untouched, by screen print.

In 1969 Allen Jones decided to create a series of sculptures which would be produced as 'furniture' in order to depersonalise them. In his usual fashion he drew a whole variety of different images, finally settling on three: a table, a chair and a hat-stand. The concept was hardly new. Caryatids were used on Greek temples, Victorian edifices and expensive furniture and objets d'art throughout the centuries. At the turn of the century Rupert Carabin designed and made a set of furniture: a table, a desk, a chair and a bookcase, carved with a variety of female figures. The armchair, in particular, was held by a large nude kneeling and embracing the sitter. In the 20s the Surrealist artist Kurt Seligmann designed upholstered stools with three female legs while Man Ray designed a sofa as Mae West's lips. The carved wood of Carabin, the upholstery of Man Ray or Seligmann, served to emphasise the utilitarian aspect of the pieces in question. Allen Jones chose a more dangerous route. He chose Dik Beech, a commercial sculptor who worked as a freelance with Gems Wax Models which made moulds and casts for Tussaud's Wax Museum. Jones provided Beech with drawings and specifications, and he modelled a life-size clay figure which was adjusted daily under Jones's direction until the figure was precisely stylised. Each of the figures was then cast in fibreglass with resin by K Gems Ltd, then sprayed, rubbed down and sprayed again until perfectly smooth. Entirely hand painted, subtle flesh tones were matched with appropriate facial make-up and painted eyes. John Sutcliffe, who had founded the firm of Atomage which specialised in the most intricate leather clothes (he designed outfits for the television series *The Avengers* and for James Bond movies) made the appropriate leather garments, in particular the strap work on the standing figure. Zandra Rhodes made the Lurex pants of the *Table* model, a small item which required three fittings. The wigs were made by Beyond the Fringe, the boots by Anello & Davide, the theatrical and ballet footwear manufacturers, and the glass table-top made and installed by Design Animations Ltd. Only the gloves were bought ready-made from Weiss in Shaftesbury Avenue.

Marco Livingstone quoted Allen Jones in the catalogue of the 1979 Touring Exhibition organised by the Walker Art Gallery, Liverpool:

The paintings were getting so much more visually hard and precise . . . that it did occur to me that maybe the paint surface was redundant. Much as I thought I might be committing suicide as a painter, I later realised that philosophically there's no way you're going to make painting redundant. Sculpture is three-dimensional and painting is two-dimensional, and what you simply do is polarise the problem . . .

The furniture idea (standing figure first) was to further dislocate the expectations of the viewer by introducing a motor response that was common to everyday life (table – sit – use) so that the viewer would have to decide for him/herself about the aesthetic stance . . . The object of throwing the viewer off-guard is to get at him whilst he is still pure, to elicit a response unfettered by preconceptions . . . My exaggeration of the female form is for a good reason. The figures of course are not real people, but painted signs and a sign should be clear. My pictures are a manipulation of these signs to arouse various emotions. I am interested in creating a totemic presence. Apart from the female symbols of large breasts, the figures are rather masculine. Sturdy limbs and aggressiveness of posture are images usually associated with the male figure in art history. The Greeks used an essentially male image when depicting ideas of bisexuality or the duality of human nature – I use female . . . Eroticism transcends cerebral barriers and demands a direct emotional response. Confronted with an abstract statement people readily defer to an expert. It seems to me a democratic idea that art should be accessible to everyone on some level, and eroticism is one such level.[15]

In the interview in David Litchfield's *The Image*, issue 9, Jones comments:

The sculpture has brought some peachy kind of comments. People don't 'look' at my work; they just 'recognise' it, so the critic of the *New York Times*, two years ago in summing up a show, said that I was exhibiting a collection of nudes. Well, there wasn't one in the exhibition, and another critic asked why there wasn't a vaginal slit inside one of the jockstraps. He'd have had

39

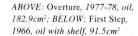

ABOVE: Overture, 1977-78, oil, 182.9cm²; BELOW: First Step, 1966, oil with shelf, 91.5cm²

ABOVE: Automatic Shift, *1968, oil, two panels, 182.9 x 91.5cm;* *BELOW:* Self Portrait, *1973, lithograph*

to put his hand inside to have found out, and I think that's fantastic . . .[16]

The 'furniture' sculpture was illustrated in an astounding quantity of magazines all over the world. Several of the more serious critics understood what Allen Jones was trying to do. Robert Melville wrote that 'the girls come from a strip-joint not of this world',[17] while Richard Cork found them 'so exciting. They tread on the wavering border-line between art and life, and end up by claiming an extra slice of territory for art. A small slice, perhaps, but one that astonishes and delights'.[18] Some papers attacked him, calling him sexist, anti-feminist, even 'the arch-enemy of women's liberation', all of which came as something of a shock. In the Peter Webb interview he said:

I think that the cause of female emancipation is trivialised when someone gets uptight about a piece of sculpture, whilst enormous problems of inequality still exist amongst live human beings. Suppose my sculptures did underline a human condition; when Goya painted a blood-bath, it did not follow that he condoned it.[19]

Contemporaneously with the first exhibition of these sculptures, he published *Allen Jones Figures*, a book which illustrated a cross-section of the images which inspired him, cuttings from fetish magazines, specialist clothing catalogues, magazine and newspaper illustrations, film publicity, advertisements, interspersed with drawings, sketches and photographs inspired by them, as well as preliminary drawings and watercolours for some of his paintings. There were several photographs of his wife Janet, long his muse and inspiration, often wearing some fetish clothes he had designed for some project or other.

In January 1970 Stanley Kubrick approached Allen Jones to design the Korova Milk Bar scene for his forthcoming film of Anthony Burgess' *A Clockwork Orange*. He designed a sample cafe table and an eminently practical, washable, skin-hugging waitress' outfit totally concealing the body from the neck down to the tip of the toes with just a cutout opening for the buttocks to cheer up the diner after being served. In the end Kubrick and Jones did not come to an agreement, and Kubrick used a design inspired by the Jones kneeling woman table, but not by him. The waitress' outfit was not wasted. Tim Street-Porter photographed Jones' wife wearing the outfit, seen from the back, balancing a tray high above her shoulders; the photograph was blown up to life-size, silhouetted and mounted to be freestanding; and it was introduced into 25 restaurants, from the most chic to greasy spoon caf', and the resulting photographs reproduced in a very limited edition book entitled *Waitress*. It also appeared in another book, *Allen Jones Projects*, representing various executed and abandoned projects for the theatre, film or television. *Album*, 1971, another

portfolio containing seven colour lithographs, had an analytical self-portrait (many with tie) off-centred on each sheet with an upper corner showing a fetishistic image, either drawn (dominatrix with whip, pin-up girl with high heeled shoes) or photographed (Mrs Jones in colourful latex outfit).

In 1968 Allen Jones issued his definitive statement on shoes with the publication of *Shoe Box*, an album containing seven lithographs, with an embossed cassette containing a polished aluminium sculpture, the cassette labelled 'EXOTIC'. The sculpture was a ballet shoe-last on point, the severely monochromatic lithographs representing a high-heeled boot equipped with rowelled spur, a mixed woman's and man's shoe, two shoes, and four plates depicting pointed toed shoes with vertiginously high heels, either empty or painfully tight on a foot. Four further shoe lithographs were issued as single prints *en suite* with the boxed set. All were shoes he had previously depicted in various paintings.

'Suddenly the dancing stops – the climactic moment . . .' was a triple illustration by Eneg for the transvestite magazine *Female Mimics*.[20] In the first image a man in a business suit, wearing a porkpie hat, is framed by identical ambulant female outfits in profile: wig, earring, dog collar, belted short-sleeve dress with extended bosom, long glove holding handbag, ankle strap shoes. In the middle image the man has caught up with the female outfit and is merging with it. In the final image the female outfit is filled out by a made-up woman's face, arms, breasts and legs: behind her is an empty man's suit, complete with shirt, tie, shoes, with porkpie hat hovering in the air above. In 1972 Jones adapted Eneg's outline comic strip into three powerful and characteristic paintings, *Maid to Order I, II* and *III*. He had been presented with a ready-made scheme in which to further explore his fascination with sexual identity and role playing while again being able to equate the fusion of the sexes with the act of creation. In each of these three self-sufficient paintings he acknowledges the symbolic importance of clothes in establishing and confirming personality, but is far more pessimistic than Eneg's recognisable 'woman' wearing makeup. In *Maid to Order III* the final figure is fully dressed as a woman, but face, arms, legs are featureless black, still and perhaps forever an enigma.

Black Soft Aroma (p24) and *Red Aroma* (p25), both 1973, are the only two pictures he produced in a series intended to be called *Look/Touch/Sniff*, in which two rectangular canvases are joined vertically with a latex outfit sewn into the seam. In *Red Aroma* the red latex suit bisects and conceals the features of a woman whose elegant, gloved fingers appear to hold something invisible, or indicate the size or height of something. *Black Soft Aroma* has a pair of legs sheathed apparently in latex and shod in high heeled platform shoes, a latex suit sewn down the

centre between the canvases, the left hand canvas with bold red strokes like those in a comic book. Marco Livingstone wrote in the Walker Art Gallery catalogue:

> That cerebral caress is now made actual through the presence of a real latex jacket sewn into the join between the two canvases. From this garment there emanates also the pungent aroma of rubber, which is reinforced visually by the short-hand device of diagonal slashes familiar to us through the comic strips. It is not a question of adding one sense experience to another, for all these sensations are contained within a single object which is apprehended visually: the latex jacket . . . The incorporation of a real article of clothing into the art-work subverts our customary passivity in front of a painting, encourages identification with the life-sized painted figure, and appeals to our senses of touch and smell. Like the shelves and steps in the earlier series, the jacket also acts as a bridge between the illusionistic space in which the painted figure exists and the actual space in which we are standing. The canvas surface on which the jacket rests literally defines the boundary between the real and the imagined.[21]

Allen Jones himself remarked at the time:

> My interest in latex is that it is the only true 20th-century material not 'faking' another, and it is also the only material that seems to be still socially taboo . . . I expected the latex to deteriorate quickly or be torn off by unrestrained viewers. The pictures were conceived so that they would be satisfactory even if the latex disappeared or was reduced to small fragments that would remain sewn into the picture.[22]

Allen Jones' international reputation brought him many interesting and unusual commissions each of which presented formal problems to solve. He designed a sketch for the erotic review *Oh Calcutta*, devised by Kenneth Tynan and named after Clovis Trouille's painting, a play on '*Oh quel cul t'as*' (Oh what an arse you've got), designed a video spectacle for West German Television, *Männer wir kommen*; designed the 1973 Pirelli calendar, a copy of which was bought some years later at auction by the Tate Gallery; designed a 609.6 x 304.8cm poster for the Welsh Arts Council, garments for The Body Show at the Institute of Contemporary Arts in London, sweaters for the Ritva Man; posters for Barbet Schroeder's film *Maîtresse* (pp22-23), with Gérard Depardieu and Bulle Ogier; for the Olympic Games and for the Royal Academy Summer Exhibition; and designed a giant mural overlooking the Railway Station at Basel in Switzerland, spread over two separated walls, advertising Fogal Hosiery (they also used the image on a limited edition of plastic bags). A pair of disembodied crossed legs in lace-up boots with a gloved hand appeared as a new sculpture entitled

Secretary (pp26-27), as well as a new version of the kneeling woman table, this time in green and with a glass top in the shape of an artist's palette.

The passage of time has transformed the way one looks at Allen Jones' work. While some critics felt that he took his shoe designs from the 40s, when he had actually attempted to universalise the experience of the shoe as out of time, the passage of time led to *Vogue* referring to the models in an Yves St Laurent collection as 'wearing Allen Jones shoes'.[23] The 'furniture' sculpture have outlived their early notoriety and shock value to become icons of the art of the second half of the 20th century. A few years ago *The Sunday Times Magazine*, exploring the subject of 'Beauty' sought 'The perfect female image' and asked 27 'personalities from the world of the arts and literature' for their nominations. Ralph Koltai, the theatre designer, chose the kneeling girl table, Mark I wrote:

> Don't be misled by the posture of Allen Jones' sculpture, merely a convenience for drinking coffee. Total femininity, beauty and intelligence clearly reflected. If there is a flaw in her perfection only Roman Polanski would know – she belongs to him.

Latex, rubber and leather have become not merely acceptable, but the preferred materials for dressing for pleasure. Dozens of specialist designers of fetishistic clothes flourish in Britain, the United States, France, Germany, Italy, Holland and Spain. A new generation of feminists has outgrown that first generation which could only express itself through a rejection of sexuality and a hatred of men. More relaxed in their persona, prepared to explore and develop their individuality and sexuality, generally successful at whatever they do, indeed often with an earning power that many men would kill for, they are prepared to look at the work of Allen Jones not as that of their arch enemy, but as that of an artist exploring the duality of their communal experience.

Allen Jones was divorced in the mid 70s and has since lived with the designer Deirdre Morrow, who has been his constant model. As *The Magician* of 1974, materialising the female form into a very real pair of shoes ('Beam me down, Scottie'), he gave way in the following decade to Allen Jones the sculptor, not the prestiditator who conjured up images but the craftsman who cut out a piece of paper or card, twisted it 'like orange peel' and found that 'I could make self supporting forms that were nevertheless flat surfaces that could hold colour and add information to aid the "description" of the sculptures'.[24] In conversation with Andrew Lambirth, he elaborated:

> . . . The gentle curve which was arbitrary and inflicted by the materials, became almost an allusion to the curves of the figure without being illustrative of it. That kind of structure would not

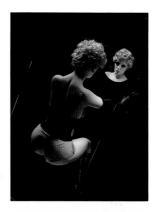

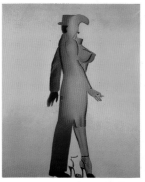

ABOVE: Table, 1969, mixed media with 'metal flake' on fibreglass, 60.9 x 83.8 x 144.8cm, one of six variations (photograph by Erik Hesmerg); BELOW: Maid to Order II, 1992, oil, 182.9 x 152.4cm

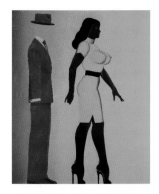

have occurred to me through drawing alone . . . (Since) paper loses its tensile strength and just sags when there is a change in the temperature . . . I began to make the maquettes out of thin sheets of very light-weight aluminium which can be cut with shears the way you cut paper. When you bend the aluminium, it stays put. I then planish it on the edge of the table beating the metal surface with a special rounded hammer that makes an indentation. It tempers the metal at the same time as shaping it, giving it a structural strength. The steel fabricator (John Crisfield, recommended to Jones by Anthony Caro) takes tracings of the various surfaces and enlarges them to the scale required. We have a system where he cuts outside the enlarged contour so that when the new large shapes are tacked together, I can redraw the contours taking the new scale into account. I originally thought I would be painting all the steel pieces, but I've realised that the forms are often quite self-sufficient.[25]

Allen Jones uses a variety of materials for his sculpture. Small bronzes are used to make images that can be shaped in wax by hand and the cast held in the hand. Steel is generally used for complete figures, normally highly stylised, and could be left rusted and lacquered; made of stainless, mild or forged steel left in its natural state; or painted a single colour.

More complex sculptures in which 'the contours move in and out of figurative description', the visible portions shifting as the perspective changes, may be made of wood or steel, are generally painted in whole or in part.[26] The outline may enclose the whole subject, painted as a unity, or the painted portions may be complementary aspects of the sculpted image, or even produce unexpected delights and surprises. Identical sections may be painted with images that confirm or deny the apparent thrust of the conception. All Jones' favourite preoccupations appear in a new guise, from the self-portrait to acrobats, from theatrical imagery to dancing figures, ballet and ballroom. The scale of these sculptures which alternate between small table-top pieces and tall floor-standing ones has increased spectacularly as he has carried out an increasing number of public commission: a *Tango* for the Liverpool Garden Festival, 1984; a 731cm high sculpture of interlocking figures commissioned by St Martin's Property Corporation in Cottons Atrium, London Bridge, 1987, for which he received an award; *Red Worker* (p103), 1986, at Perseverance Works, Hackney, London Buildings; a large rusted steel sculpture for the Sterling (now Hilton) Hotel at Heathrow (p127), 1990; a large cor ten steel sculpture installed at Milton Keynes (p128), 1989; and a monumental figure spanning two-and-a-half floors at the new Westminster and Chelsea Hospital (pp130-

131), 1992; as well as a sculpture for the Frederick R Weisman Foundation in Los Angeles.

In between sustained periods of sculpting, Allen Jones has returned to sustained periods of painting as well as sustained periods of print-making. In 1984 and 1985 he produced a major new set of large paintings on the subject of The Party. Each is a complex composition entwining men and women at play, dancing, loving, embracing, singing and making music, dominating, serving; masked or unveiled they are expressive, involved and, unusually for Jones who likes to go for the universal, human. A voyeur appears in some: the artist himself sketching in the background of *Night Moves*, a figure skulking behind a sofa holding up a miniature camera in *The Visitor*, both 1985. Impressed by the major retrospective exhibitions of Picasso and Manet in Paris, he resolved to paint:

. . . a big painting (which) should represent a big subject, suitable for our time. The Party seemed the best excuse I could find for organising a lot of figures on a big canvas. As a talisman I chose the exact dimensions of *Les Demoiselles D'Avignon* – just not a square, and I painted a series in this size so that I would not be intimidated by the scale.[27]

In the same issue Sir Lawrence Gowing wrote: 'If, as I believe, the "Party" pictures are the masterpieces a whole generation has been waiting for it is because colour is asserted with a new coherence, as well as all the old defiance.'[28]

Allen Jones has mastered the disciplines of painting (including drawings and watercolours), sculpture and graphics. The later sets of lithographs, the six plates of *The Magician* in which the eponymous manipulator brilliantly levitates, expunges, rematerialises or transforms his assistant are all the tricks only the artist can control with a flick of the brush; while the eight lithographs of *Para Adultos*, 1984-85, and its accompanying set of monotypes further explore aspects of the 'Party' theme and the voyeuristic artist, in the process of somehow amalgamating with a new recurring character, the old man up a tree from *The Music of Time*, 1984, or the Ivy Restaurant mural.

Allen Jones is, above all, a great colourist. Totally outside the English tradition of muddy colours such as adherents of the Camden Town group and their followers, he spreads his colours voluptuously, gradating them subtly to achieve brilliant effects. He uses erotic imagery to disorientate, dislocates expectations with witty pictorial comments which can be self-mocking while simultaneously treating his subjects in a totally serious way. He is slightly detached, very precise, subtly metaphorical, self-critically analytical but always conscious of his own ability and creativity, and perfectly convinced – and convincing – about the consignificance of the formal elements in his work.

Notes

1 Notes by Jones following a lecture by Maurice de Sausmarez on 'Dynamism' on February 10, 1960, at the Royal College of Art, quoted in *Allen Jones Retrospective of Paintings 1957-1978*; organised by the Walker Art Gallery, Liverpool, with the assistance of the Arts Council of Great Britain, the British Council and the Staatliche Kunsthalle, Baden-Baden, 1979, catalogue by Marco Livingstone, note 8.

2 Ms reply to Peter Webb, July 1972, *ibid*, note 8.

3 *ibid*, note 6.

4 *ibid*, note 6.

5 Friedrich Nietzsche, *Thus Spake Zarathustra*, translated by RJ Hollingdale, Penguin Books, Harmondsworth, Middx, 1961, p95.

6 In conversation with the author, October 1988.

7 *The Image*, no 9, Editor David Litchfield, The Baroque Press, London, 1973, p8.

8 *Allen Jones*, *op cit*, conversation with Marco Livingstone, note 19.

9 *Nietzsche*, *op cit*, 'Of the Higher Men', Section 18.

10 Peter Webb, *The Erotic Arts*, Secker & Warburg, London, 1975, p371.

11 *Allen Jones*, *op cit*, note 26.

12 *The Image*, *op cit*, p6.

13 Ira Licht, 'Allen Jones: the Potent Image', *Studio International*, London, Vol 174 no 891, July-August 1967, p32.

14 'Allen Jones Talking to Sally McLaren and Peter Daglish', *Inprint Printmakers Council Magazine*, no 2, London, November, 1968, p17.

15 *Allen Jones*, *op cit*, note 35.

16 *The Image*, *op cit*, p8.

17 Robert Melville, 'Pop in Efigy – the Happy Home of Allen Jones', *Vogue*, Vol XXVII no 1, London, January 1970, p57.

18 Richard Cork, 'Admass World on Edge of Orgy', *Shropshire Star*, 5 February 1970.

19 *Webb*, *op cit*, p373.

20 Originally illustrated in the magazine *Female Mimics*, it was reproduced in *Allen Jones Figures*, Galerie Mikro – Edizioni O, Milan, 1969, p10. The first section was also reproduced on the cover of *Ambit*, no 53, London, 1972-73 and the full image on p33; *Maid to Order I, II* and *III* were reproduced on pp23-25.

21 *Allen Jones*, *op cit*, note 43.

22 Letter to Marco Livingstone, *ibid*, note 43.

23 *ibid*, note 24.

24 Manuscript notes by Jones on his sculpture, 1993.

25 'Allen Jones in Conversation with Andrew Lambirth', *Allen Jones* Sculpture, Glynn Vivian Art Gallery, Swansea, 1992, pp5-7.

26 Manuscript notes by Jones on his sculpture, 1993.

27 *Art & Design*, volume 1, no 5, June 1985, Academy, London, p48.

28 Sir Lawrence Gowing, 'Allen Jones' *ibid*, p45.

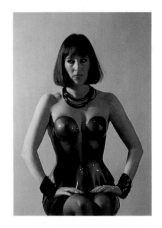

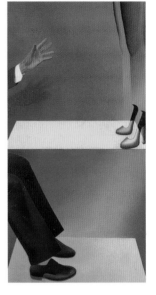

43

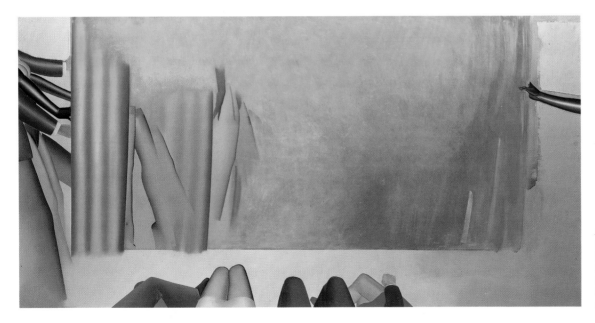

ABOVE: Deirdre Morrow wearing an Issey Miyake breastplate, 1991 (photograph by Allen Jones); BELOW: The Magician, 1974-75, oil, two panels, 182.9 x 91.4cm; LEFT: Tall, Average, Petite, 1975, oil, 182.9 x 365.7cm

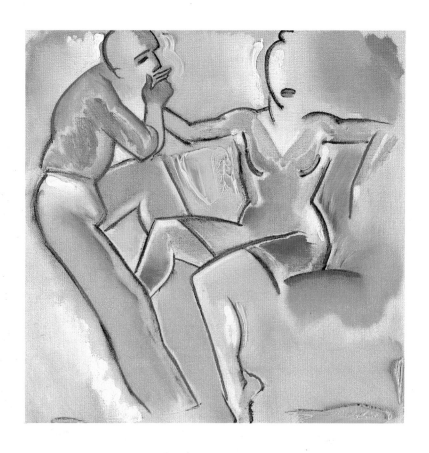

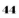

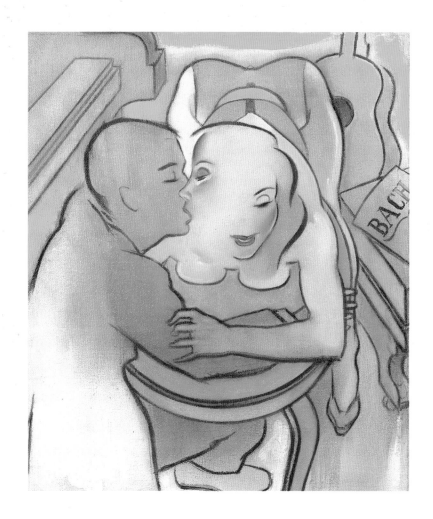

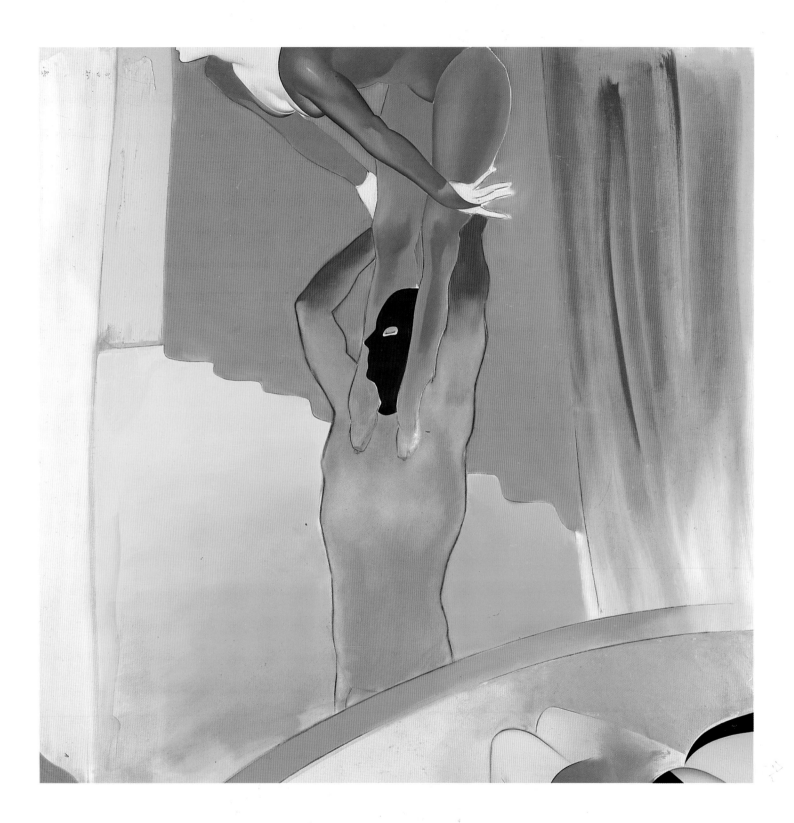

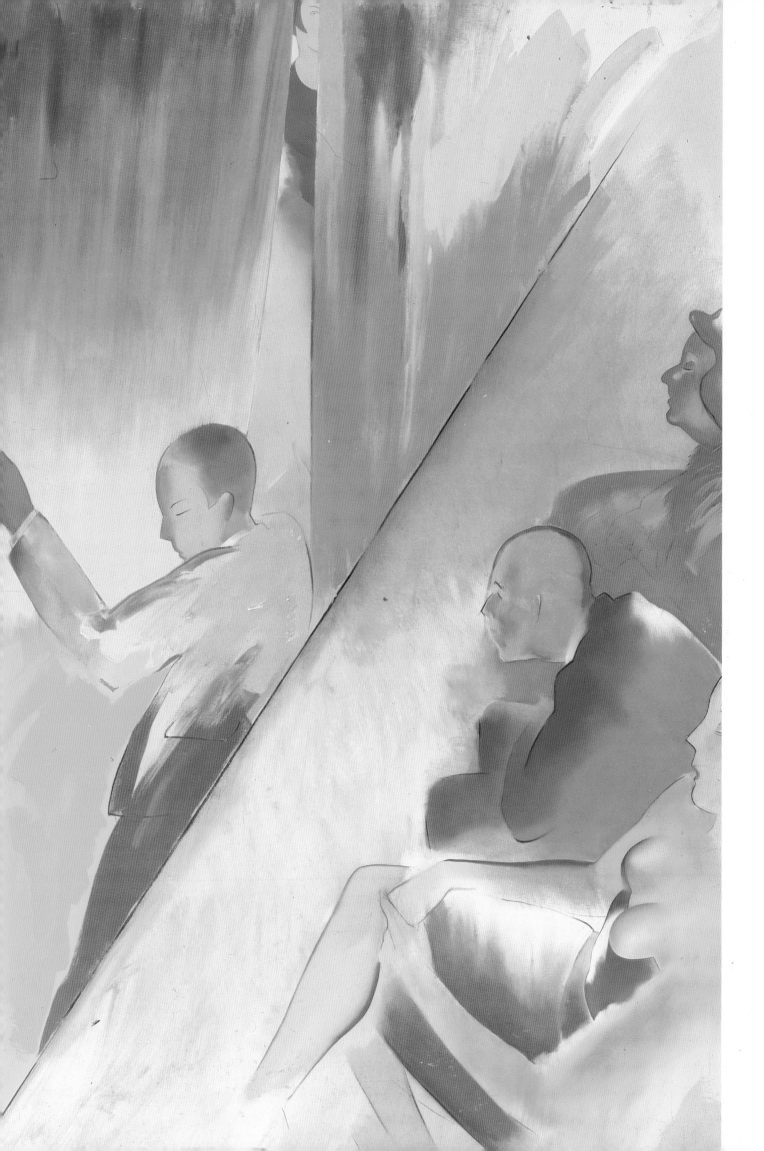

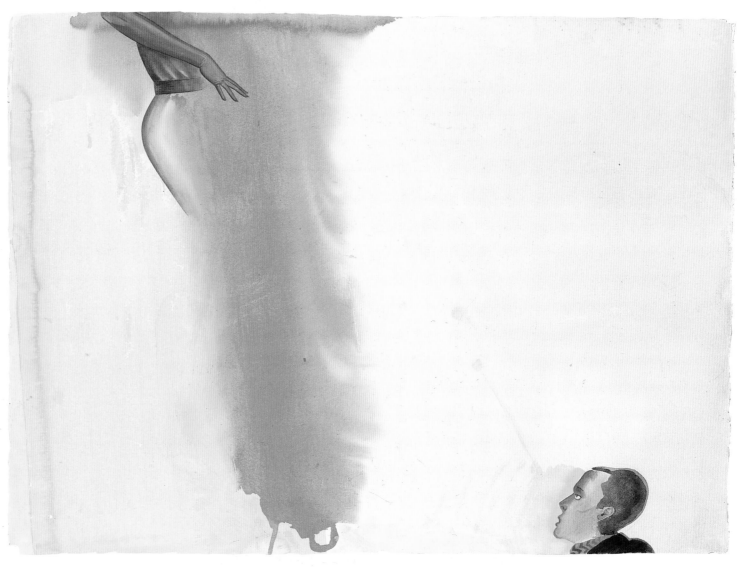

50

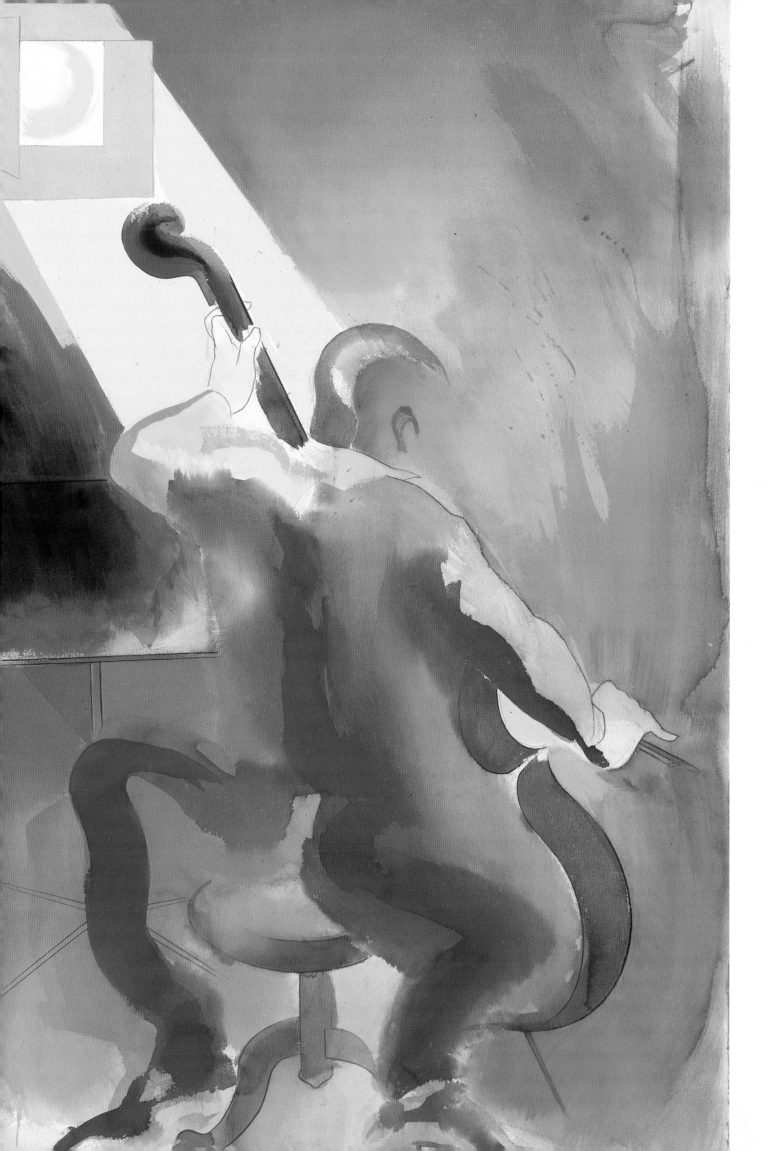

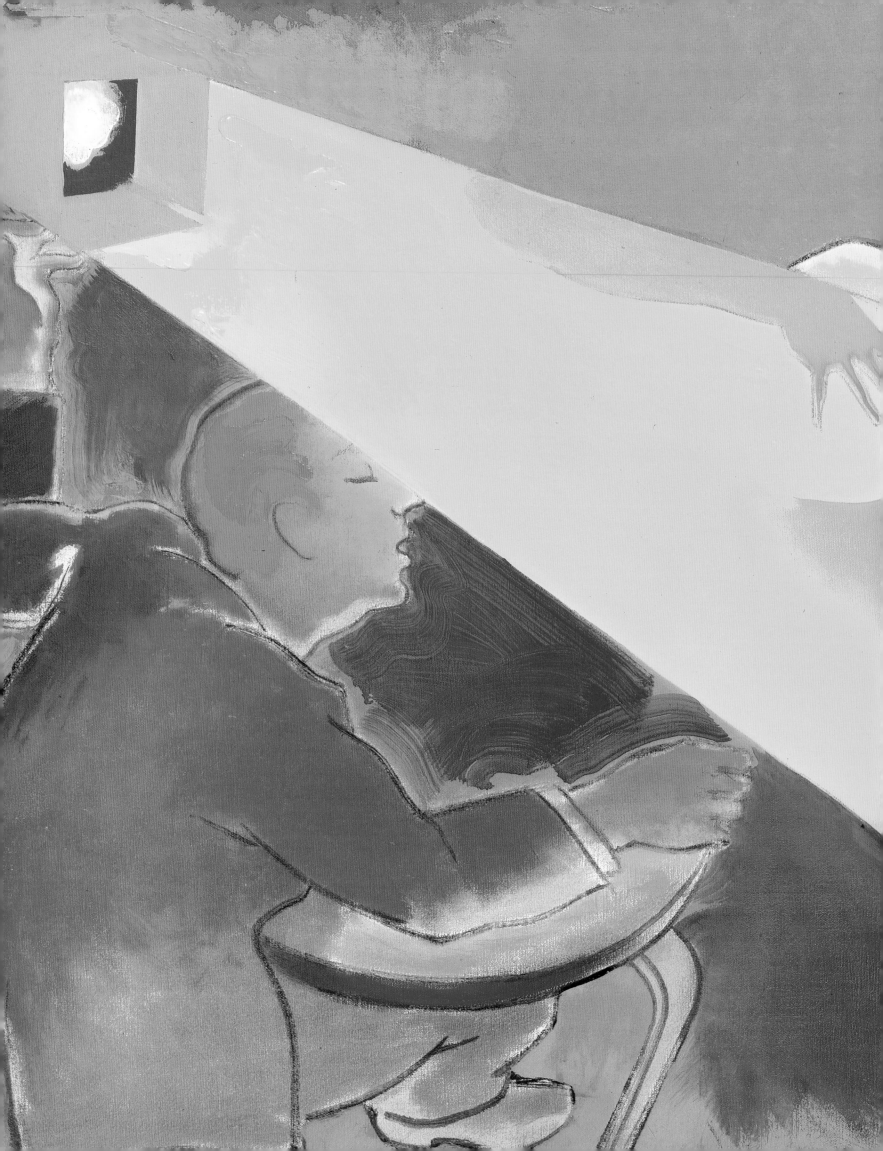

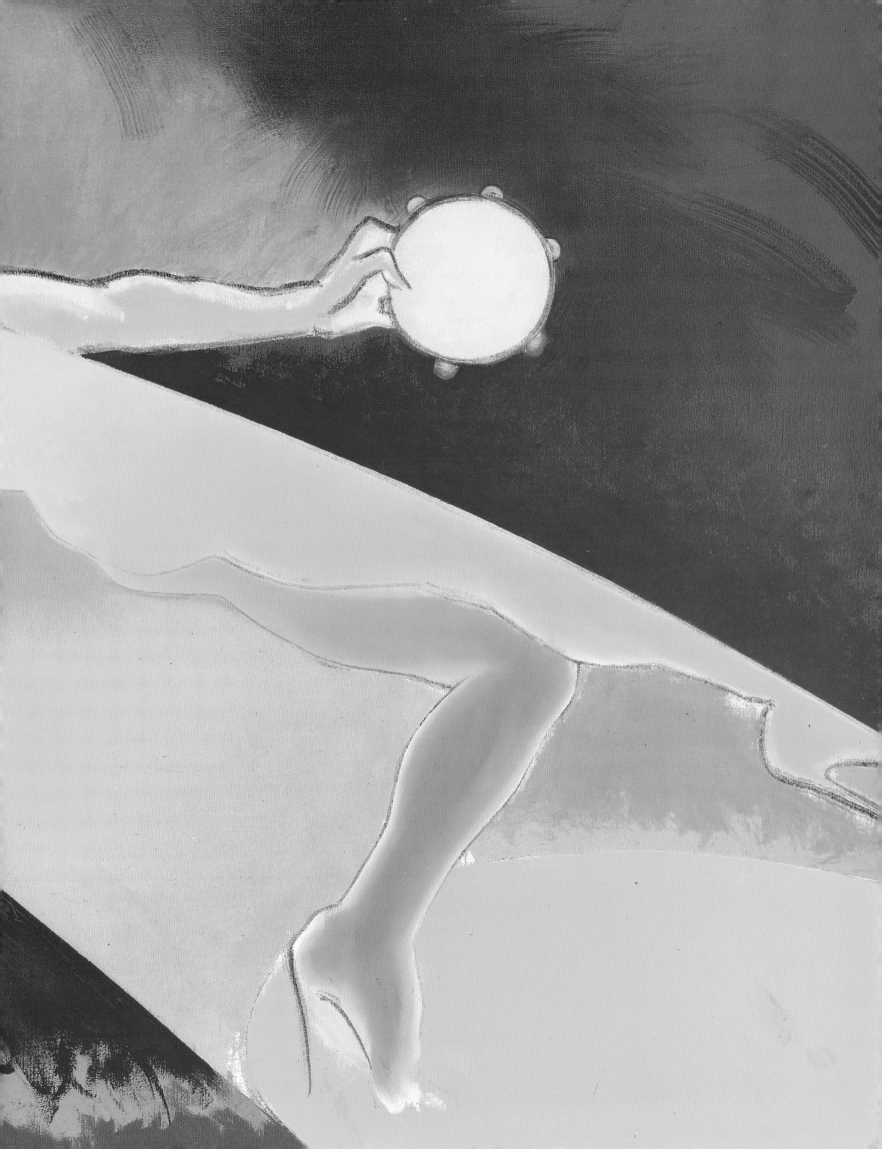

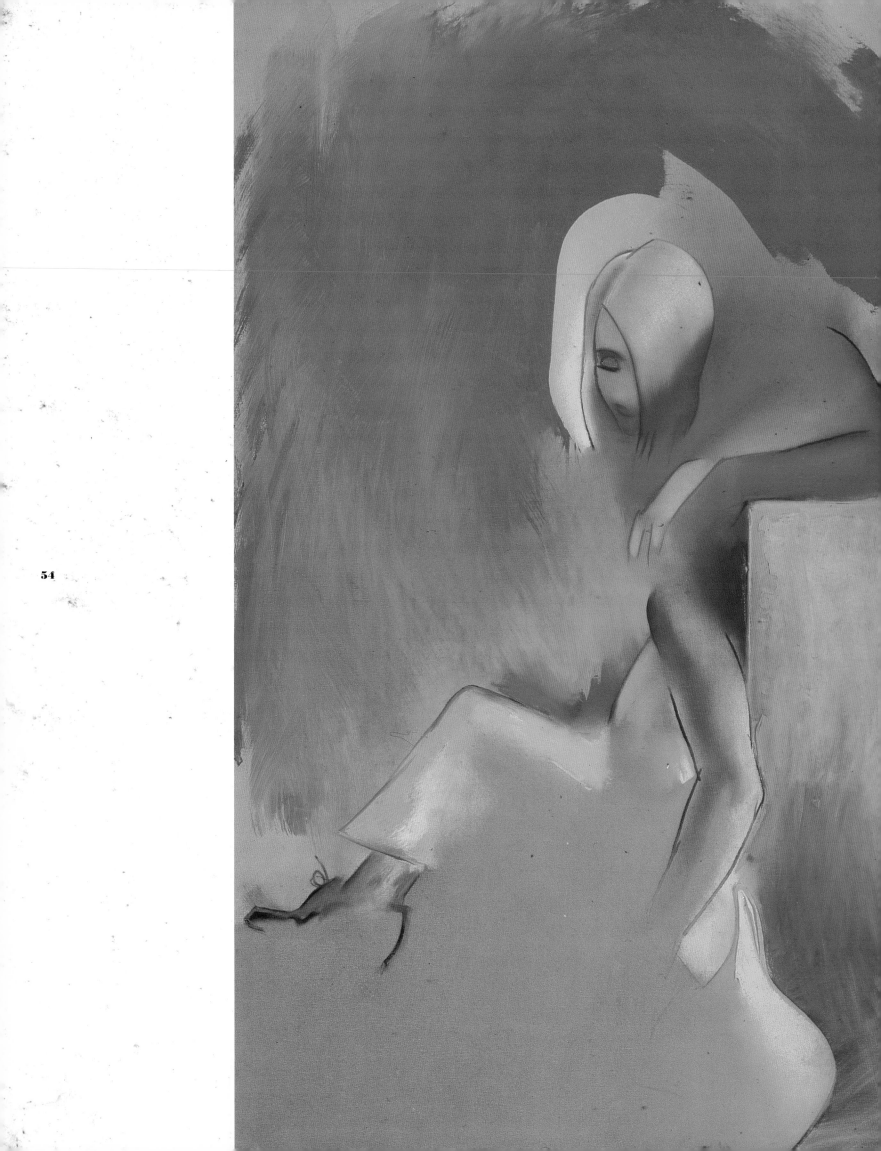

54

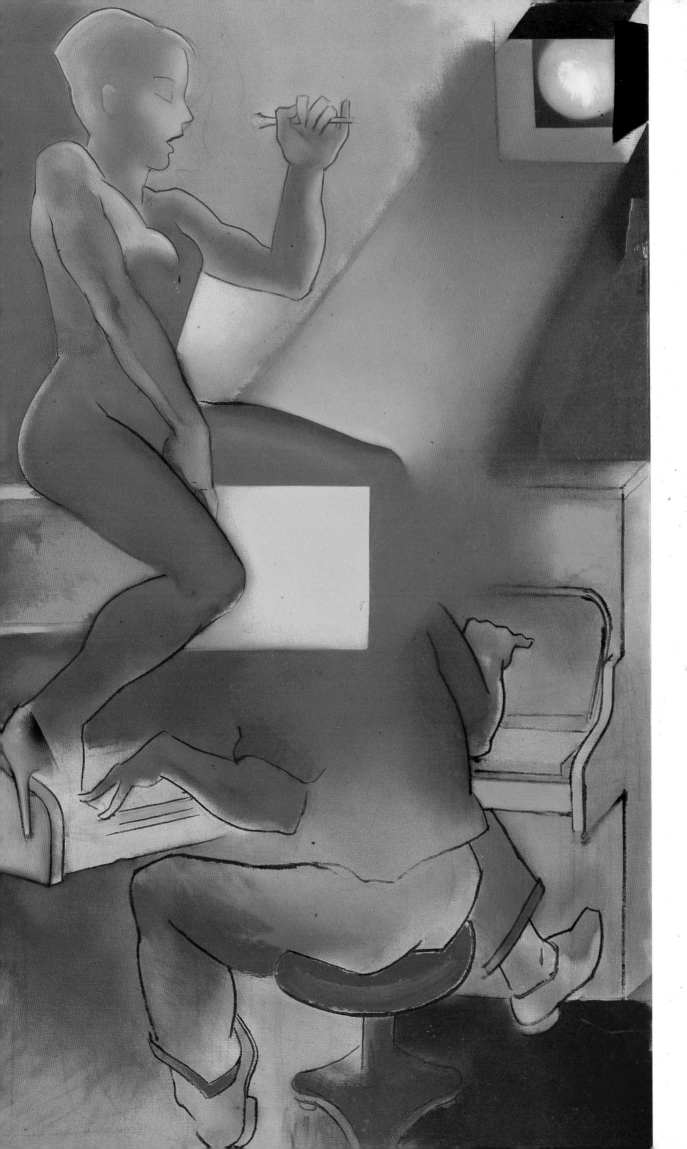

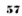

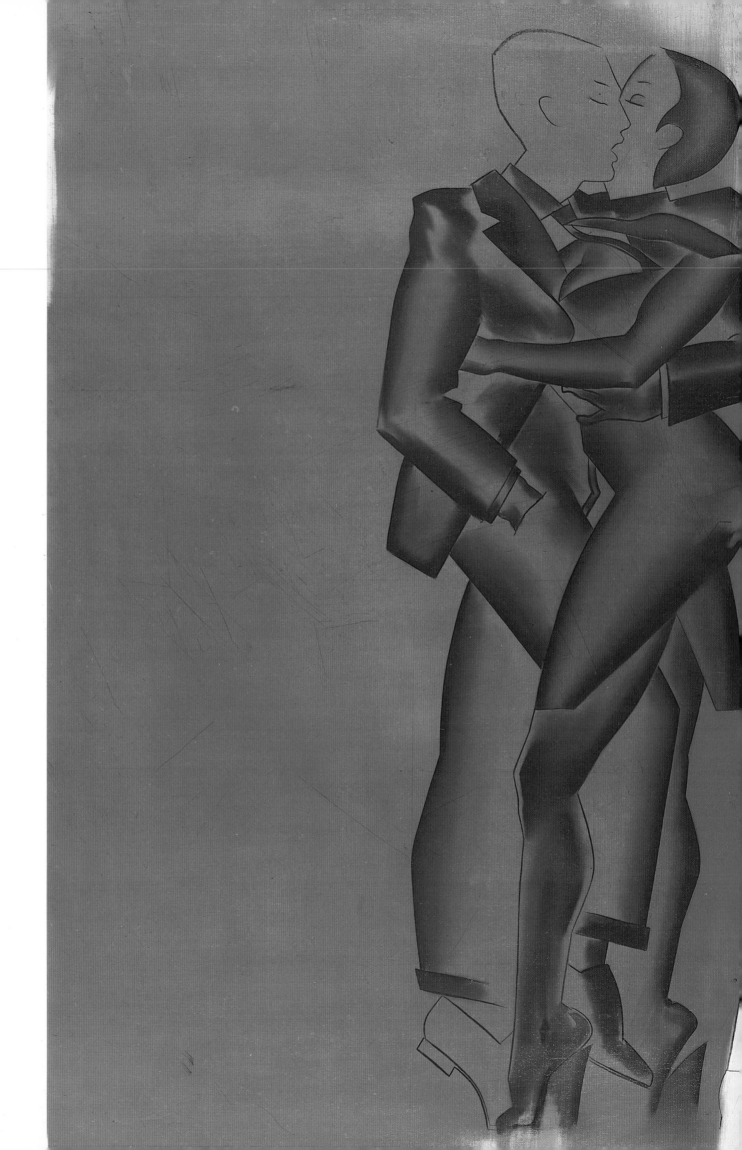

59

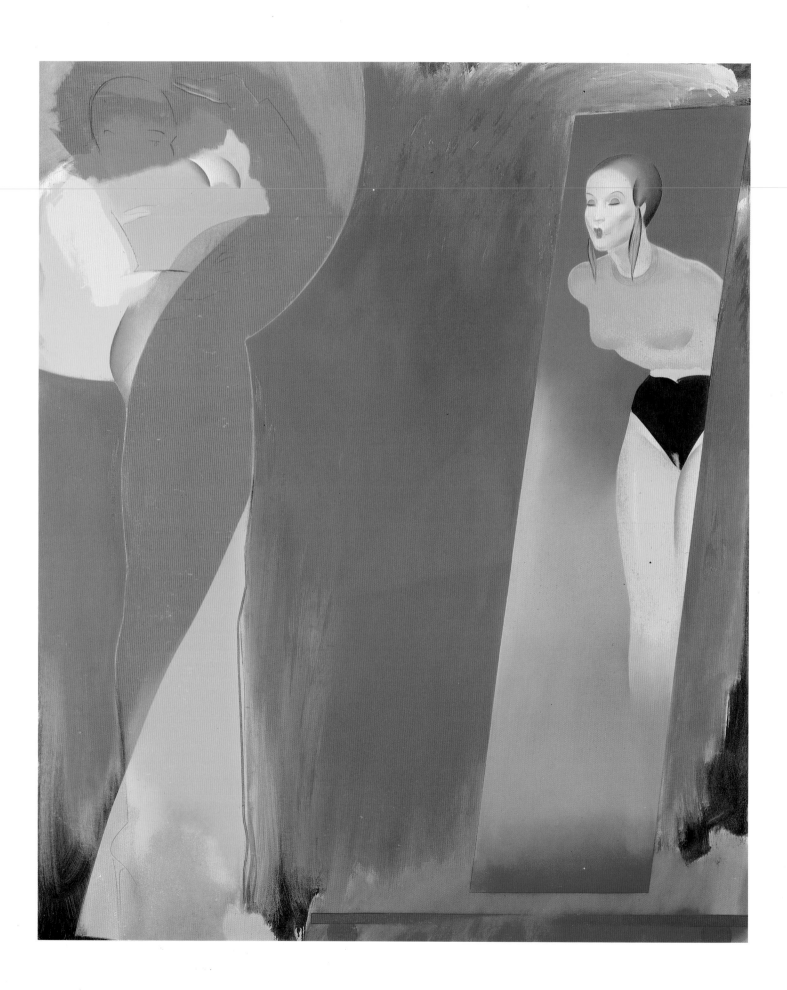

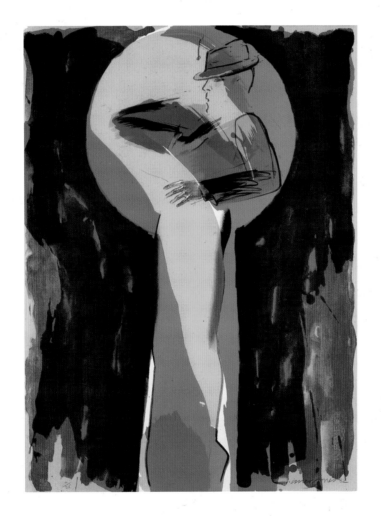

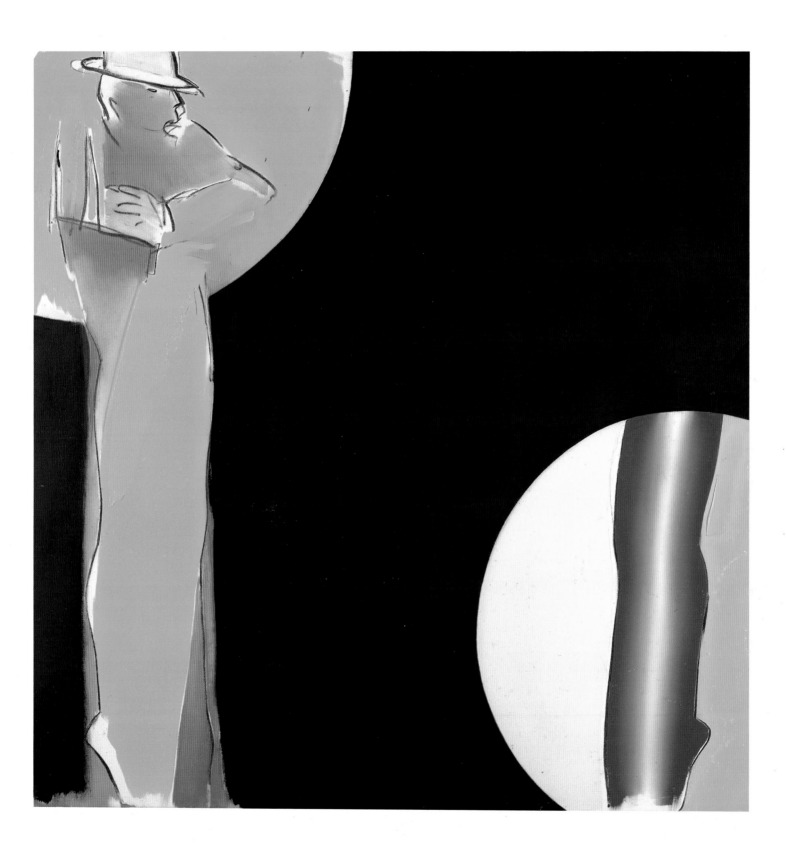

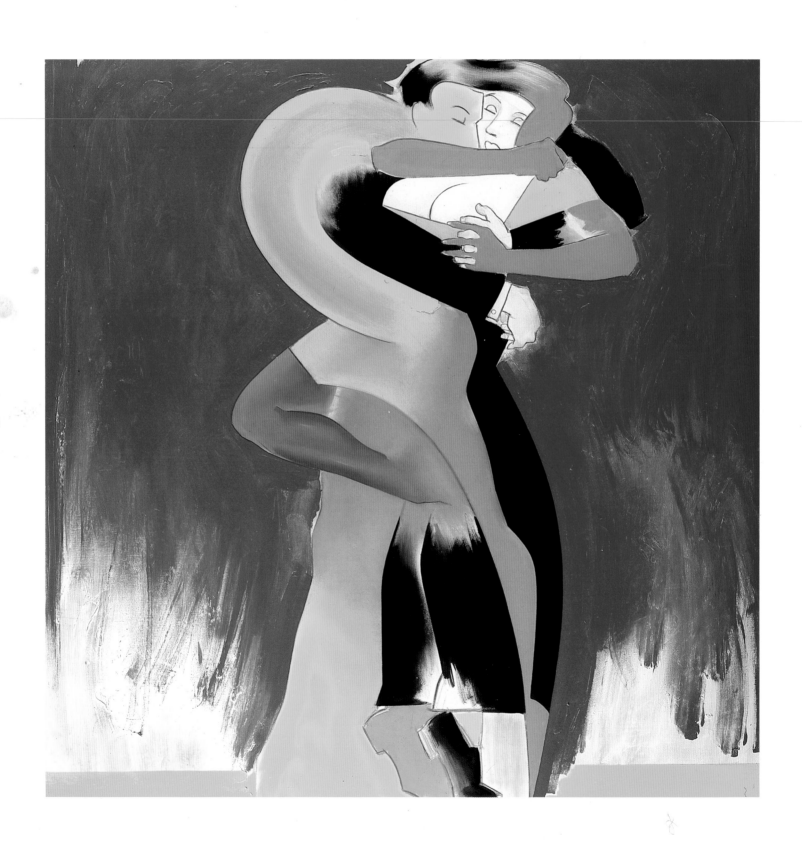

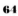

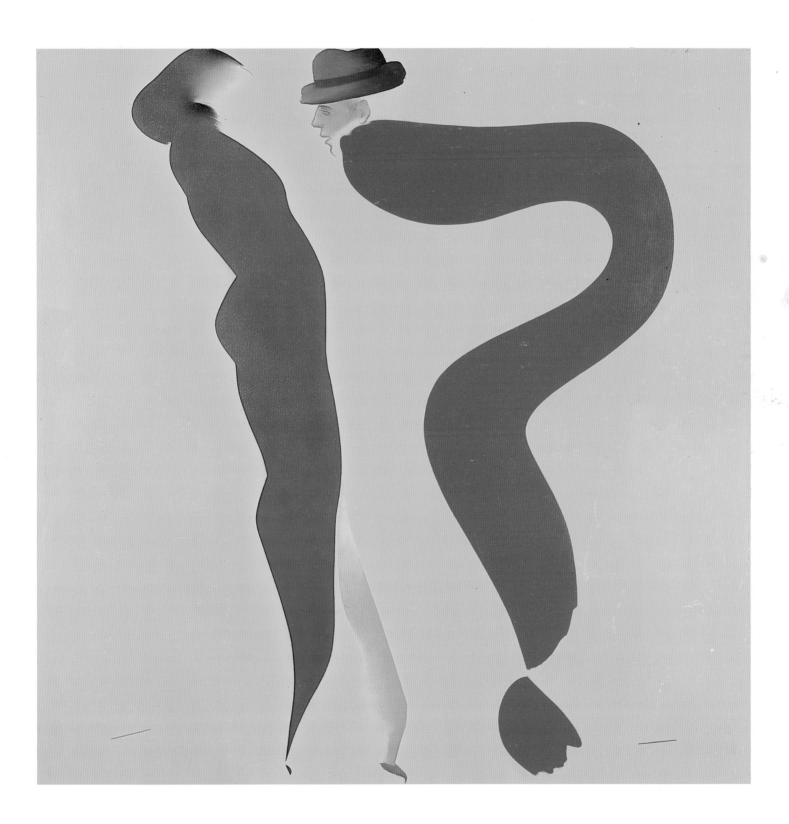

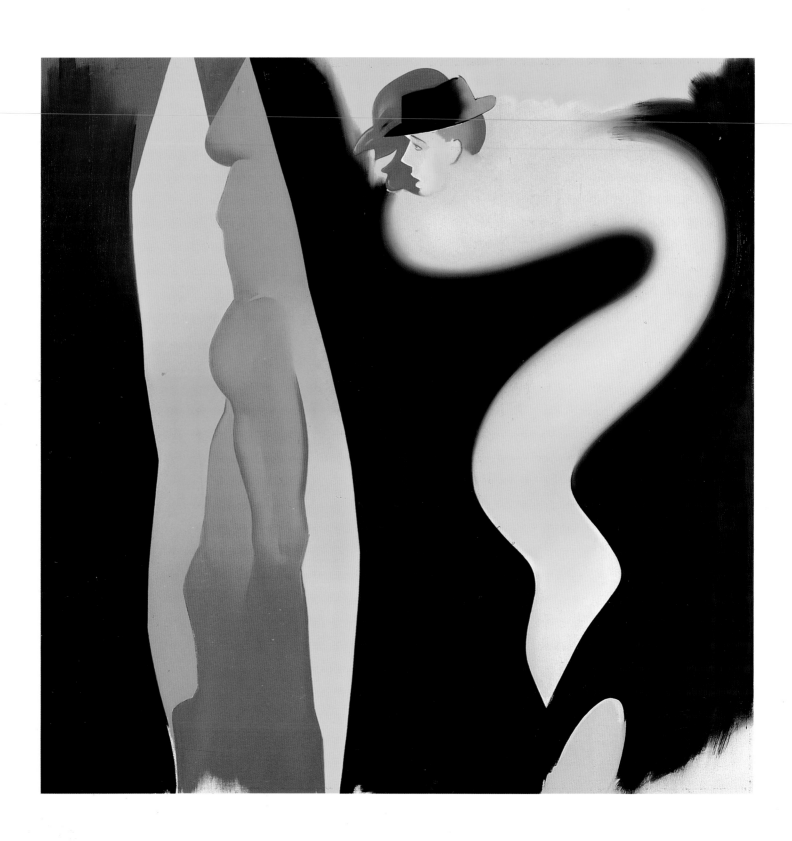

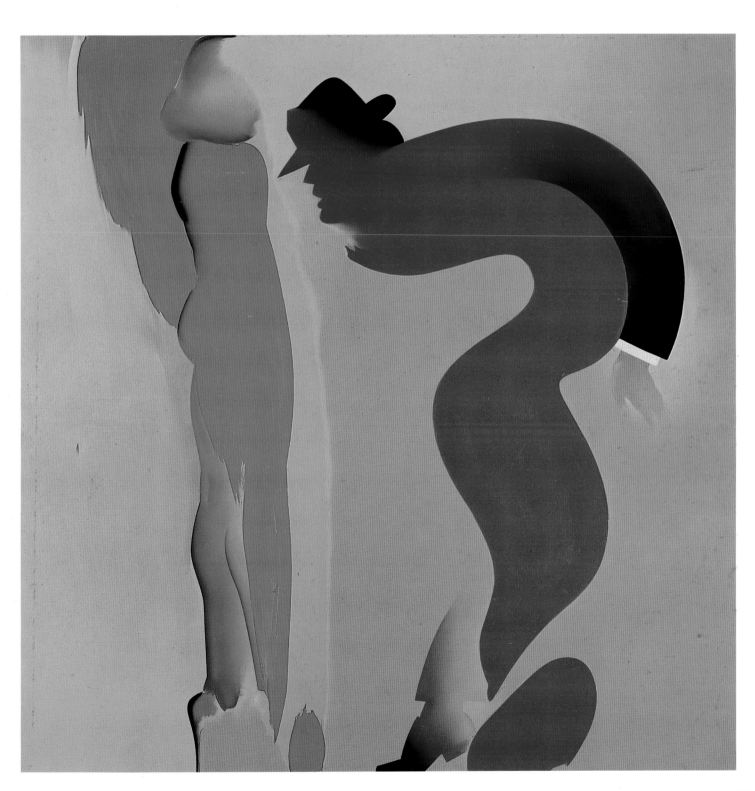

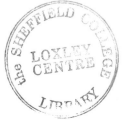

68

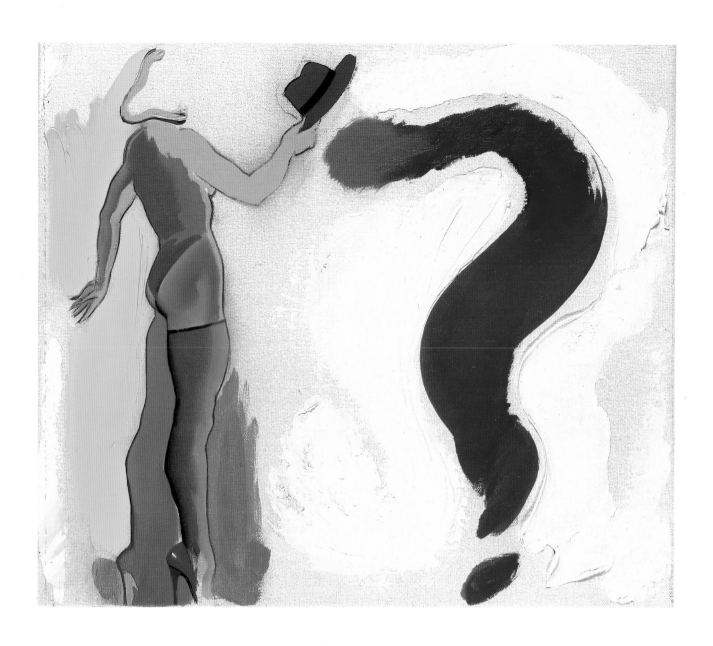

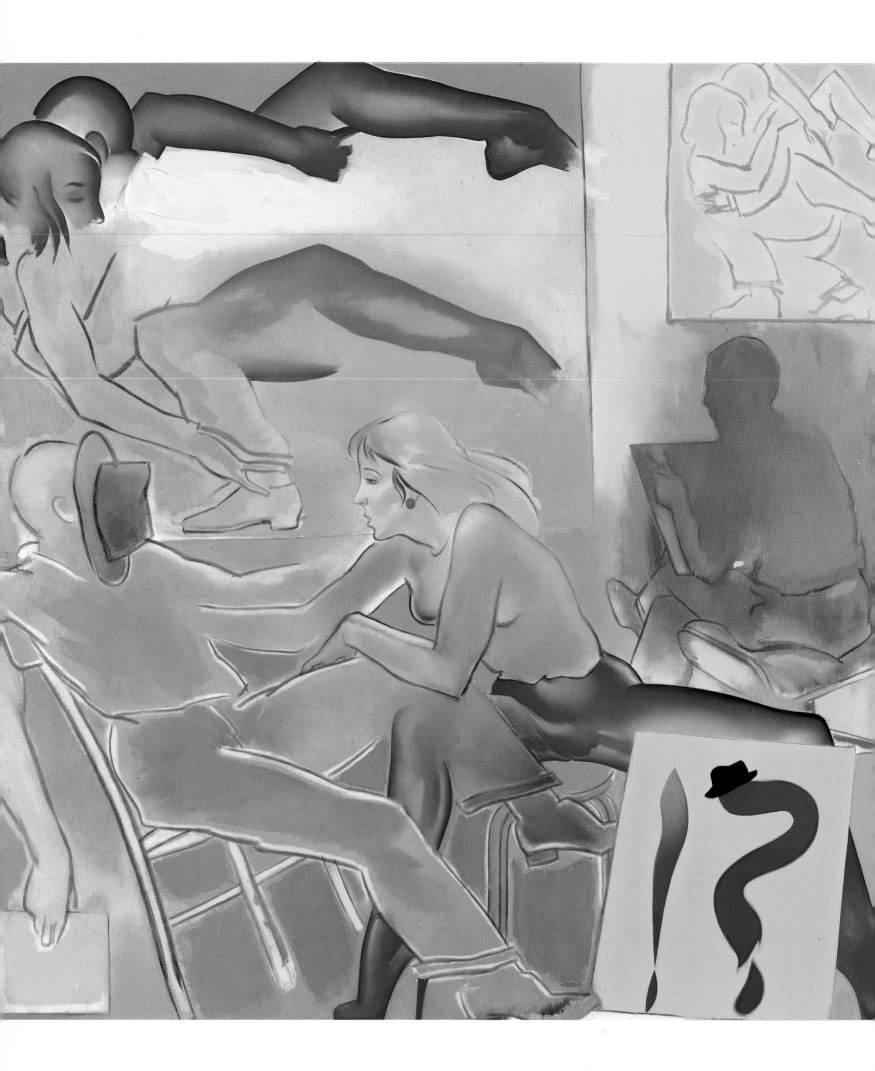

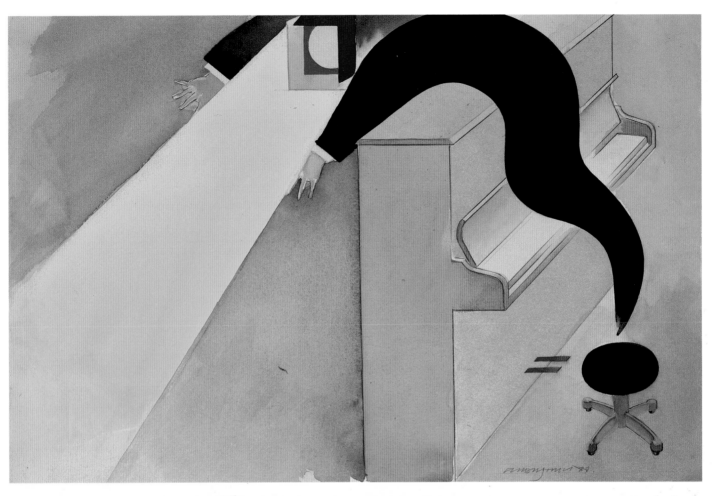

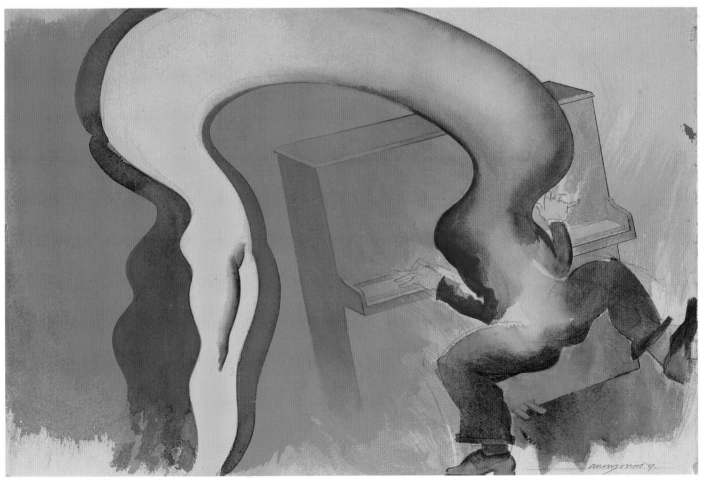

72

74

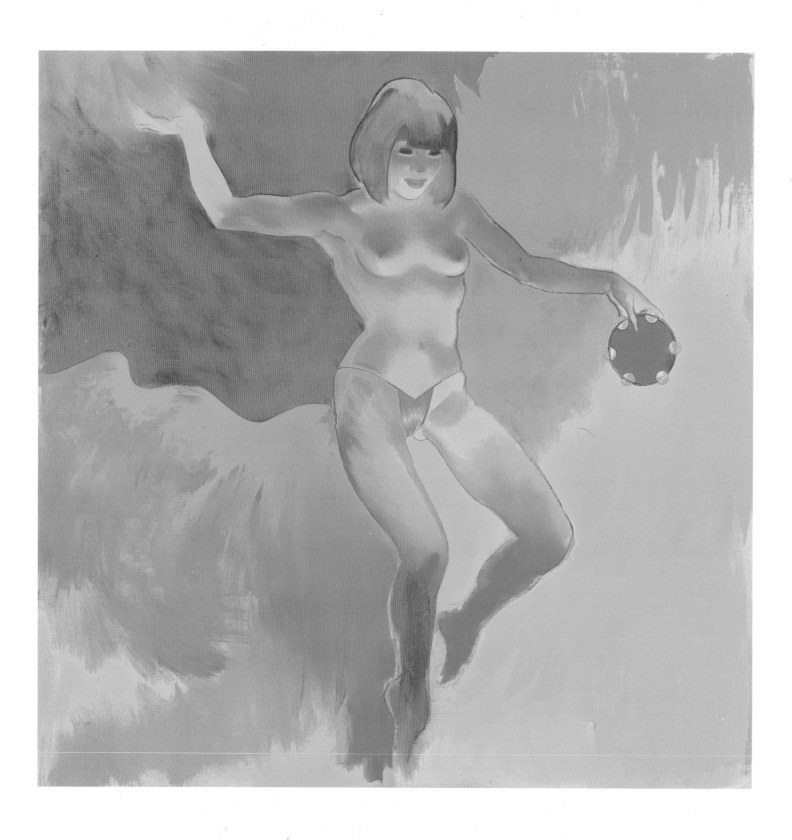

76

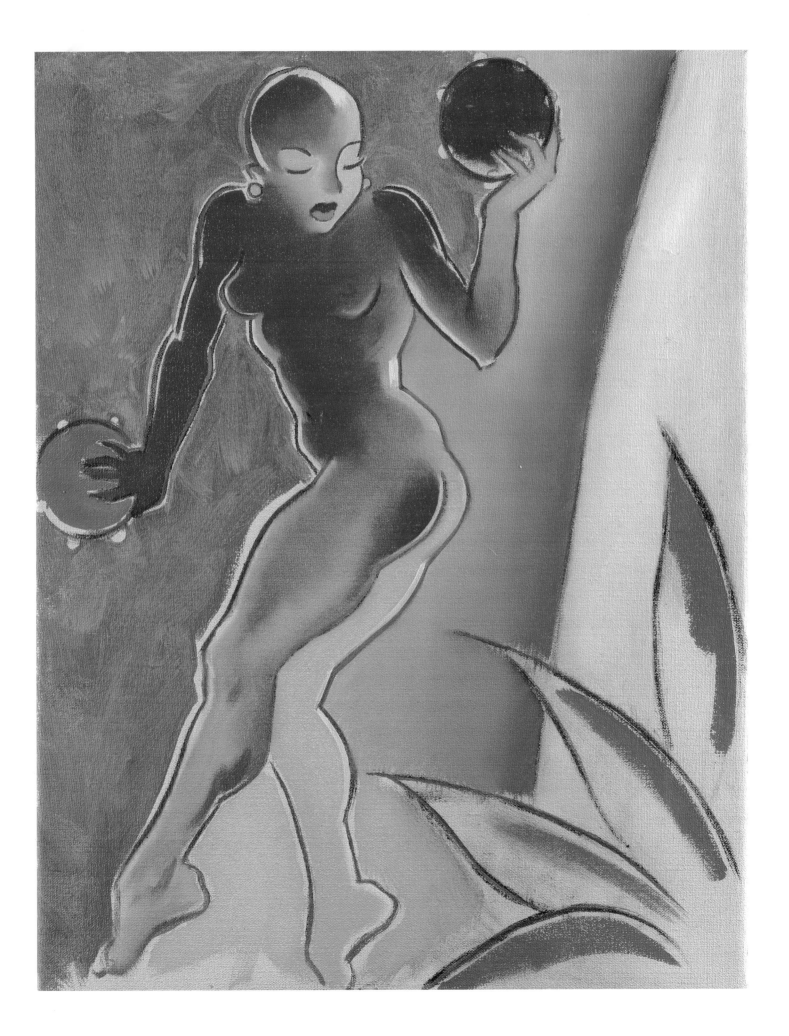

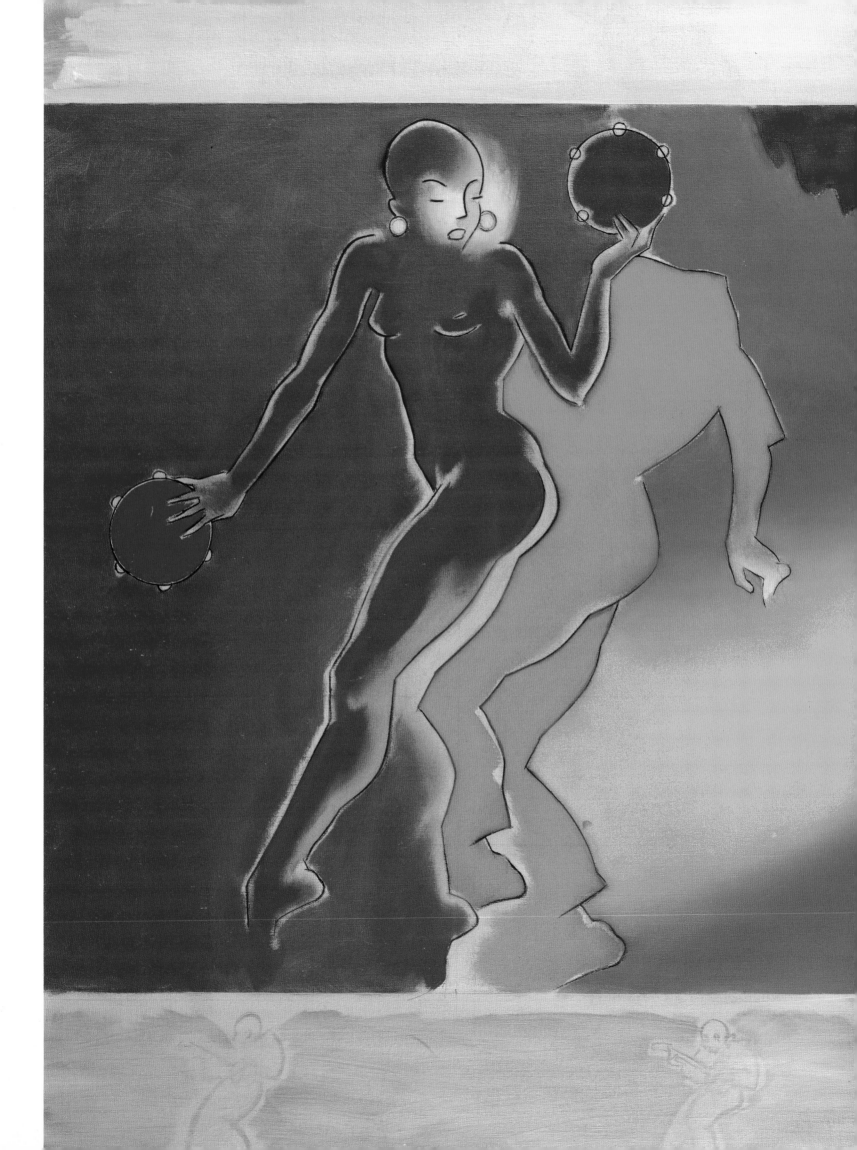

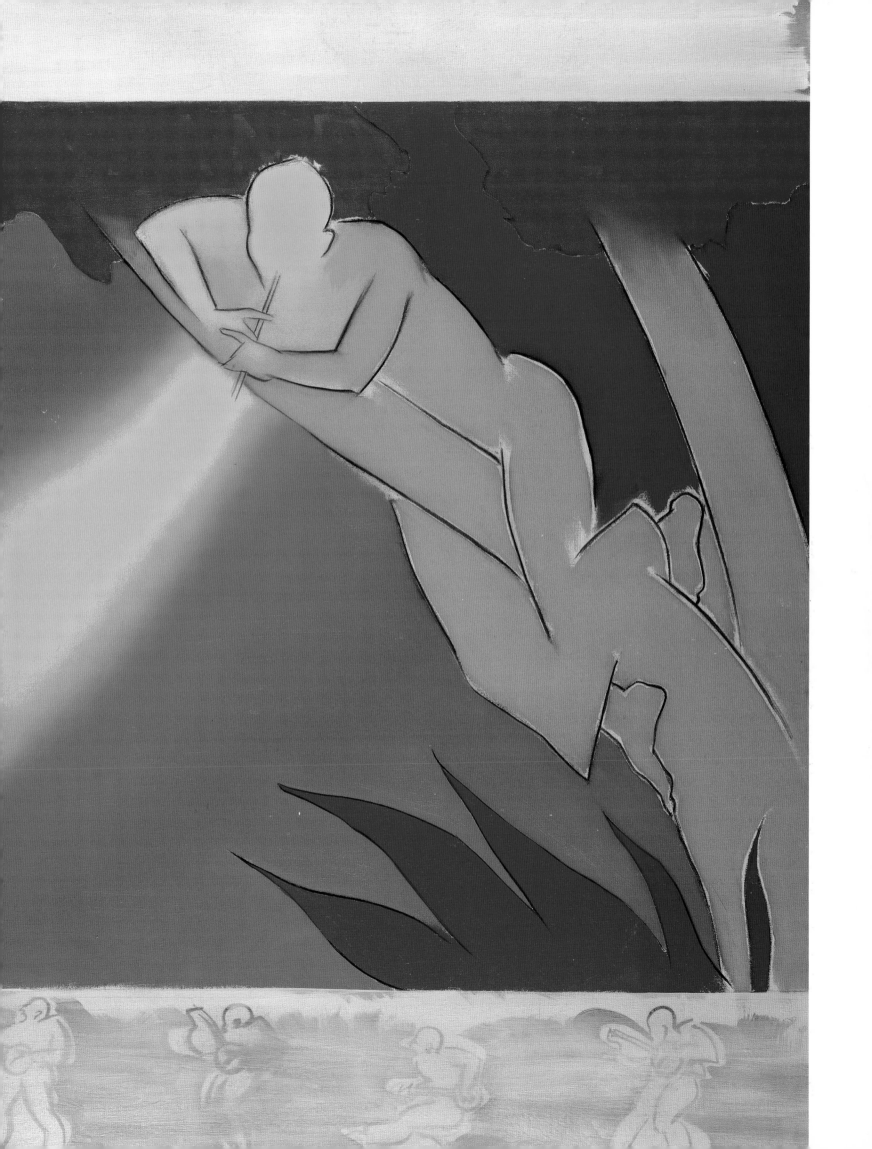

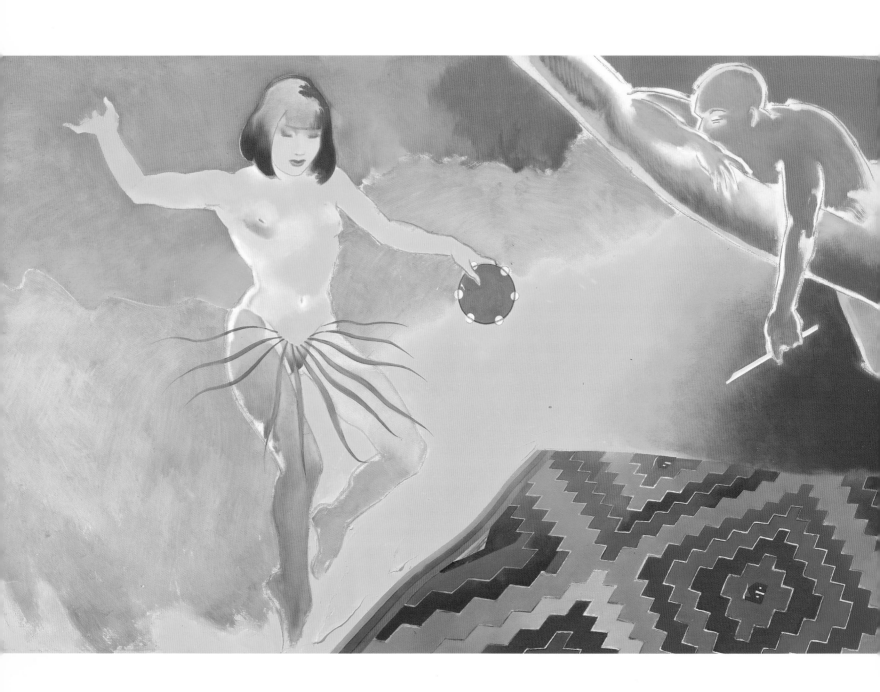

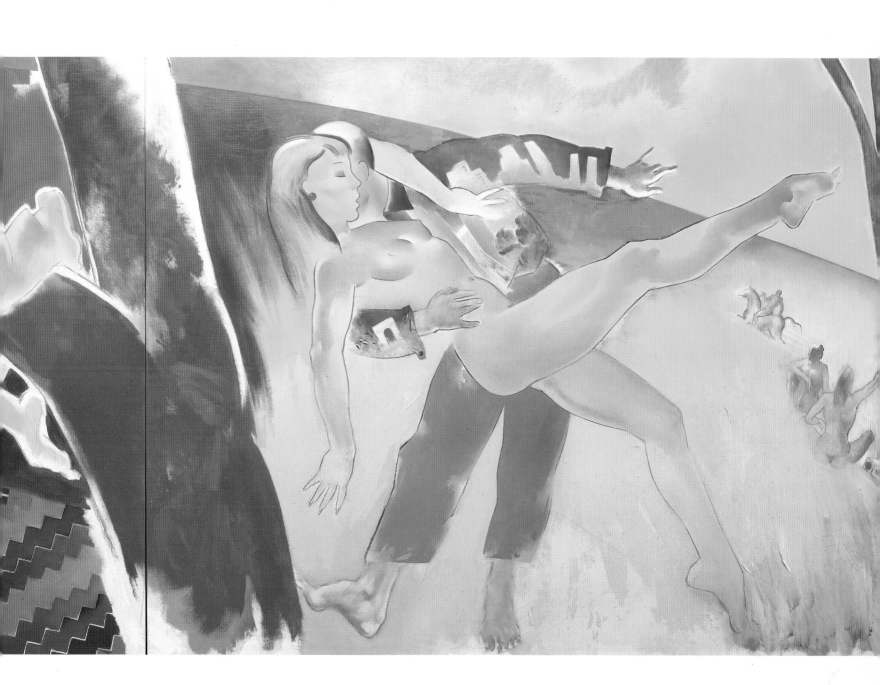

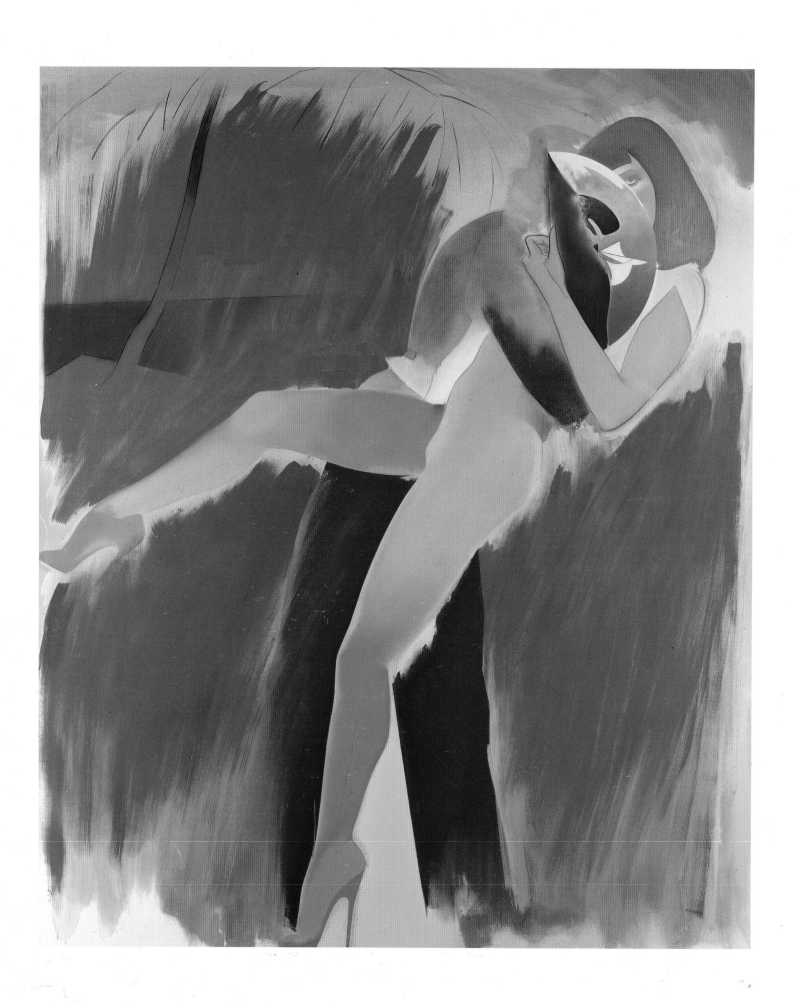

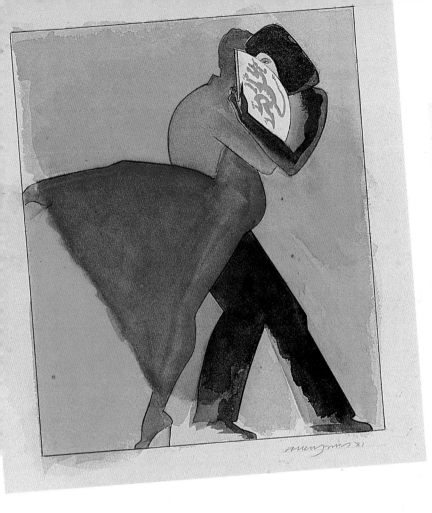

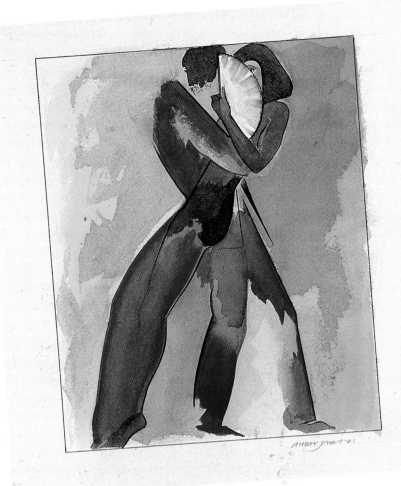

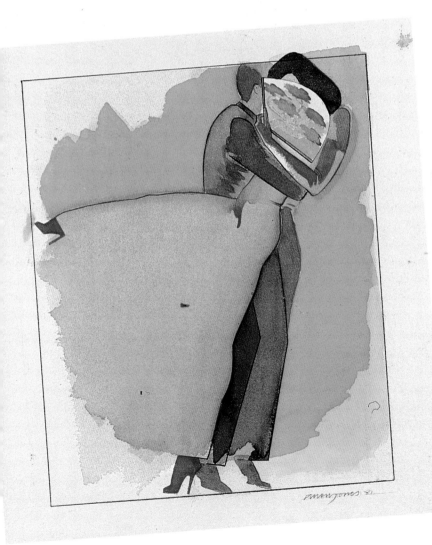

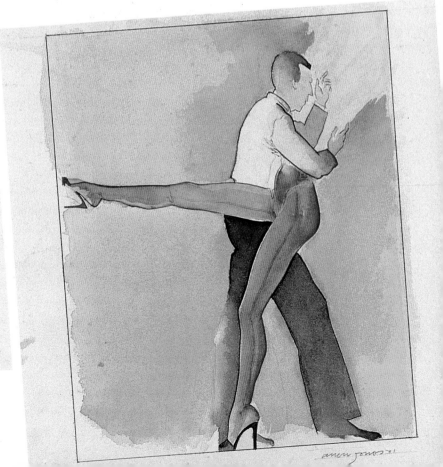

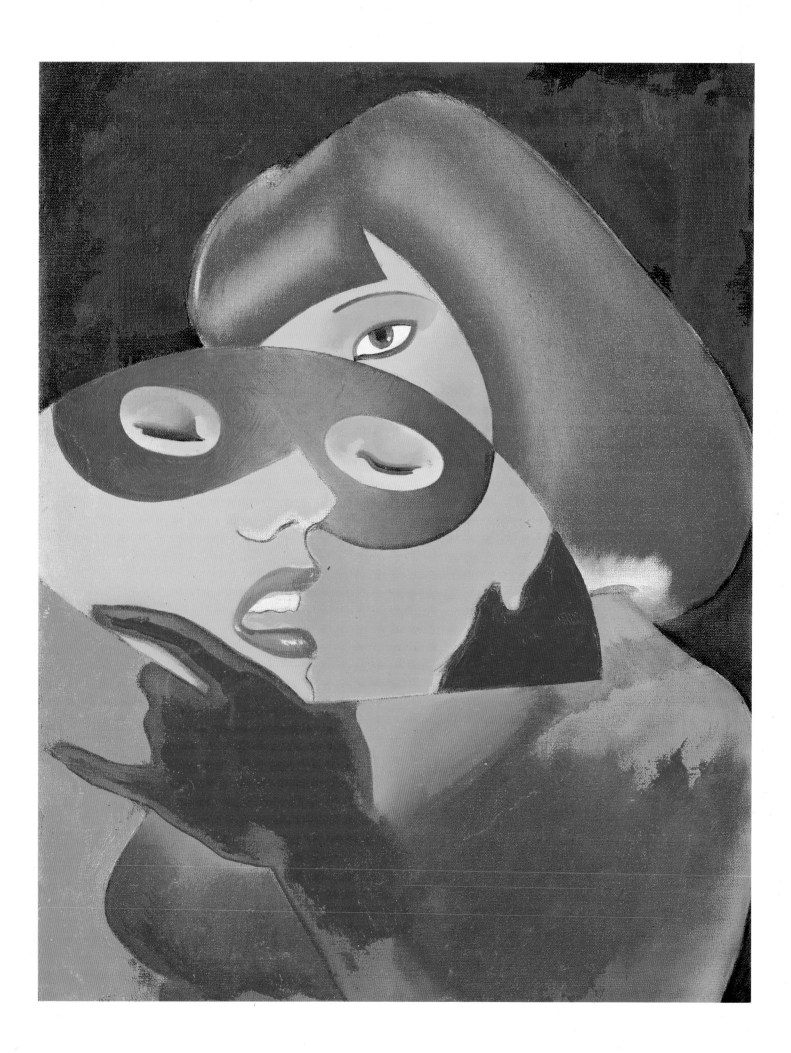

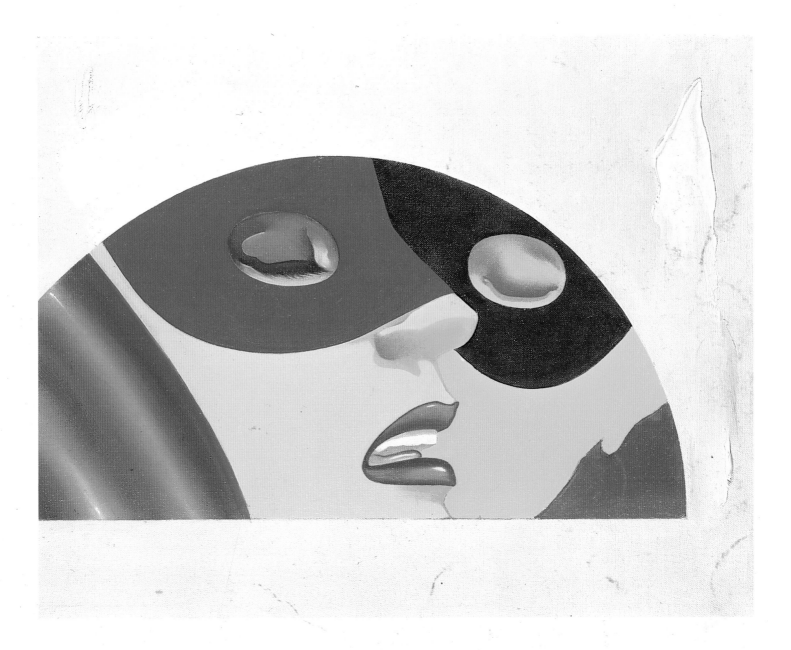

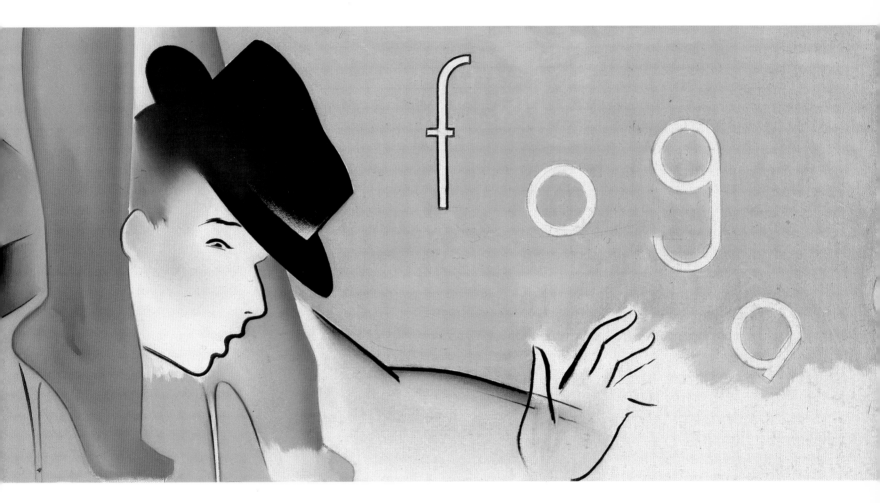

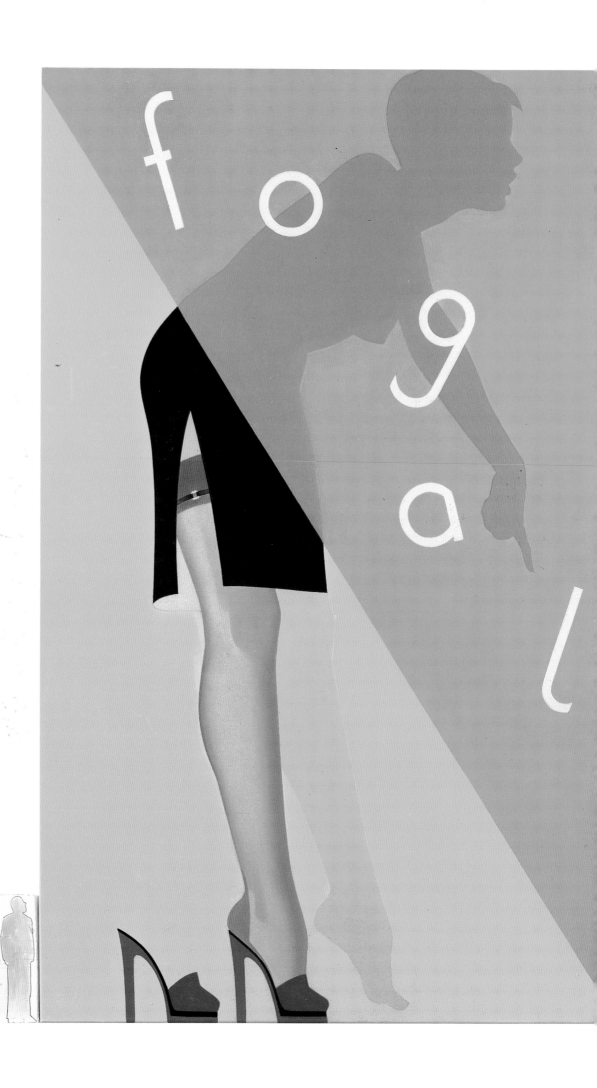

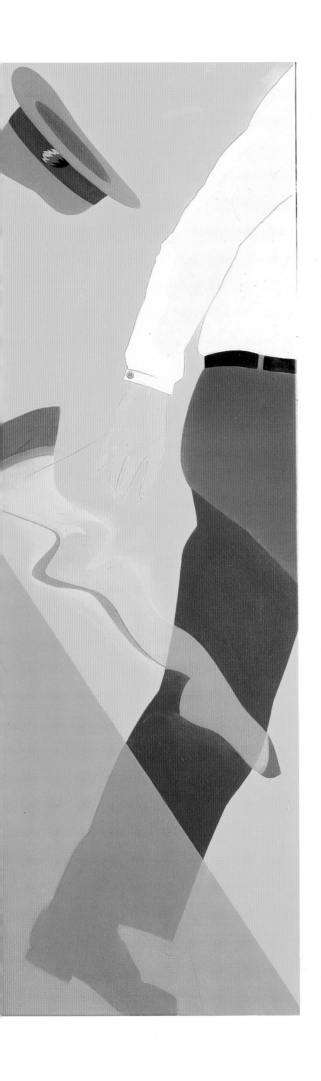

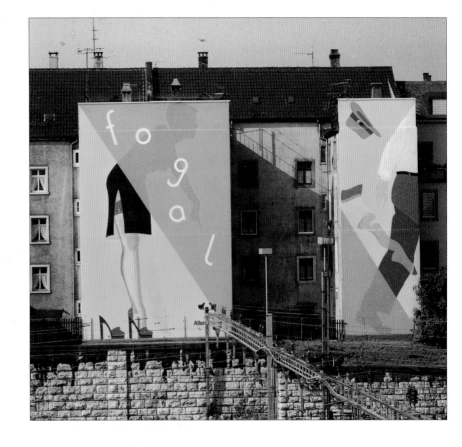

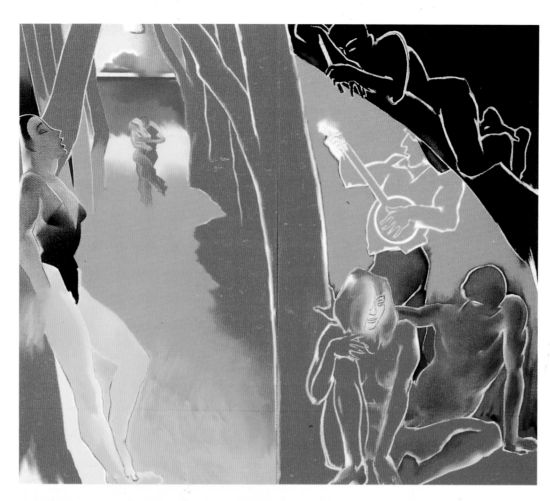

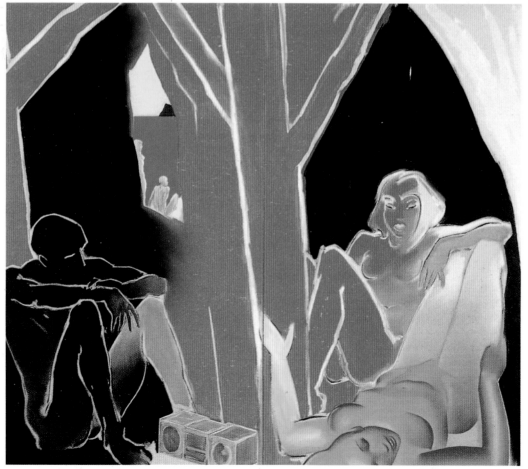

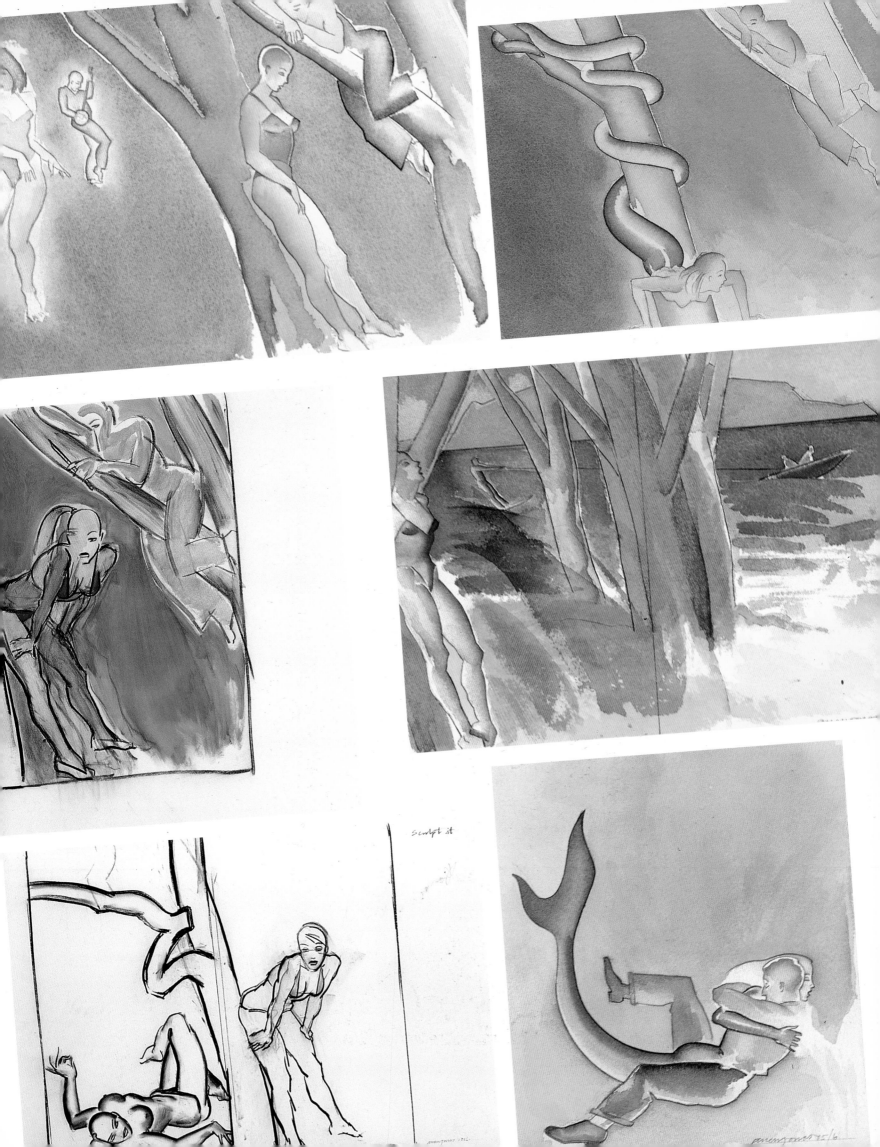

Sculpt it

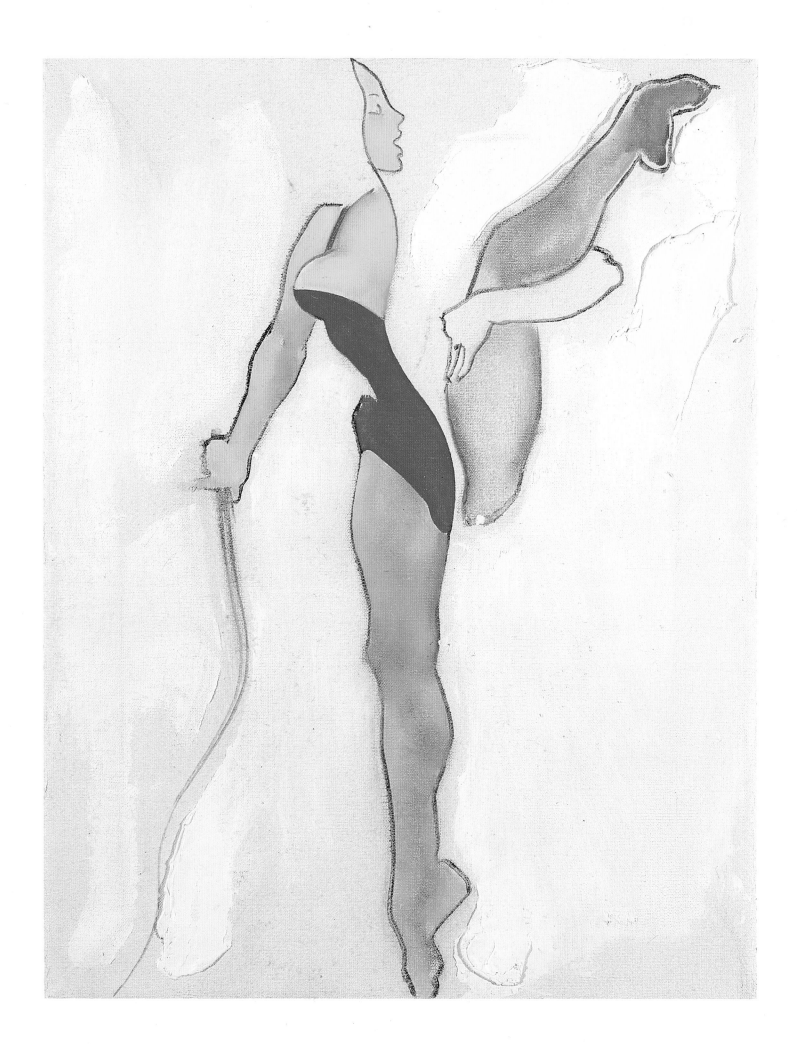

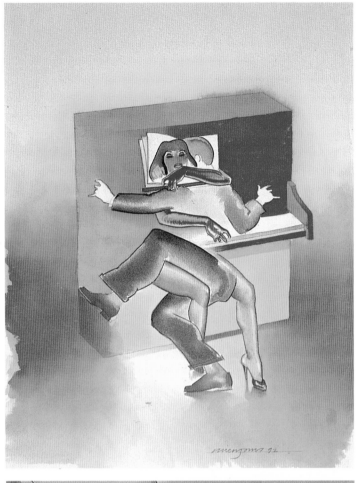

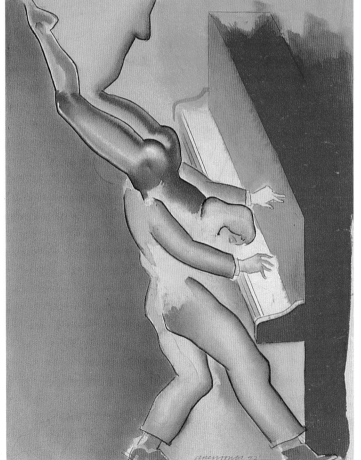

THE SCULPTURE OF ALLEN JONES
BRYAN ROBERTSON

My first sight of that elusive complicity between abstract and figurative elements, which distinguishes the paintings and, more recently, the sculpture of Allen Jones in the past 28 years, was in 1960 in the annual *Young Contemporaries* exhibition at the Suffolk Street galleries. Even then, it was an alert and edgy complicity rather than a tacit alliance. There was little attempt to synthesise the opposing elements of figuration and abstraction which were, instead, set out as equal events, interdependent but separate, with explicitly uncertain boundaries. His painting then and often since reminded me of Kandinsky through the way in which hotly coloured form and space seemed to move across the canvas, and set up a tension obliquely, on the diagonal. I featured Jones' work in the 1964 *New Generation* show at the Whitechapel Gallery.

Paintings of such demonstrative precocity and sophistication are rare. The sophistication was in the formal handling of the imagery, not in the subject matter: a clothed hermaphroditic figure or a packed but airy composition of rectangular lozenge shapes with fluttery edges which turned out to be buses. The paintings bristled with paradoxes which still characterise Jones' subsequent work including the more recent painted sculptures created from 1981 onwards. His work then, as now, seemed both ambiguous in concept and crystal clear in structure and delineation: delicately thin in painted surface but robust, almost raucous, in colour. Radiant with light and yet peculiarly cool in execution, it still celebrates in sculpture or painting a formidable balancing act between compacted, sinewy force and repose, like filmed sequences of fast action replayed in slow motion. Such a razor-sharp clarity of presentation is immensely enjoyable when the imaginative context as a whole is suffused by such an energetic gaiety and brilliance of light and colour. Jones combines all this with a tightly focused fast-slow unpredictability of spatial and formal *pace*.

With the advantage of hindsight, looking again through illustrations in the Walker Art Gallery catalogue for the big 1979 Jones retrospective in Liverpool, it is plain to see that Jones had used three-dimensional elements, on and off, since 1964-65. There is the *Curious Woman* (p9) painting with three-dimensional plastic breasts and the *Curious Man* picture from which a three-dimensional wooden tie makes its first appearance as an appendage floating freely in space from an otherwise flat surface. The shelf and step paintings of this early period extended the play between the boundaries of solid three-dimensional form and the flat two-dimensional illusion of solidity. In 1969, three solid female figures were cast, rather larger than life-sized, as a hat rack, a table and a chair, concepts which rounded off Jones' rather dandified – or detached – preoccupations with fetishry and mischievously extended the caryatid theme.

In 1979 *Black Soft Aroma* appeared with a real black latex jacket sewn into the join between two vertical canvases from which also sprang two painted and illusionistically modelled svelte legs in the by now familiar stiletto heels. The paintings which follow in the next few years drop this partial approach to sculpture, playing with flat and solid, and concentrate, in flatly painted terms, on figures moving out of and into space as a near-abstract veil or conflagration of paint as colour. Some figures are trapped in and against a spotlight and the light changes contour, density and colour. Many of these paintings continue the exploration of the play between illusion and reality through other theatrical connotations: for example, a swirl of paint which might be a curtain or a cloud of fog.

In 1983 Jones held his first show entirely devoted to sculpture which seemed, not surprisingly, to be not only a complete realisation of earlier, more fragmented concepts, but to radically extend his paintings almost directly into three dimensions. Since 1983, the sculpture has become predominant, increasingly self-sufficient and dynamic on its own terms. With all its sculptural authority Jones' work in three dimensions is very much a painter's sculpture, which turns the table on the paintings by incorporating allusions to painted form with renderings of solid form through two-dimensional illusion – pictorial as well as sculptural form and shape – and maintains a thin, flat, cut-out repertoire of form and shape. If sculpture once made guest appearances in his paintings, Jones now allows painting a return performance in his sculptures in a major role. Floating over some of the sculpture, though by no means all of it, like the smile of the Cheshire cat in *Alice*, is the feeling that Jones has almost pulled the sculpture out of the paintings with such exactitude that they could almost revert precisely, if flattened out, to a previous existence in paintings. Yet, of course, this is not true. In these sculptures we are left again with ambiguity and paradox but they are held tightly inside the overall schema and identity of sculpture.

Jones seems to have been born to make sculpture. Each successive work concentrates and refines upon earlier sculptures with mounting authority; his repertoire of form, his ideas in fact, increase all the time. If the thin, flat character of the constituent parts of each sculpture is consistent with a cut-out appearance, the space that they articulate, disclose, suggest, describe, trap, occupy, activate, move through and against, is entirely sculptural. Jones puts spaces through a series of hoops and makes it work very freshly for him. His stereognostic sense is absolute. The wit is as poetic as ever. Invention continues at a stirring pace with what seems to be mounting authority and economy.

The use of colour as an integral part of sculpture is for most people a comparatively recent innovation, exploding in England in a spectacular way in the early 60s, largely through the work of Sir Antony Caro, Phillip King and Tim Scott. In fact, the English public in the 60s was re-educated in the most fundamental manner in its attitudes to sculpture. Accustomed to the images of Moore from the war years on, the public thought of sculpture as something grand,

monochromatic, relating to weather, landscape and ancientness, distanced from their own personal space of everyday reality by its pedestals and plinths as well as those time-worn surfaces which kept the work inside history.

Suddenly sculpture got off its plinth and snaked across the same ground the public had always safely occupied, and it was alarming. No longer elevated and comfortably distanced by bases and pedestals like museum art, confirmed in its remoteness by the equally historic traditional presence of stone or bronze, the new sculpture compounded the offence by blazing with light and colour.

There was little point in reminding the public that ancient Greek sculpture had once been brilliantly coloured. However fierce and abrasive to our notions of propriety and good taste the original Greek colour may once have been – for even those sensitive lodestars of cultivated Edwardian aesthetic sensibility, the delicately worn and faded Tanagra figures would once have been far too lurid in colour for English taste – it had at least been boldly descriptive of everyday reality, and therefore performed an understandable function in commemorating gods and goddesses, oracles and athletes with blazingly coloured eyeballs, black or flaxen hair and flowing purple robes. Coloured sculpture in the 60s was quite abstract, concerned with conceptions of form and space and therefore impenetrable if not straightforwardly decorative – which it never was. As a possible comparison or precedent, coloured Greek sculpture had disappeared, Egyptian coloured sculpture was confined to tombs, and both cultures were too remote to offer any comfort. The puritanism of modern taste had been supported by the more natural associations of plain stone or the rich sobriety of bronze. Colour was a shock.

The first arrival of coloured sculpture in Paris in the 20th century was even more startling after the 19th-century apotheosis of uncoloured stone and bronze which so often basked in, but also debased, history through the example of Renaissance models. There was the remote precedent of Spanish and German baroque art, but all this was monumental, commemorative and mostly confined to churches. In 1914 Picasso made his *Glass of Absinthe*, using strong colour throughout the set of variations running through the six casts made for him from a wax model – each cast being differently coloured and patterned. In these and other works, the new possibilities for sculpture in this century were established. Picasso had made the first abstract sculpture even earlier, the Cubist *Head of a Woman* of 1909, but the two unwieldy but spectacular collage-inspired costumes devised by Picasso for 'The French Manager' and 'The American Manager' in the Cocteau/Satie/Massine ballet *Parade*, in 1917, extend the more decorative principles of synthetic cubism into an area halfway between sculpture and painting – which seems nearer to Jones' present preoccupations. Jones brings the same energetic lightness of touch to whatever he makes, and the same relish for absolute freedom in swinging between cut and drawn surfaces, plain and patterned areas and the use of space as form. Synthetic cubism used to be seen as the trivialisation of cubism through decoration. It has in fact proved to be the most 'open' and potent phase of cubism for artists in recent years.

Between 1909 and 1914, the Russian sculptor Archipenko, living in Paris and in Nice, made the first fully polychromatic sculptures. These established, in a series of brilliantly coloured low-relief sculptures, the principles of negative and positive abstract space which so exercised artists everywhere 50 years later. These early works by Archipenko, perfectly pitched between sculpture and

painting, foreshadow Constructivism and radically extend the dialogue between sculpture and painting. Archipenko's 1912 assemblage, *Medrano I*, a revolutionary masterpiece, was in the New York Armory Show of 1913. He must be ranked with Picasso as the inventor of modern polychromatic sculpture.

Picasso not only fired everything he touched with genius but opened sculpture up for other artists through the free way in which he moved between sculpture and painting, his pioneering use of collage and the absolute openness of his approach. For most artists, including Allen Jones, Archipenko still remains an unknown figure.

Both Calder and Arp extended the expressive potential of colour in sculpture in the 30s: Arp with a series of low-relief wooden sculptures in which the simply coloured elements are presented as a shallow three-dimensional composition within a neutral white space; and, more radically than anyone other than Archipenko, Calder with his marvellous invention of mobile sculpture. His use of coloured forms which moved with and against and across each other in infinite variation may find correspondences in nature, like wind moving across leaves, but Calder's great mobiles and stabiles establish an entirely new dimension for abstract art as well as extending the nature of sculpture.

More particularly – and with regard to Jones' identity as a sculptor – Calder brought into modern art the first sensations of wit, weightlessness and airborne gaiety, and form as pure colour. His art is also free of nostalgia – an essentially 20th-century freedom. Jones has something in common with Calder's spirit in his love for primary colours, in the *élan* of his own painted figures, and in his freedom from nostalgia.

Noguchi has also used abstract colour with both dynamism and invention from the late 30s onward, notably in his innovatory stage decors for Martha Graham in the 1940s. He shares with Calder the distinction of creating the best possible solutions, to the problems of public sites in crowded modern cities, through the use of monumentally simple forms and intense, brilliantly schematic colour.

In the late 30s Barbara Hepworth, in England, began to explore the use of colour in sculpture, using it spatially and abstractly and never descriptively, notably in 1940 in a carved white plaster hollow cone lying on its side in which the deep blue interior space is traversed and commented upon by taut red strings radiating from an interior source. A large stone ovoid in the 50s, up-ended, has three shallow ovals cut away, with each of the three resultant flat surfaces – each one only visible in isolation from the other two – painted a different depth and intensity of blue, from palest azure through cobalt to ultramarine, thus denying the solidity of the stone and implying, in sequence, three different spatial distances.

In America, in the 40s and 50s, David Smith explored colour in a number of works but less successfully than Calder or Noguchi. Smith was a sculptor of genius who lyrically extended the principles of welded assemblage set out by Gonzáles – but his colour sense was insecure and brought a curiously turgid and 'indoor' range of colour and density to essentially outdoor welded pieces. I saw these sculptures with colour with the artist at his studio at Bolton's Landing, Lake George, in the early 60s. After David Smith's death, these works were repainted in what seem like chic designer colours by permission of Smith's executors so that any record of the artist's own feeling for colour now appears to be lost.

It was with the impact of Caro's great coloured sculpture in the 60s that the physical, functional and energising properties of colour seemed to be spelled out and demonstrated most vividly, as if for the

first time. Yellow, we were reminded, moves faster across the ground than sluggish purple; red receives light and partially transmits it, blue merely absorbs it. Caro worked miracles with form and colour and gave the public as well as other artists a new visual dimension. With Brancusi, Moore, Picasso, Smith and Calder, he has changed the way in which sculpture is perceived.

How does the sculpture of Allen Jones relate to this extremely various set of references, to widely divergent approaches in the use of colour in sculpture? One of its strengths is its comparative disrespect for any accepted taste in art – it has a speedy, cut-out jauntiness, a wild insouciance, which risks flippancy, vulgarity, formal or anatomical improbability, over-complexity – but it raises issues which relate to most of the historical precedents that I have sketched out. But before exploring the sculptures any further I must convey the sheer pleasure that it arouses.

These sculptures give off a strong whiff of joy . . . The very word 'joy' seems to belong to another era, to Matisse's *Jazz* perhaps in the 40s, but joy is what Jones' work contains, joy as it was still experienced by really good charleston dancers of the 20s or formation dancers doing The Madison in the 60s and which continues to be felt by a few thousand every now and then at rock concerts, the Olympic Games, or listening to Mozart. There isn't much joy in recent art, at least not since the death of Calder in 1976. But joy is what we get with Jones . . .

Jones has no interest in narrative or direct representation but his preoccupation with theatre began many years ago – he goes regularly to opera – which shows itself in many paintings of the late 60s and 70s, concerned with illusion, reality and imagined stage scenes. It is conscious *presentation* as an analogy with theatre which fascinates him, together with the idea of *device*, but his gifts as a potential stage designer – given sufficiently intelligent collaboration – are immense. Some of Jones' figures have already joined a kind of personal repertory company, and reappear from time to time in a series of metamorphoses . . .

The big *Fascinating Rhythm in Red* (p115) painted in 1987 has its forerunner in a sequence of similarly titled works, large and small, in 1982-83. All of them have the serpentine energy of a Romanesque majuscule or capital – but in the 1982-87 version, look at the flip of the girl's skirt and the thrust of her dancing feet and then discover the disarming view of the man's face framed by the curving arm. These details created a sharp syncopation of their own, set against the overall, larger rhythmic flow of form. This sculpture flashes out delightful messages about sexuality, co-ordinated abandon, the elation of mutual enjoyment, *togetherness* – and a transient occupancy of space by form in motion so that form flows in and out of space. The sculpture contains the essence of that edgily balanced complicity between sculpture and painting, illusionistic space and real space, solid form and flat shape.

In the way that the best abstract painting from Tobey and Pollock to Rothko, for example, raises questions about the significance and ultimate eloquence of a mark on canvas, such as when does a mark become a gesture and then a sign, and a sign turn into an emblem, and an emblem become a form or a symbol or an image? Jones' sculpture also raises questions about the function of colour: colour as commemorative description or souvenir, as decoration, as speed, as space, or as a painted equivalent of solid form and therefore illusion.

As a group of work, Jones' sculpture presents us also with a particular characteristic that is still comparatively new. The sculpture has a tactile quality which exists only for the eye, optically and imaginatively, and not for the usual physical sense of touch through the hand. You cannot caress these unembraceable figures made of painted metal: the action will tell you nothing about their essential character. The charm, humour, vitality, briskness and certainty – or coalescence and insubstantiality – of form can only be apprehended through the eye.

This is also true of Calder's or Caro's work and it was true on a slightly different plane when Bridget Riley began to use colour constructively in the 60s in such combinations in her paintings that the image, of a golden flash or a floating spectrum of new colour, only appeared at an optimum point in the space between the spectator and the canvas itself. Close inspection of the canvas revealed only crossing bands of rather mundane, certainly very restricted, colour, apparently disconnected from the sensuous mirage obtained only by distance. The analogy with non-tactile sculpture is rather stretched but there is a correspondence in the way that the tactility, in both cases, can exist only in the eye . . .

Jones' mastery of scale is less personal to him than the quicksilver fluidity of his vision as a painter/sculptor. For 40 years, the sculptures made by painters in our century have been held in special esteem and seem particularly relevant in their more fluid, existential or even provisional nature to our transitory, fast-moving and evolving society in which for so long the directness and immediacy of the sketch have been treasured above the considered finality of the finished statement in art, from Constable's sketches to Abstract Expressionism. Jones is part of this tradition, running from Renoir and Degas through Matisse and Picasso – and extended by Calder and Caro quite differently, in their work, as sculptors in love with the expressive fluidity and licence for pure colour in painting. Jones composes like a sculptor but *orchestrates* like a painter the quality of form in his sculptures, ranging between molten, flowing form and staccato, blocked shapes acting as bridges or terminals. His command of counterpoint is quite bracing: the man's second leg in *Artisan* (p102) is palpably there but only if you read the space shape correctly between his first cut-out leg and the painted illusionistic space in front of him cleaved by his hand and spade. The space shape between the two events is his second leg. Jones' incisive invention is as constant as his high spirits: working so sharply together they are responsible for some of the strongest and most cheerful sculptures to be seen in England in the past 30 years.

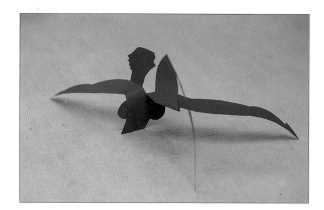

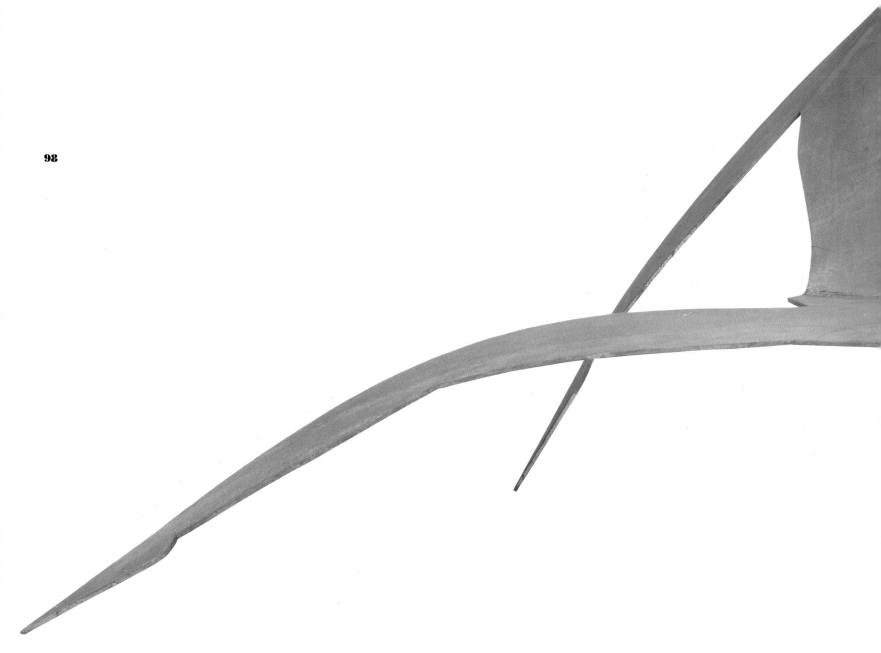

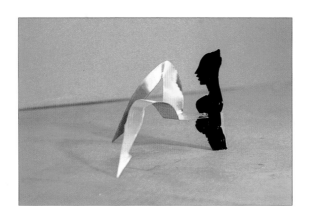

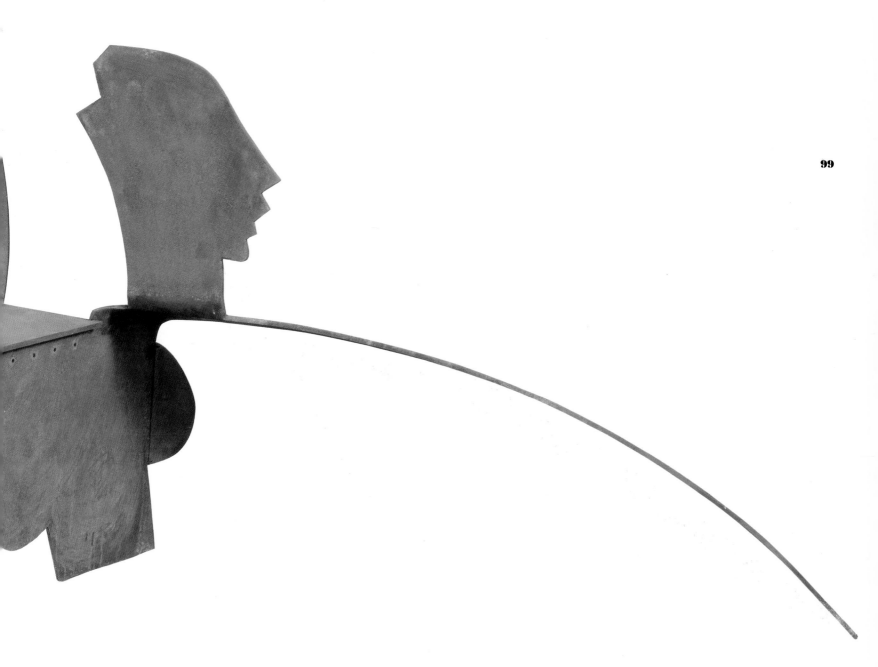

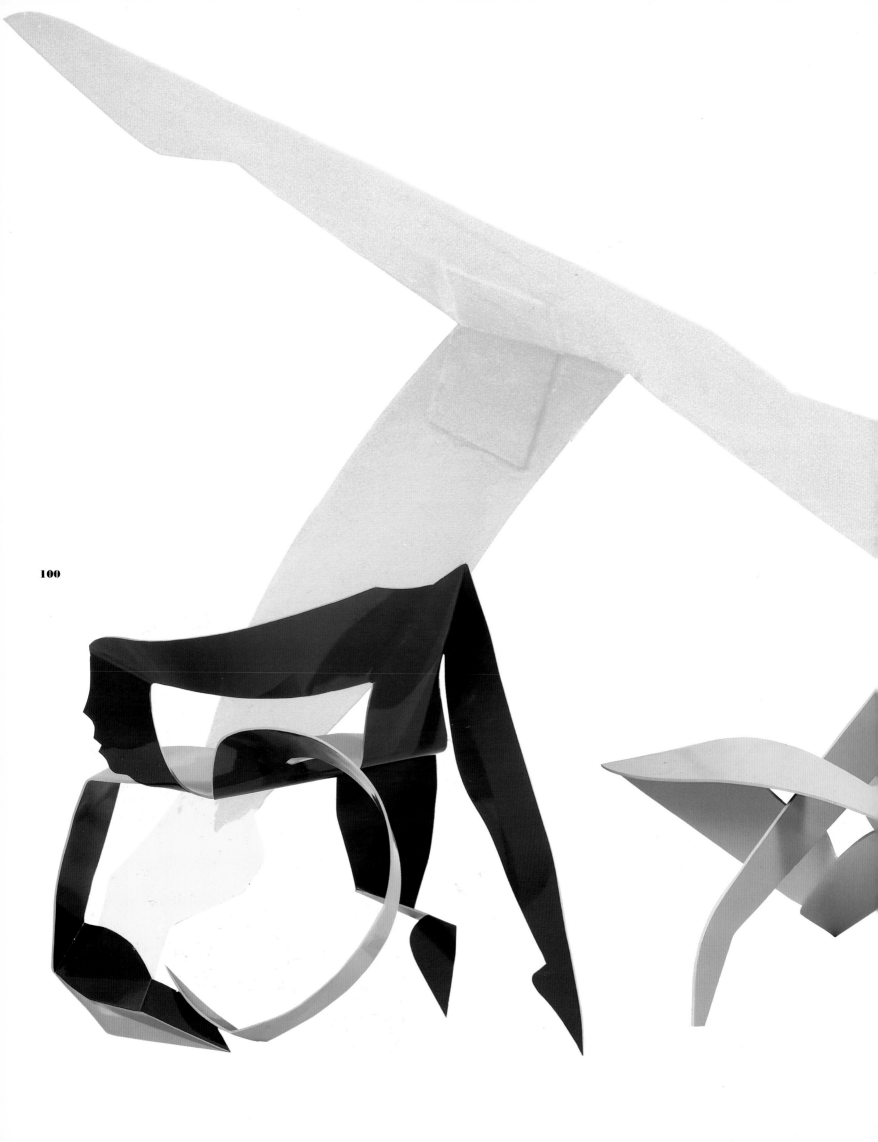

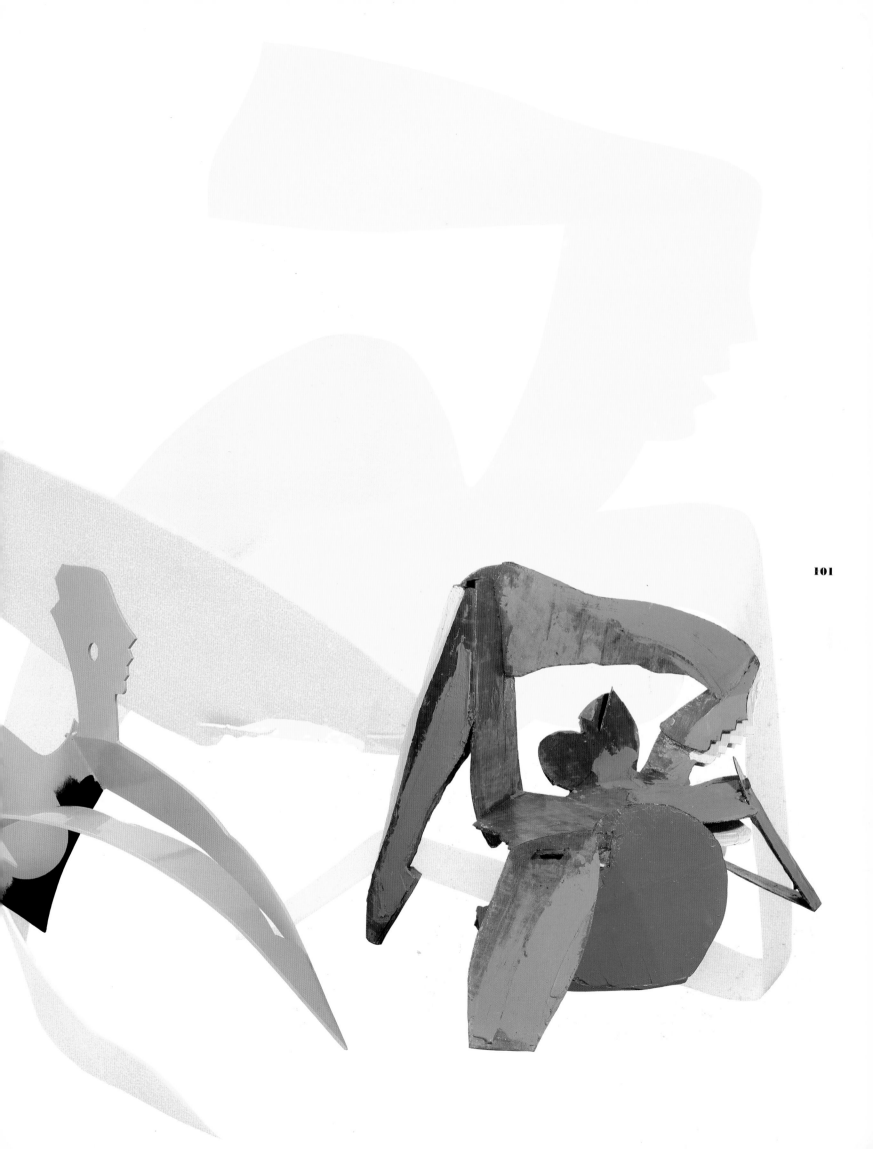

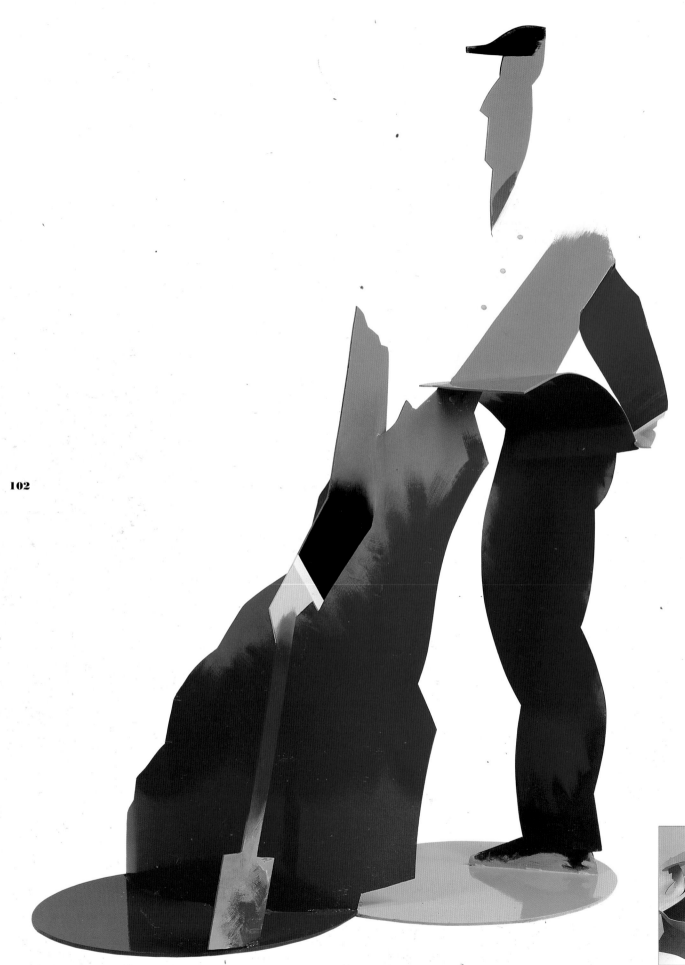

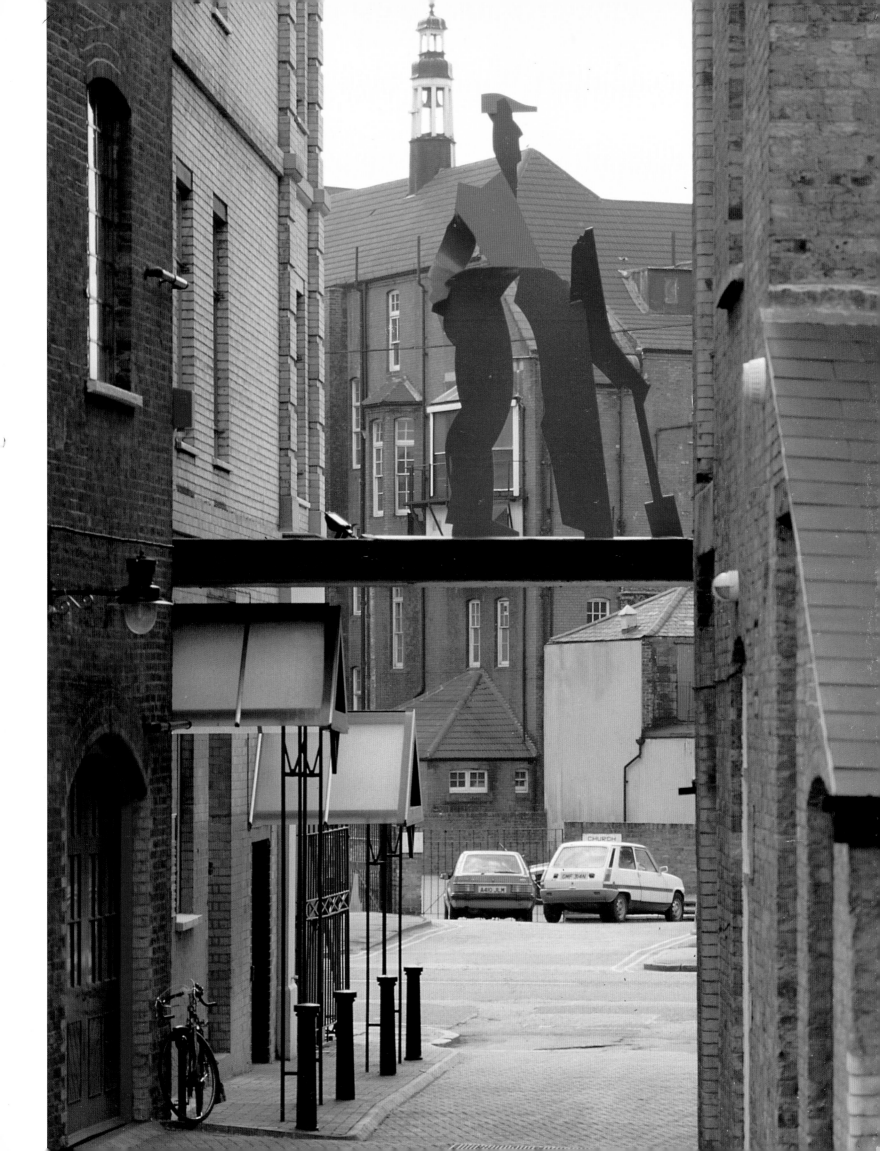

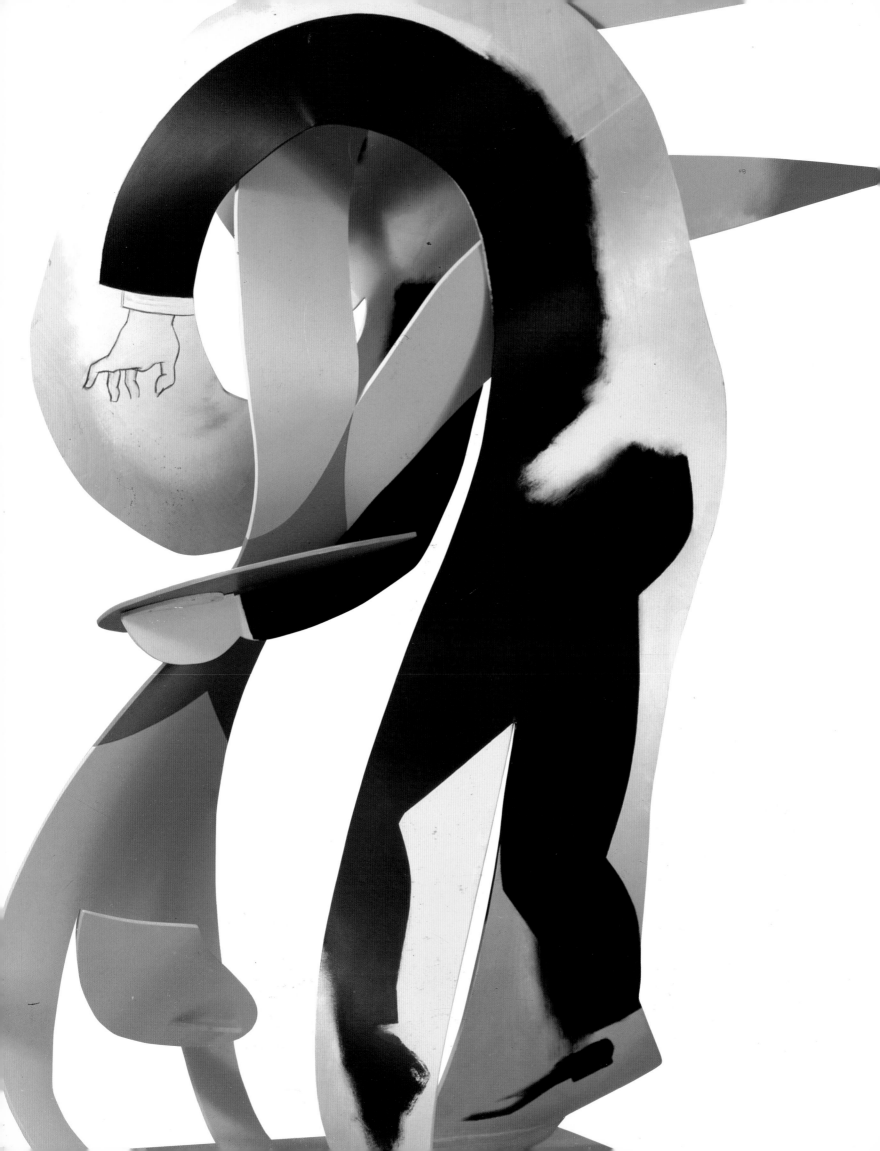

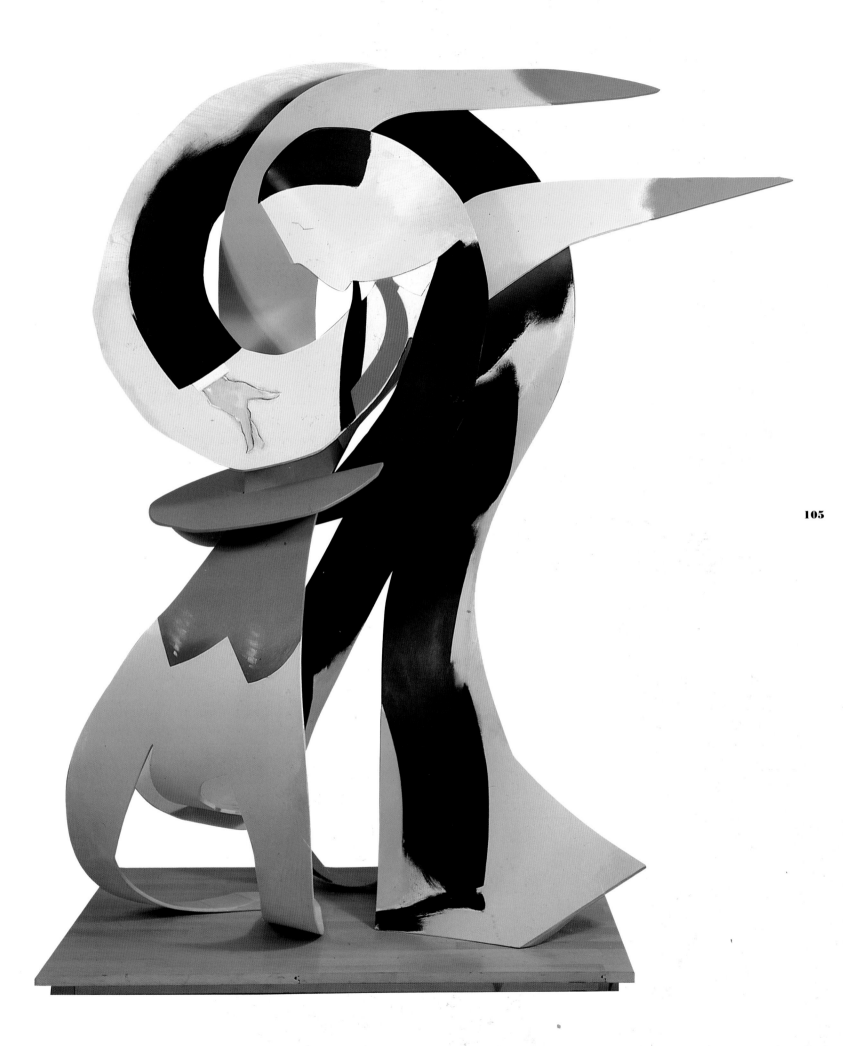

106

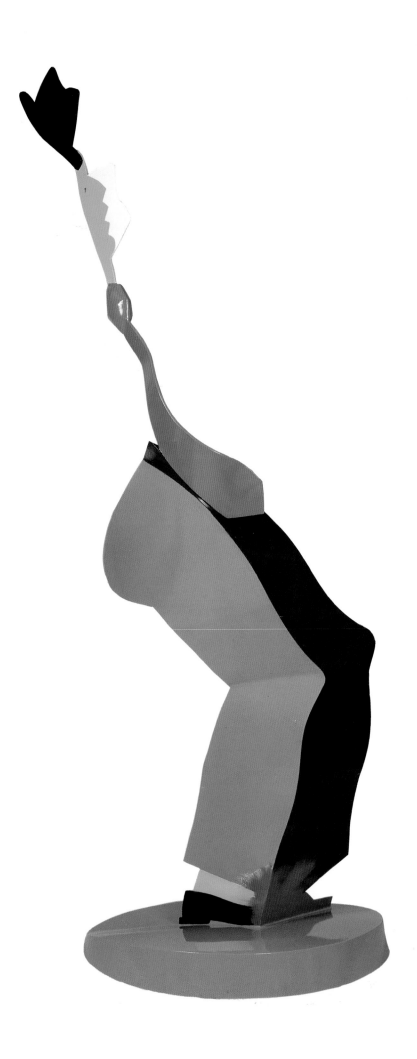

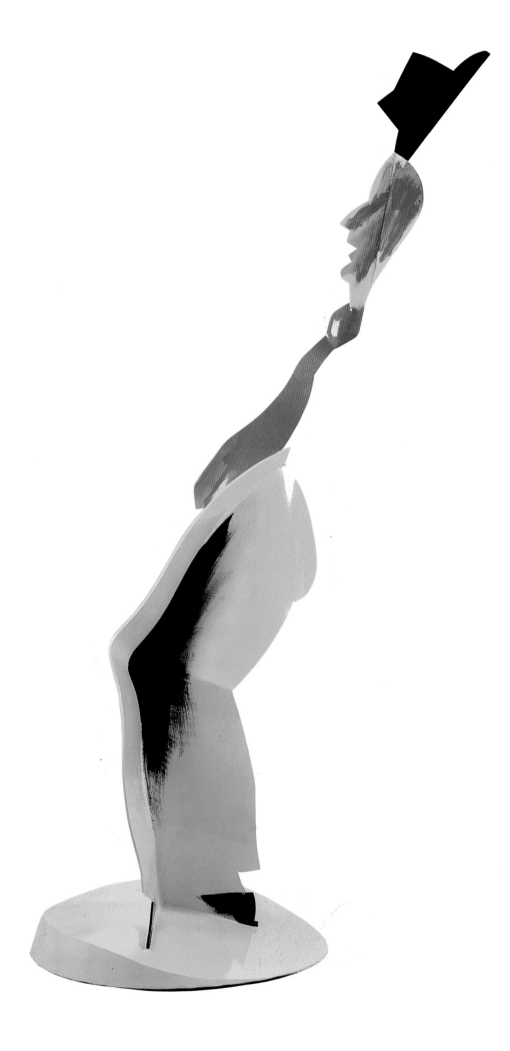

108

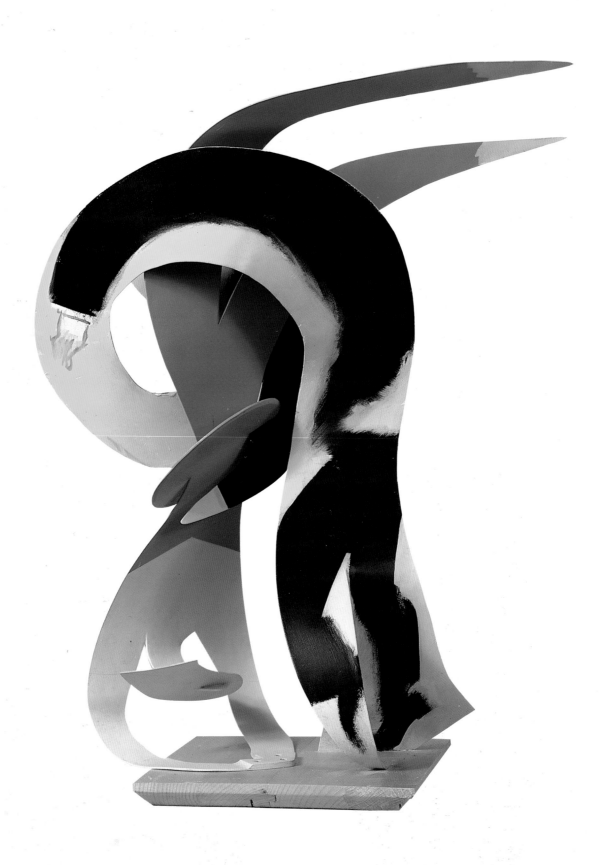

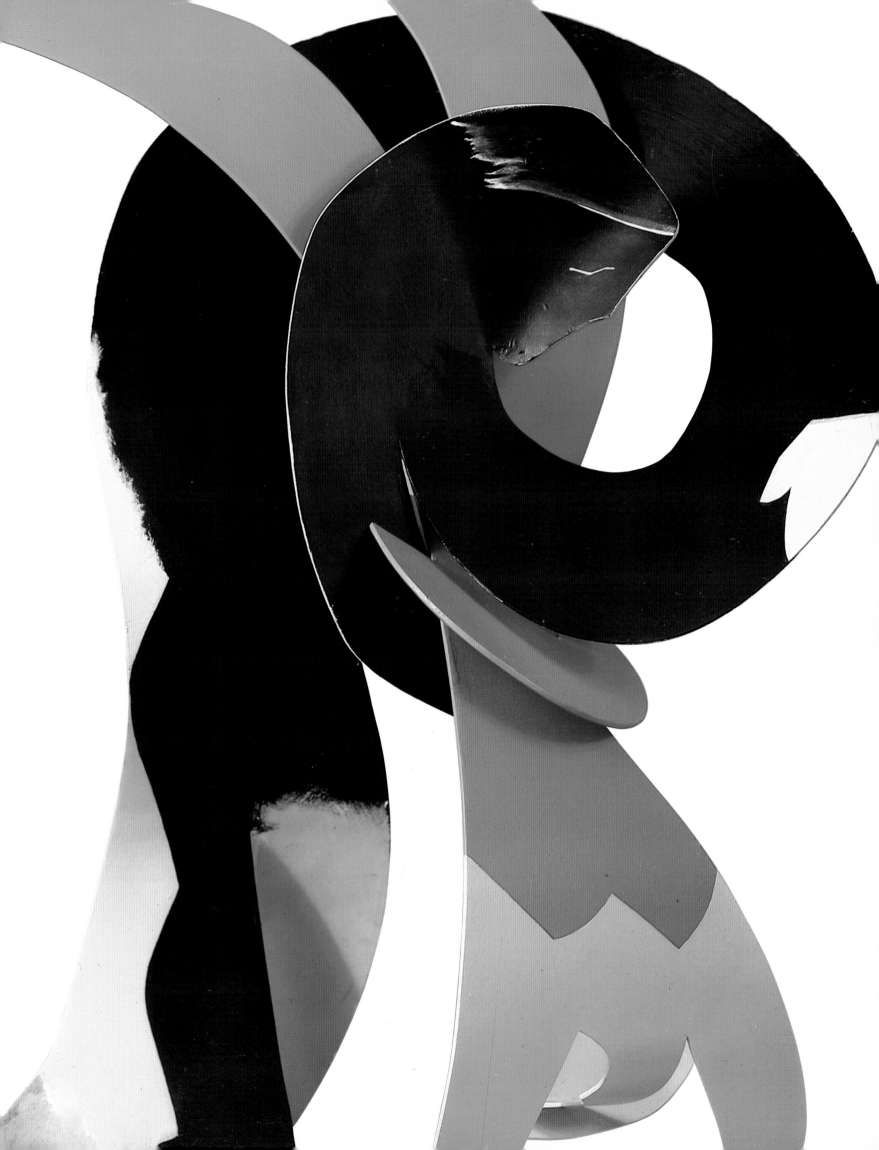

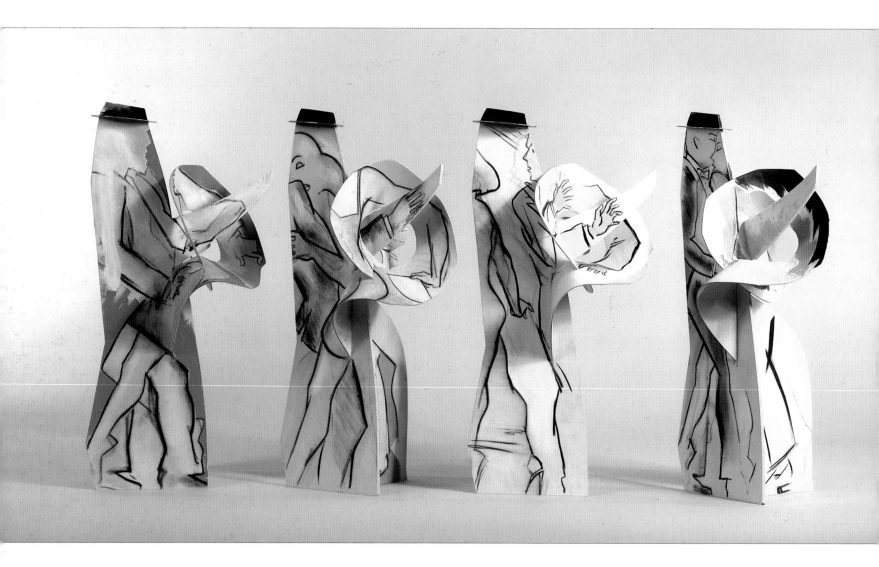

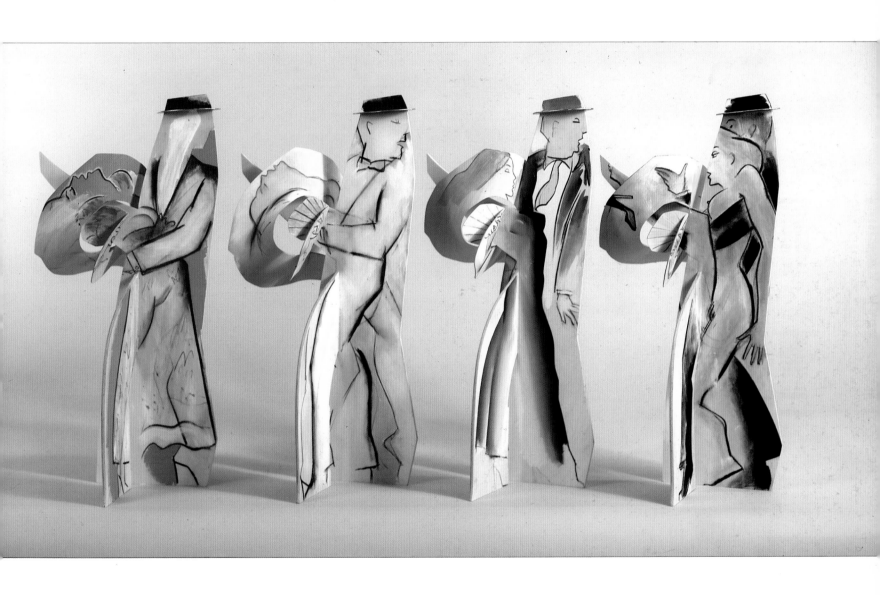

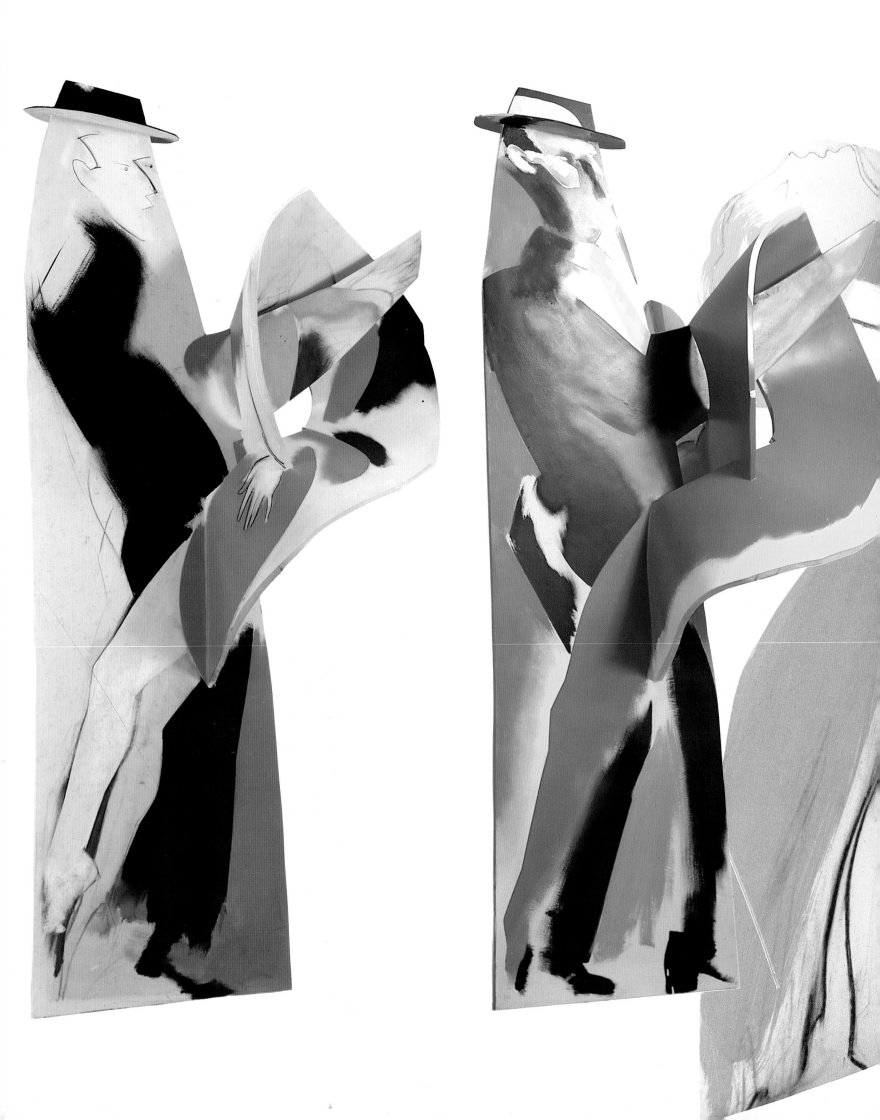

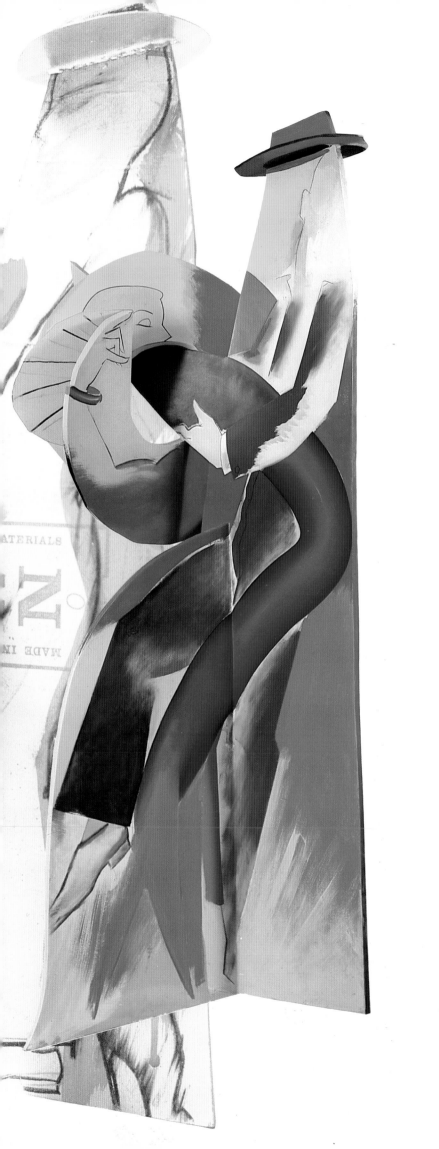
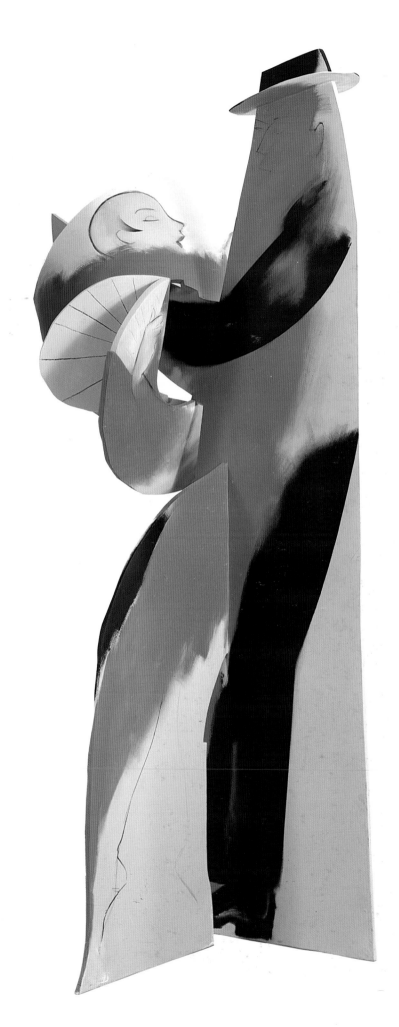

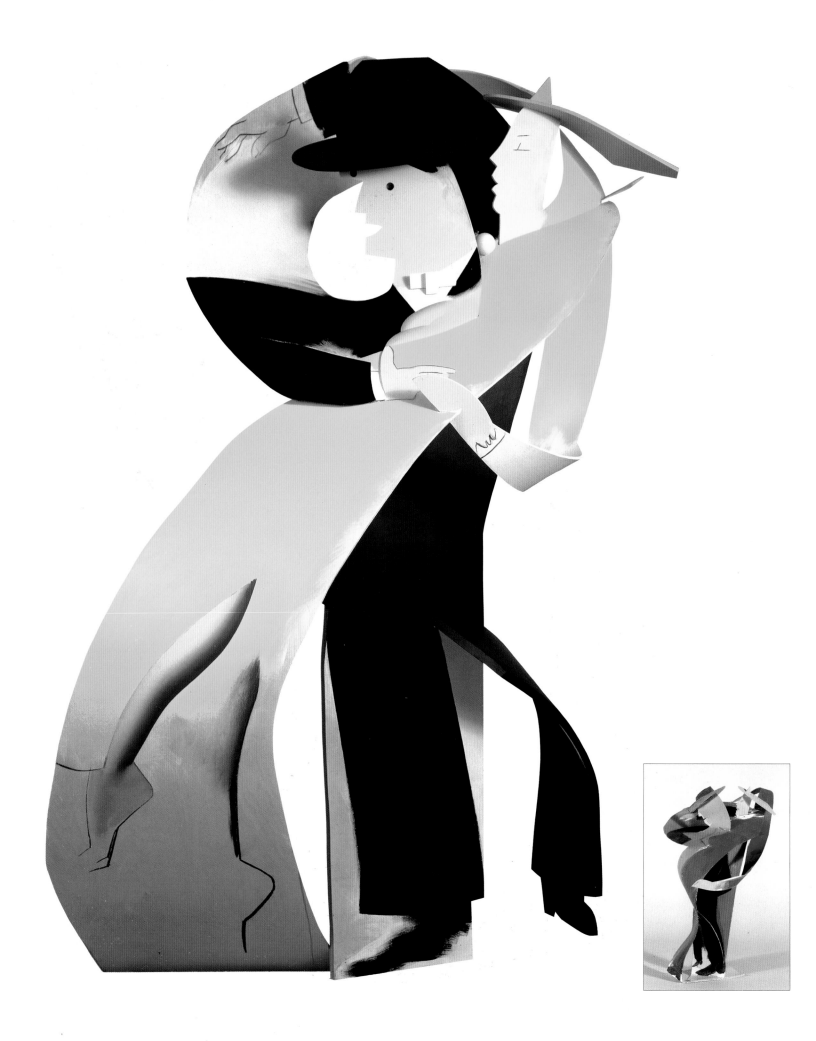

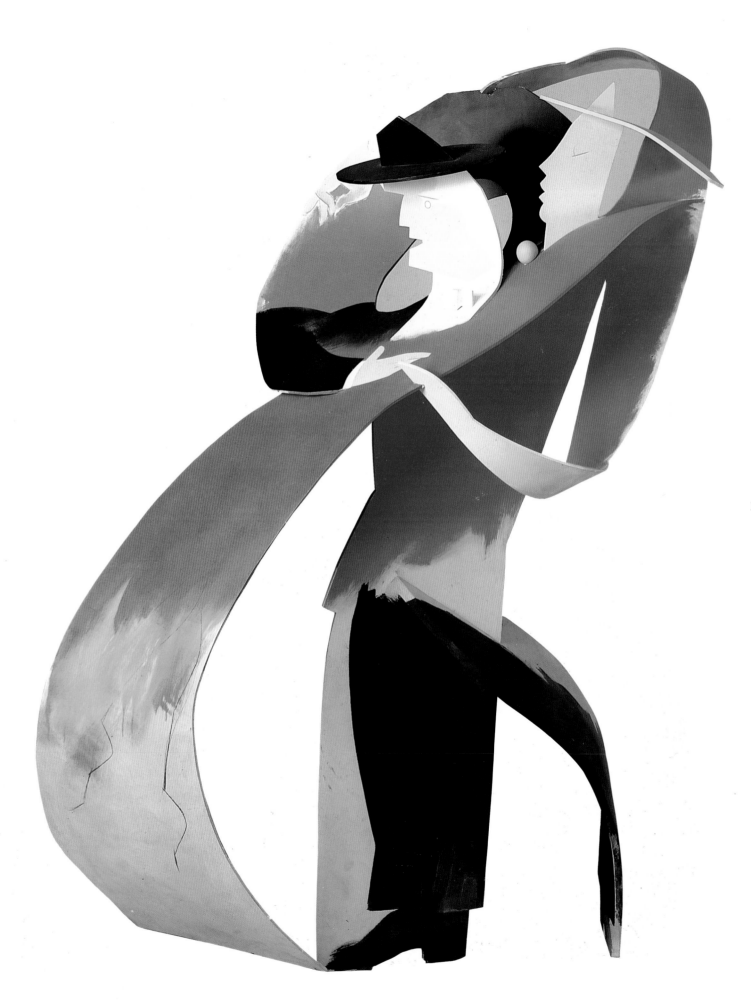

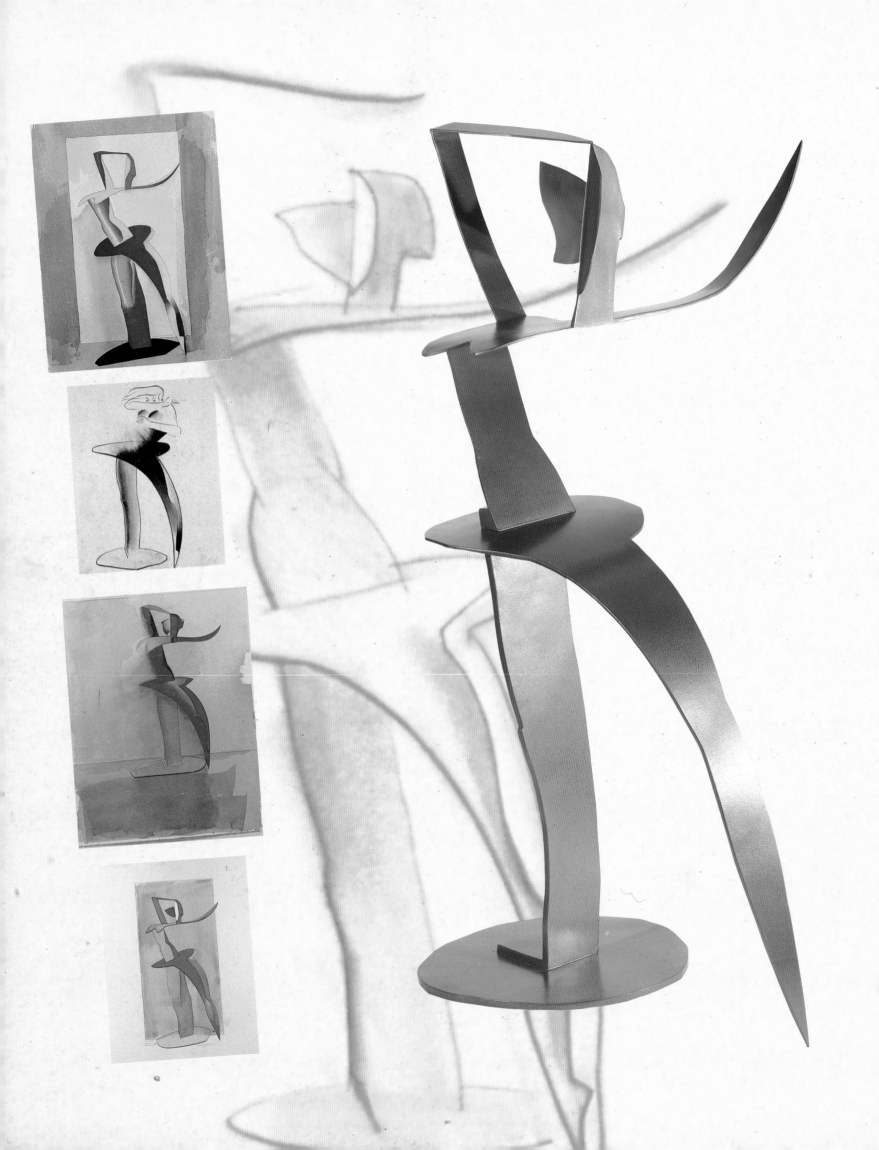

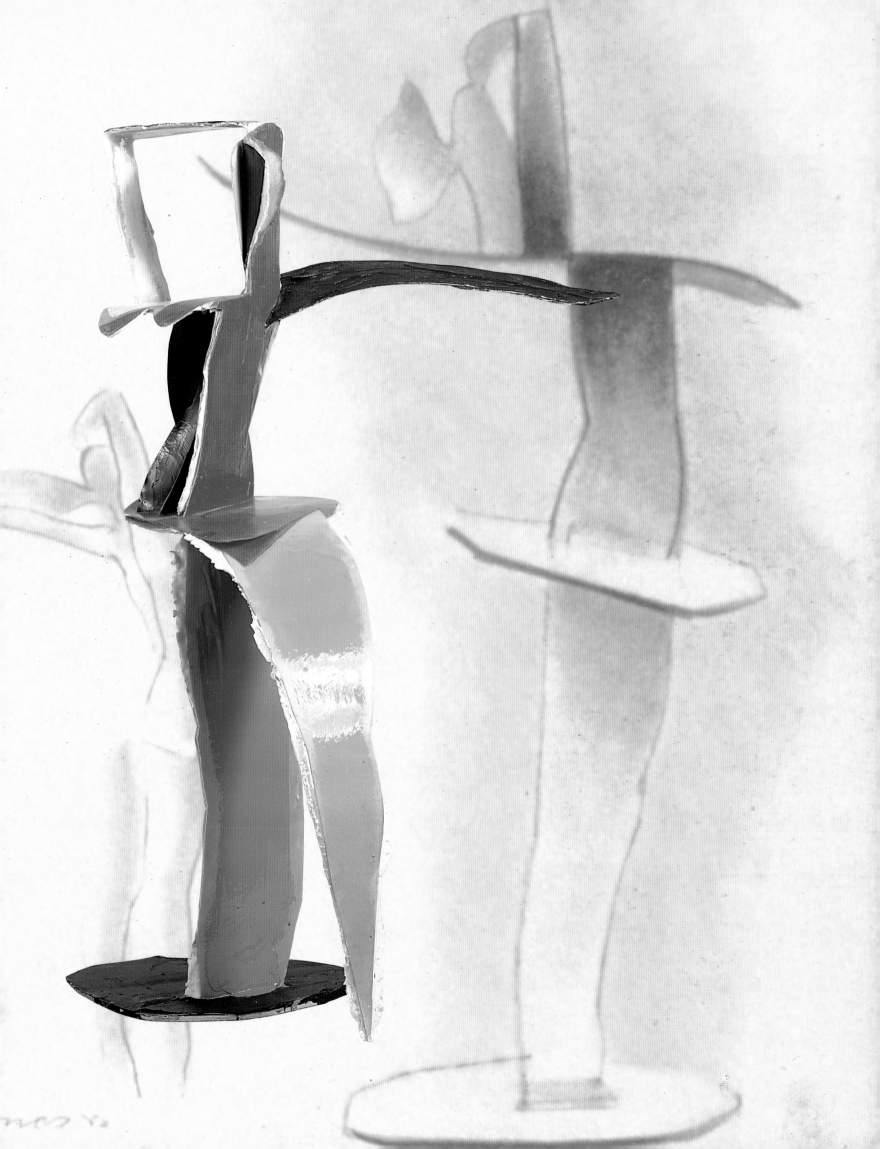

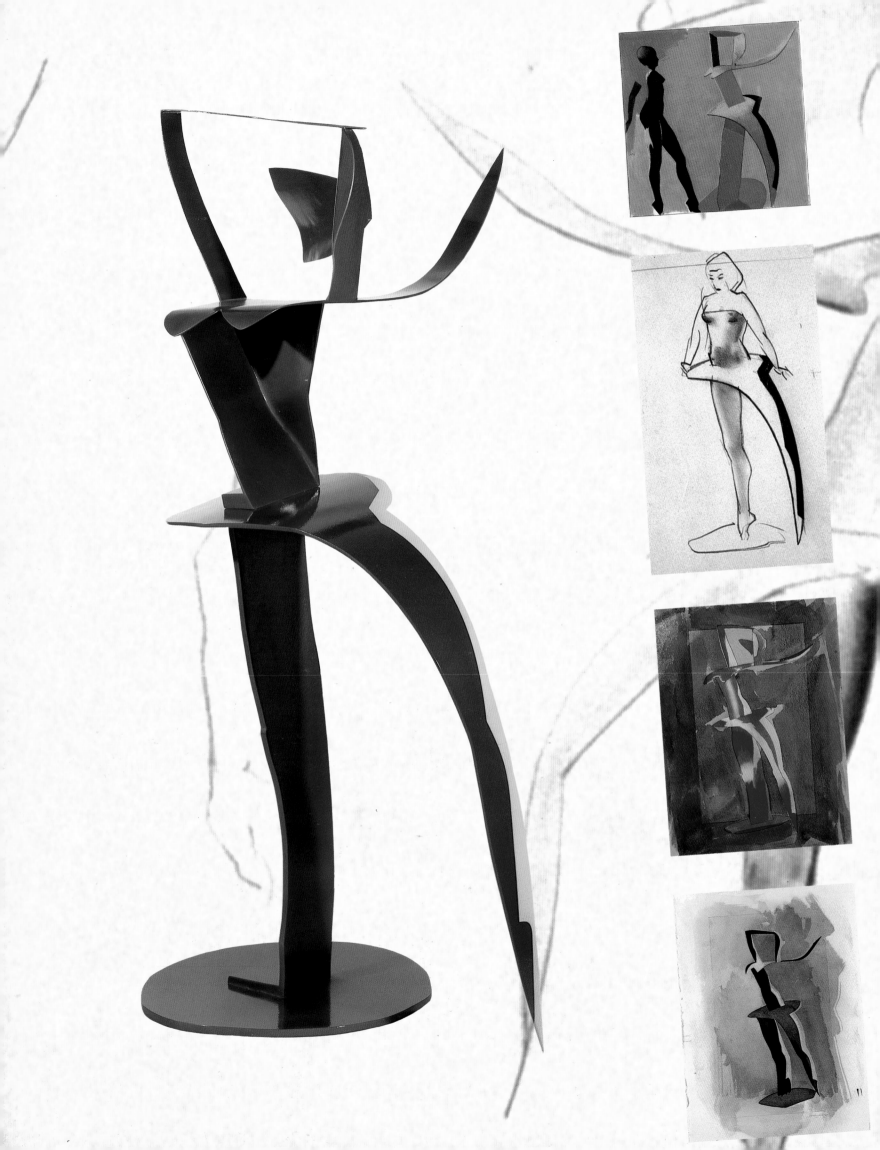

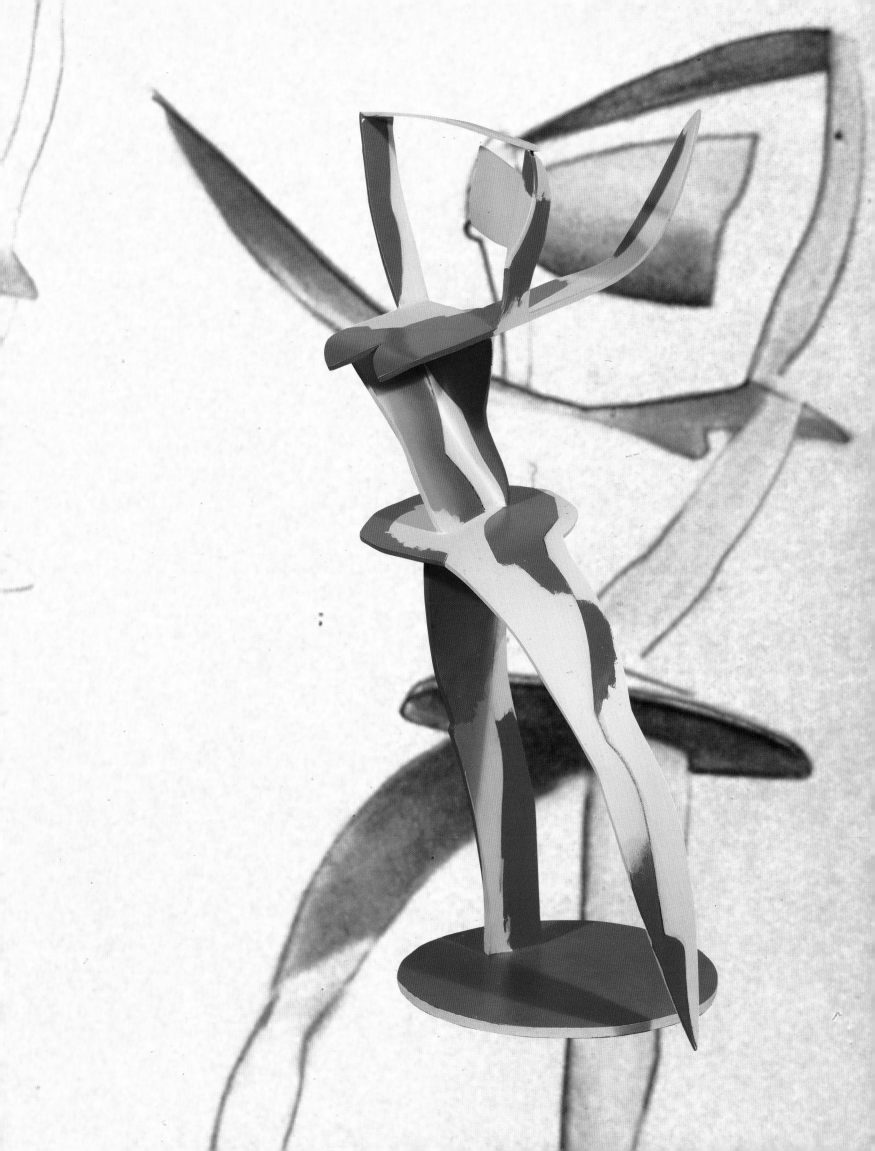

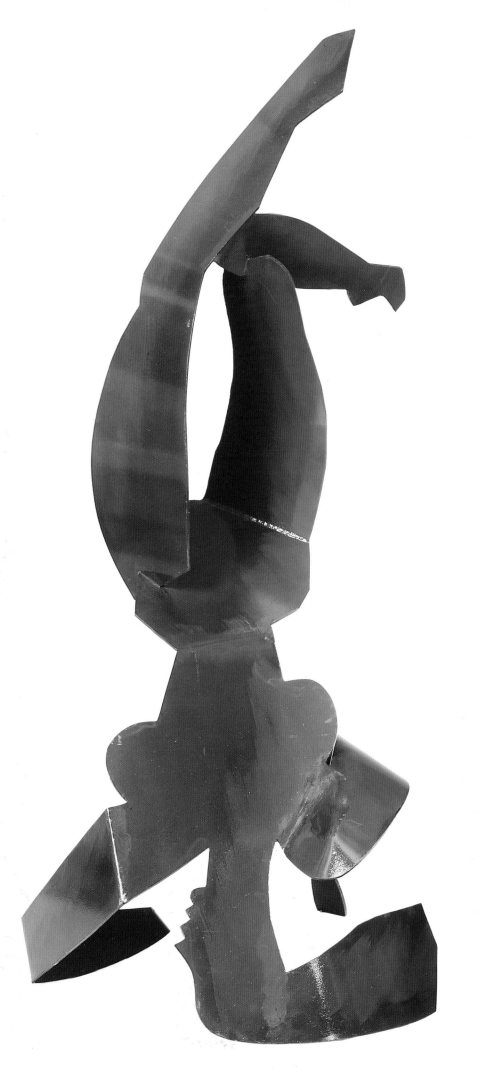

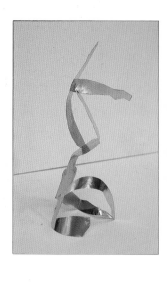

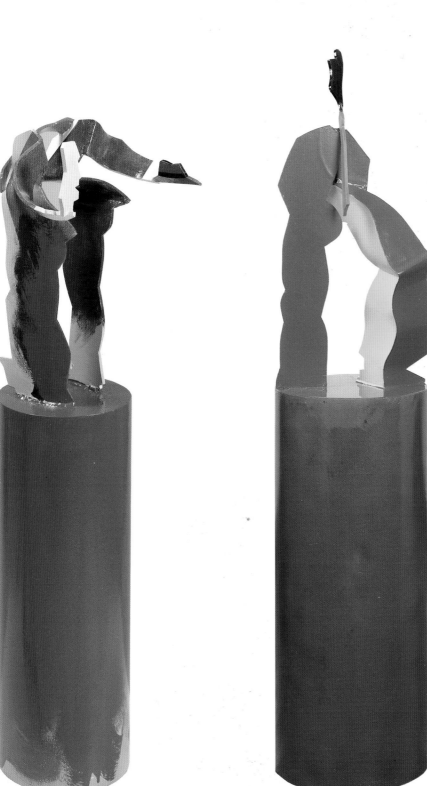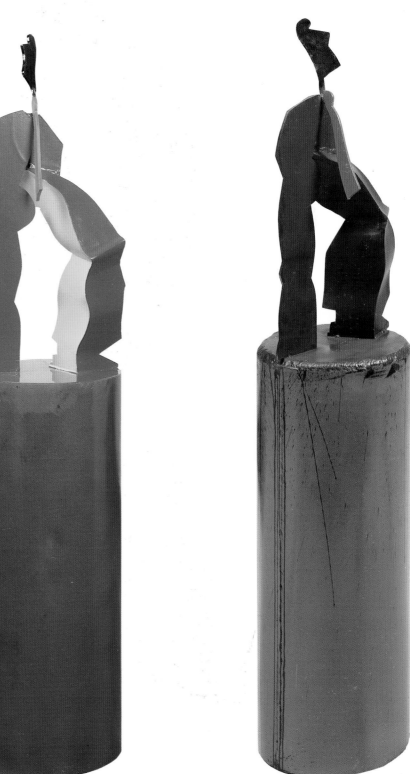

121

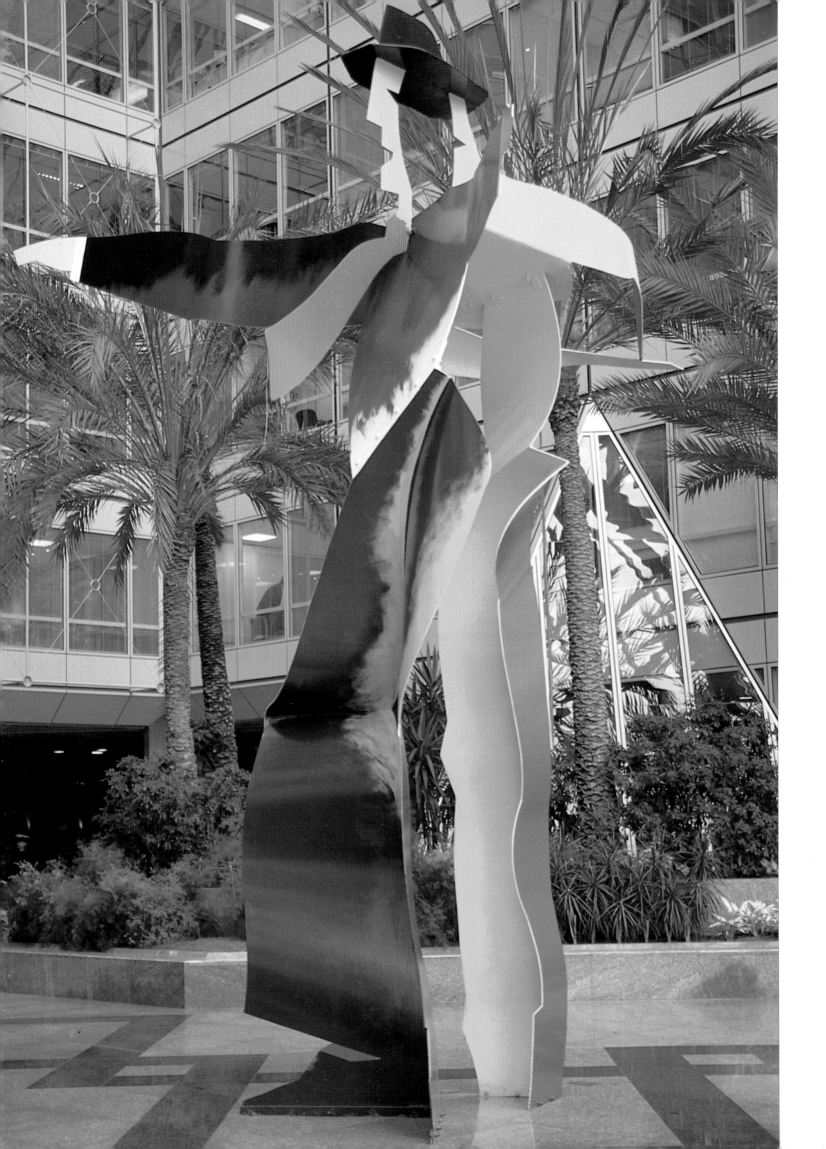

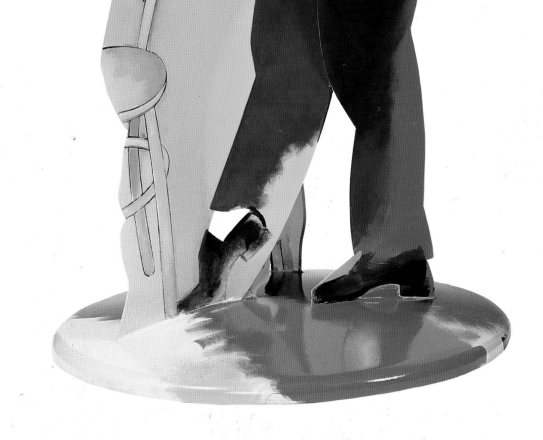

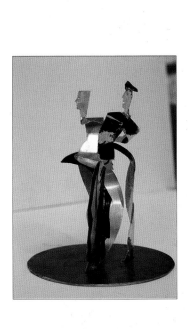

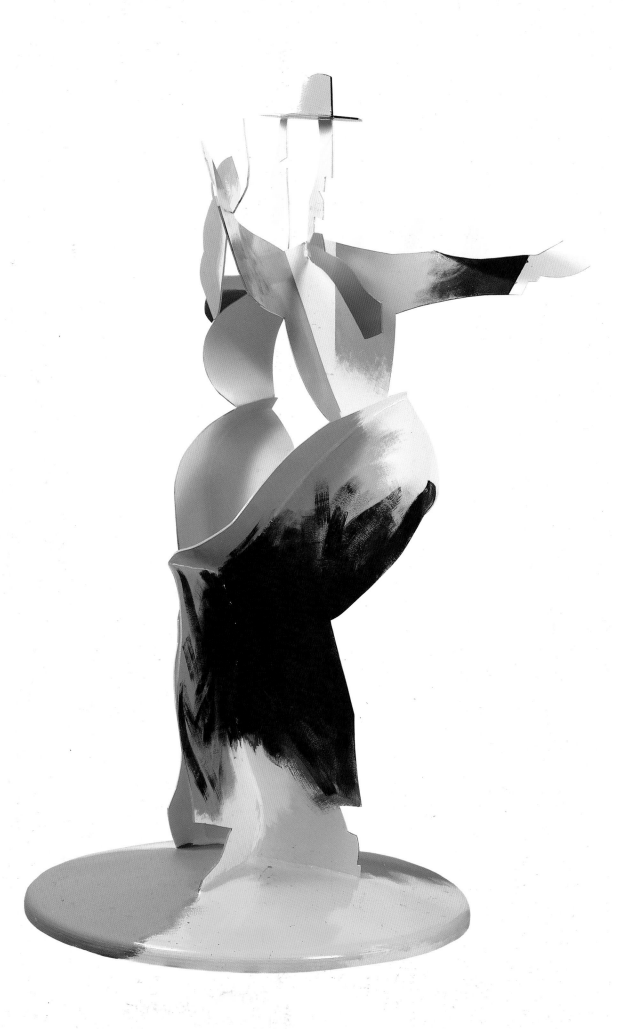

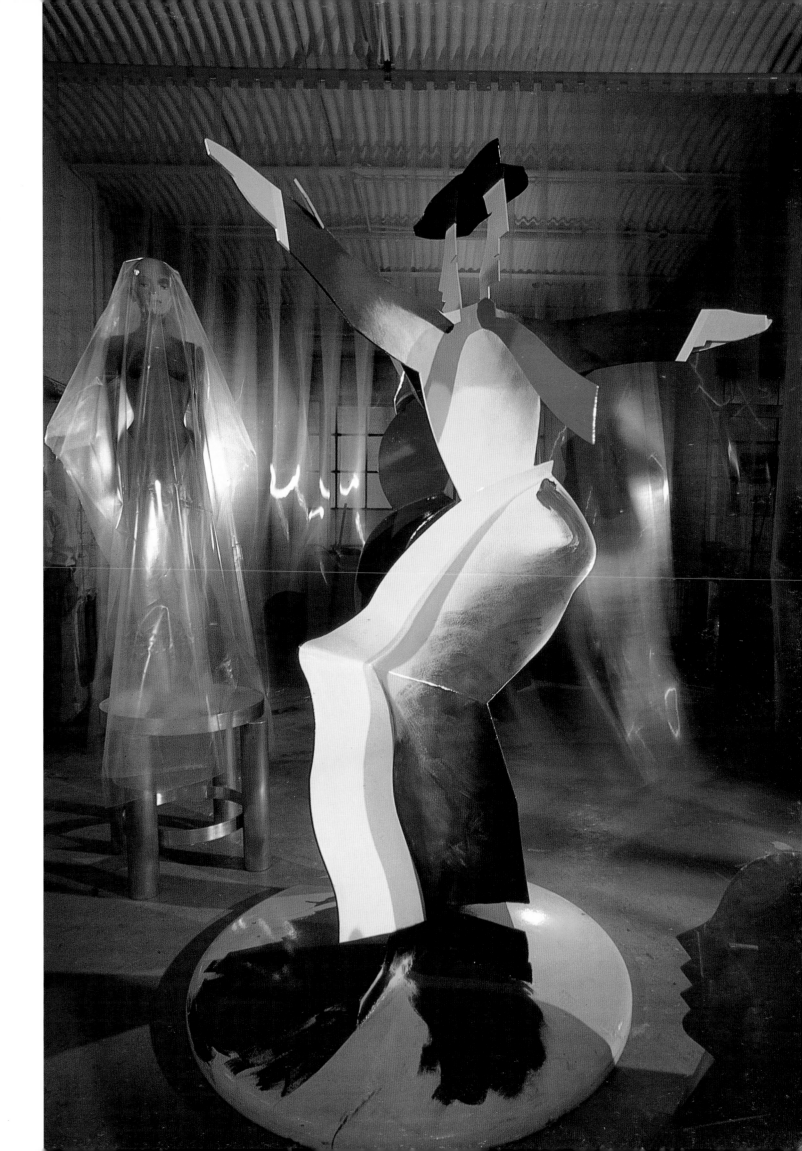

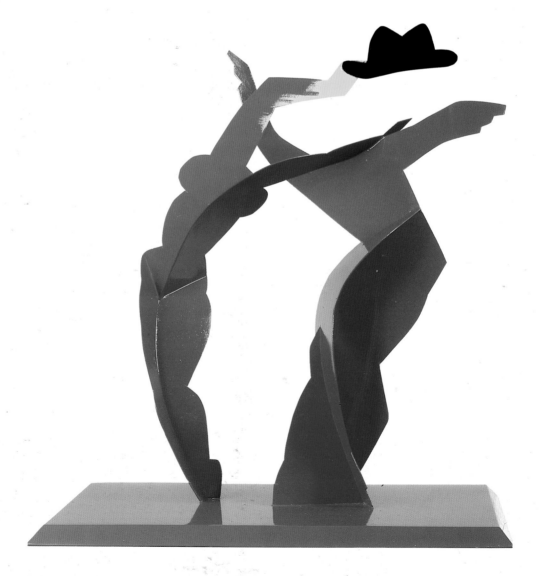

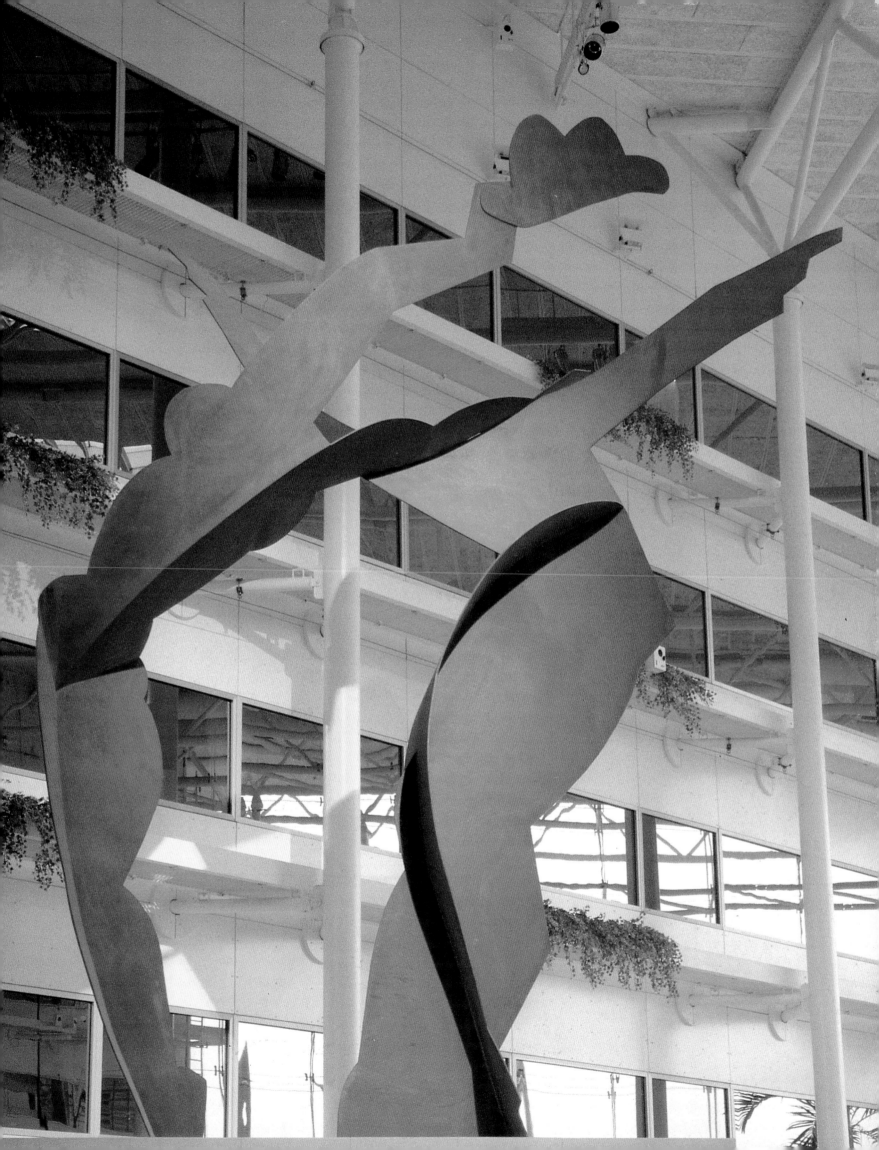

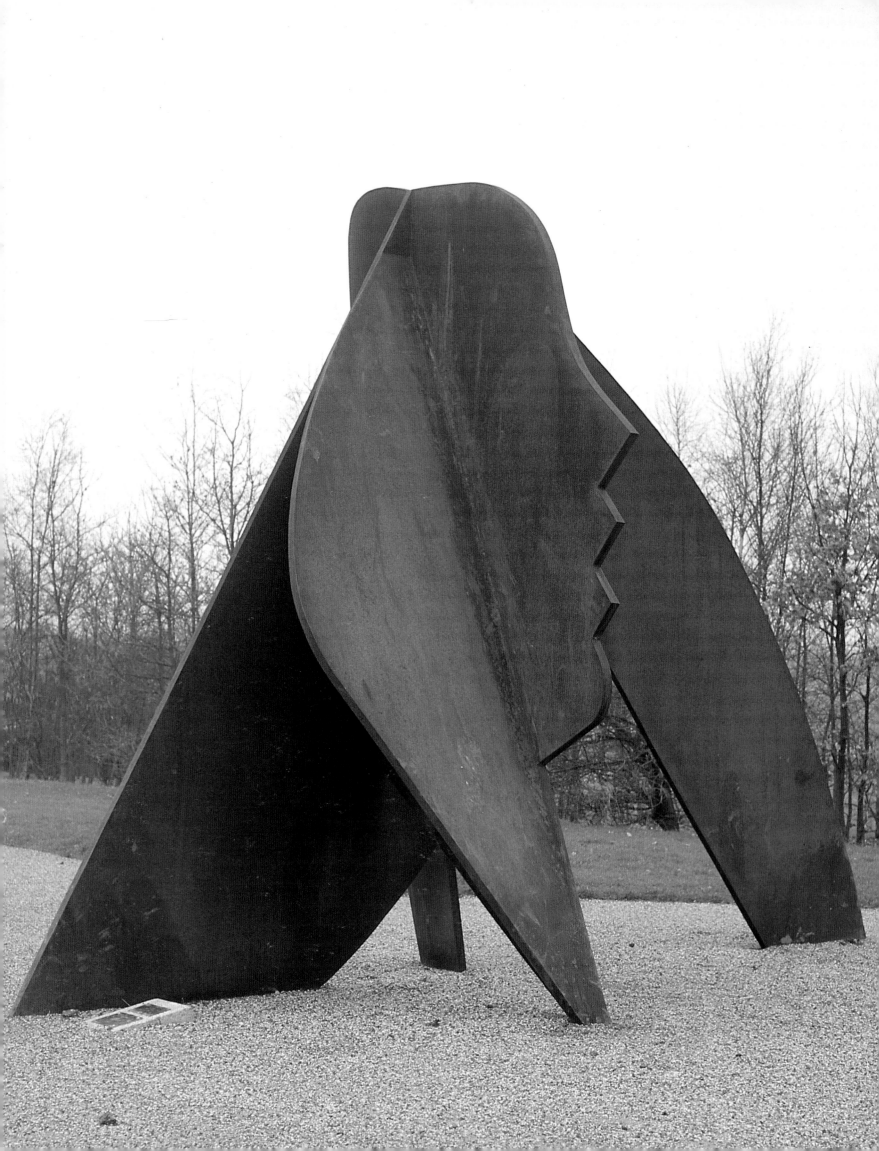

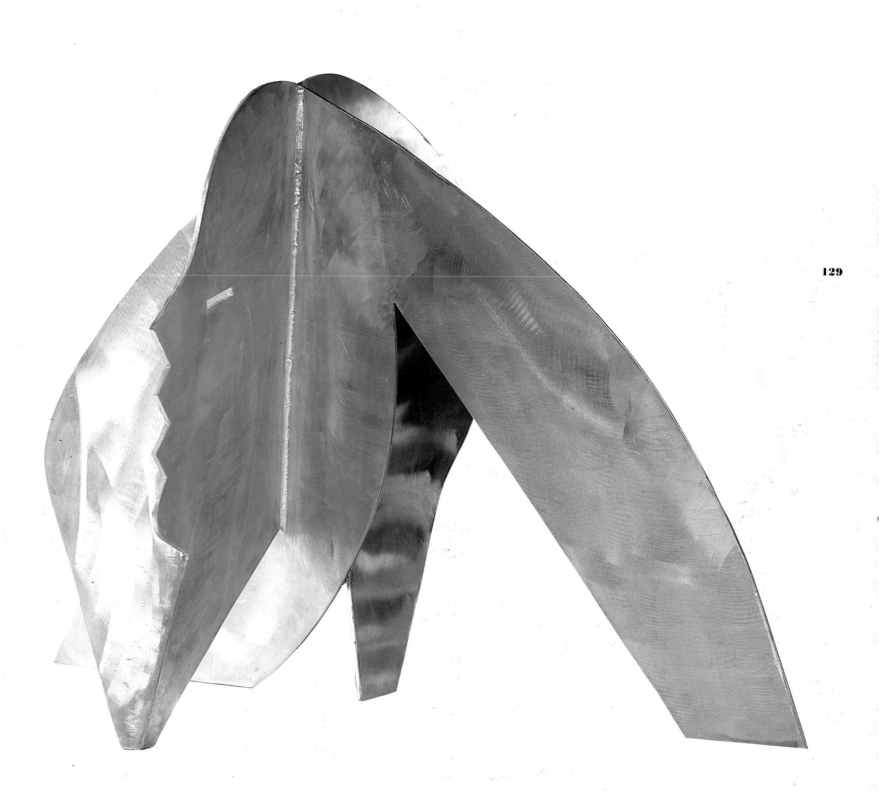

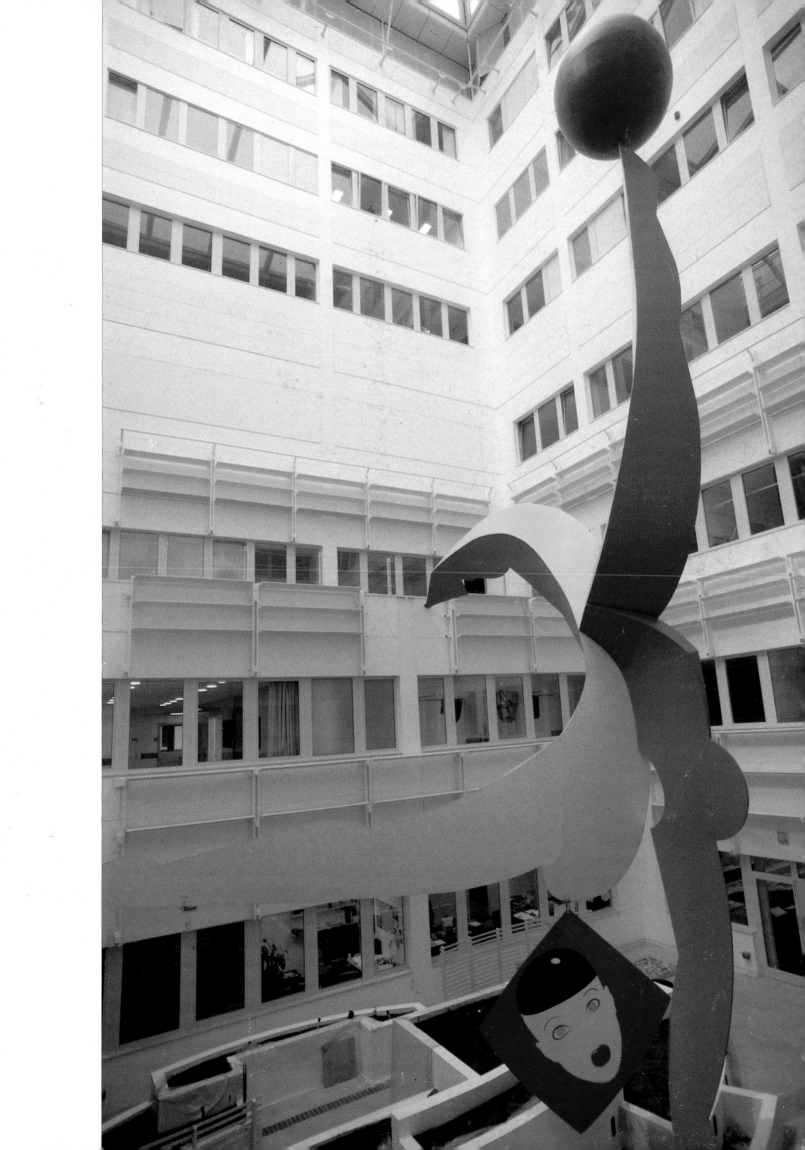

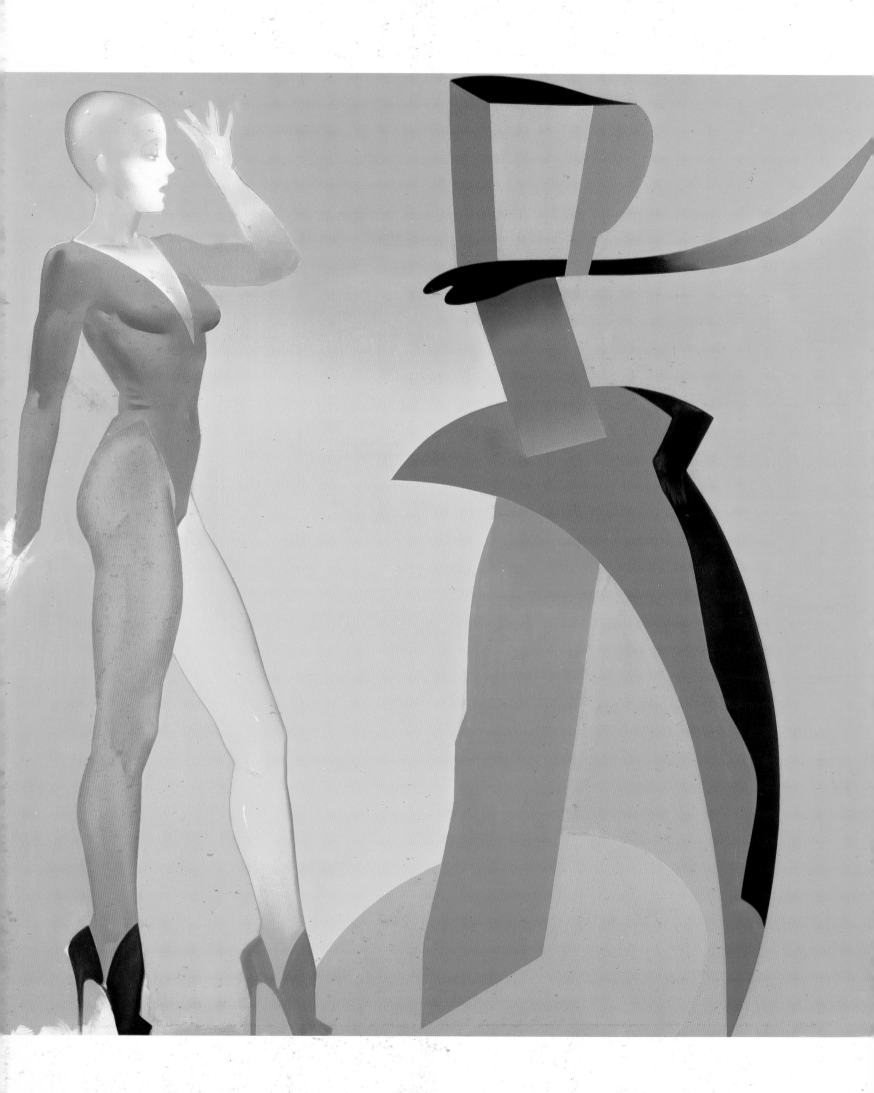

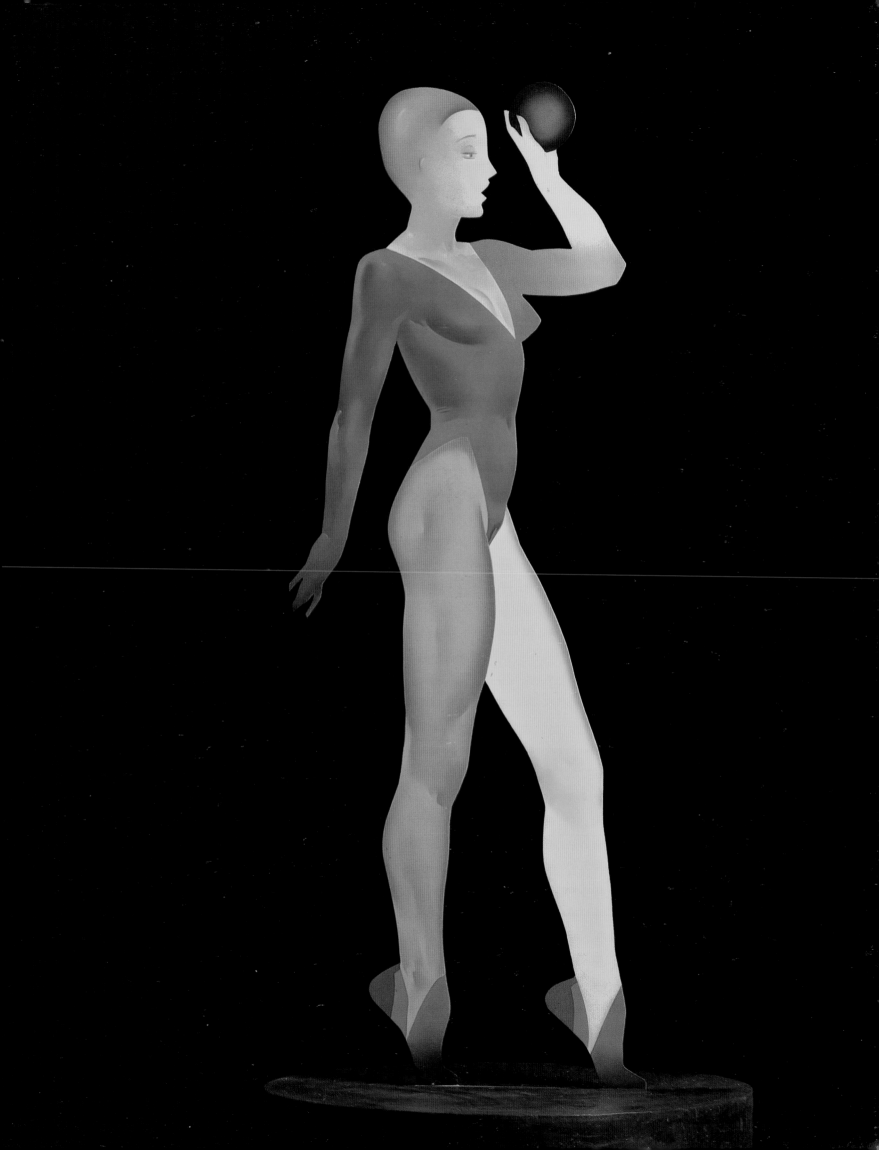

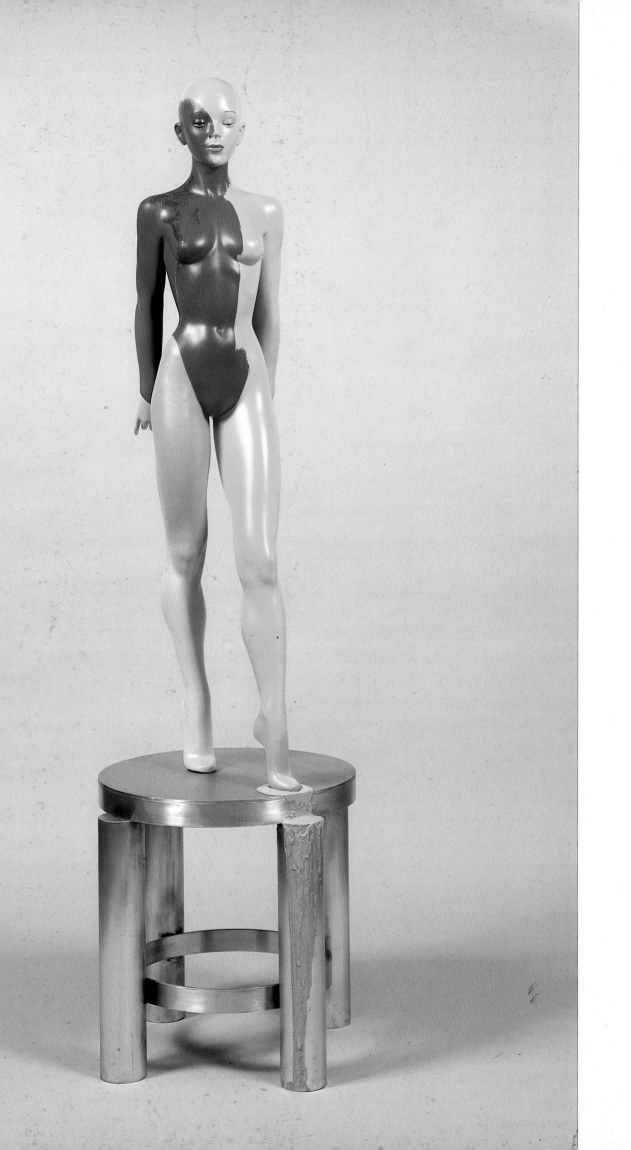

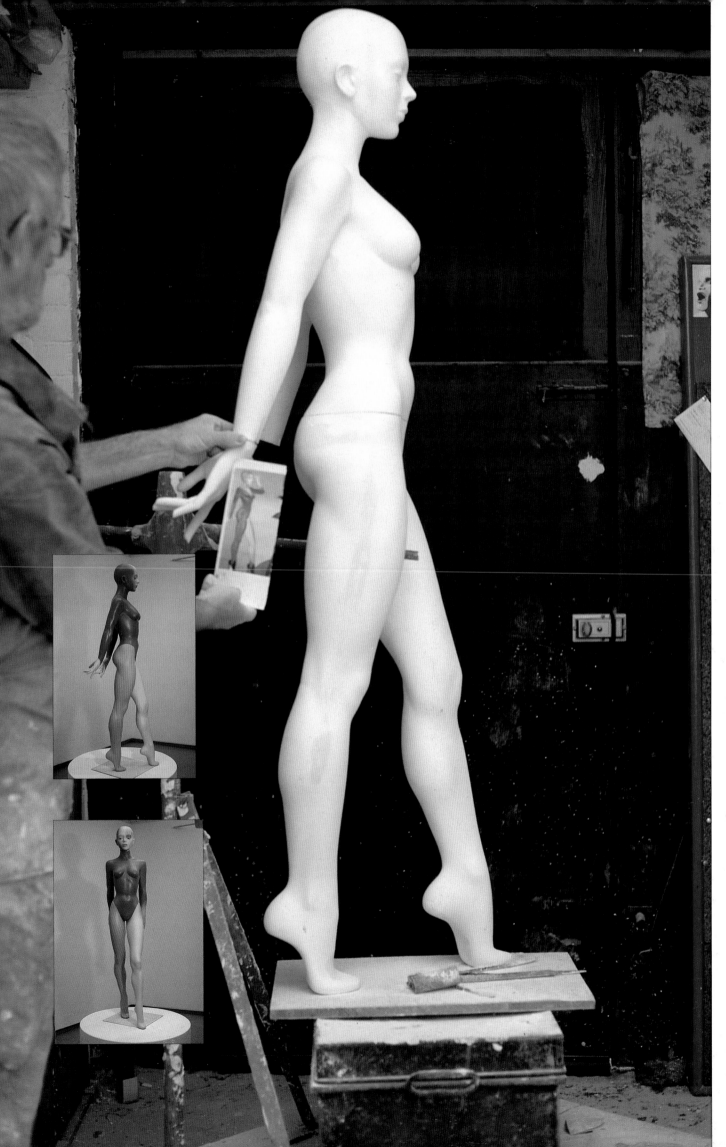

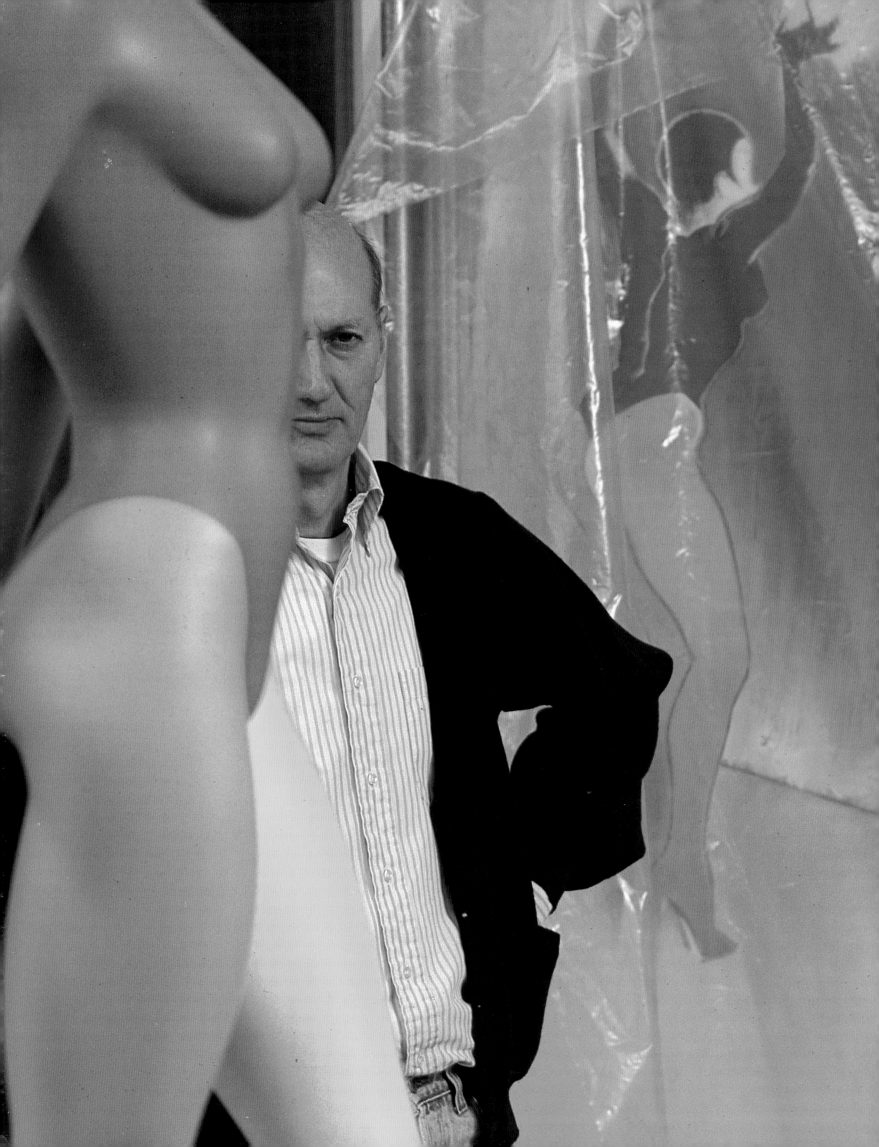

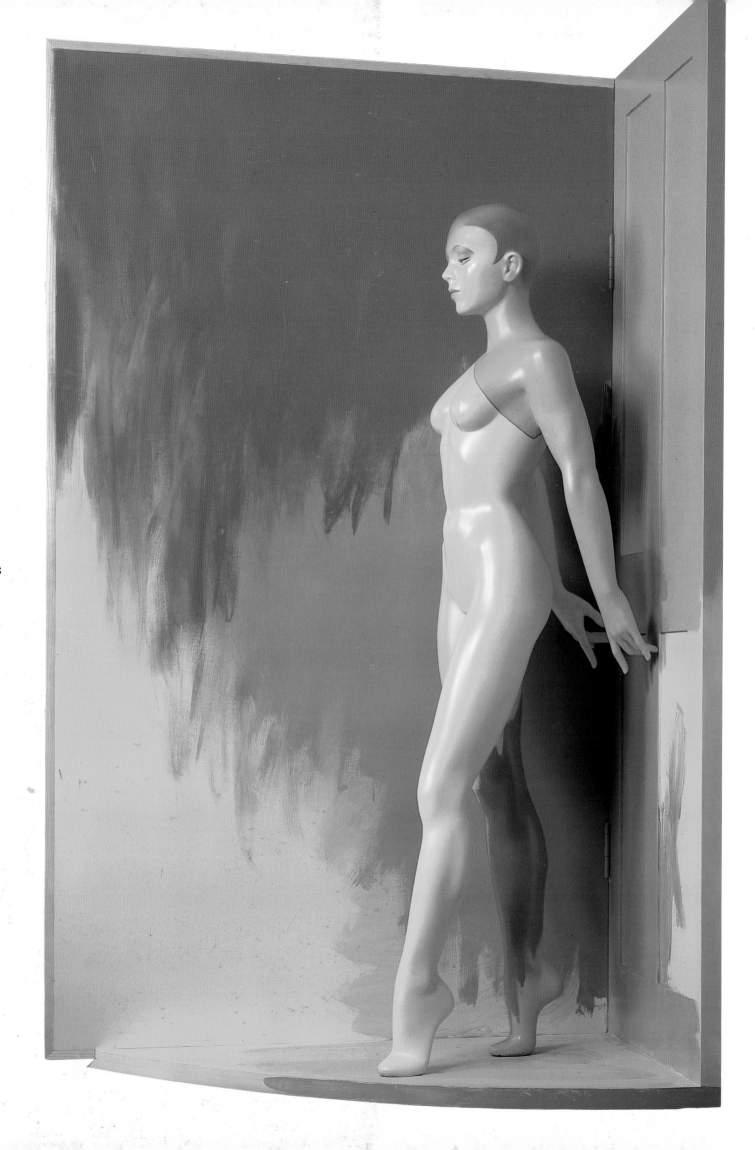

138

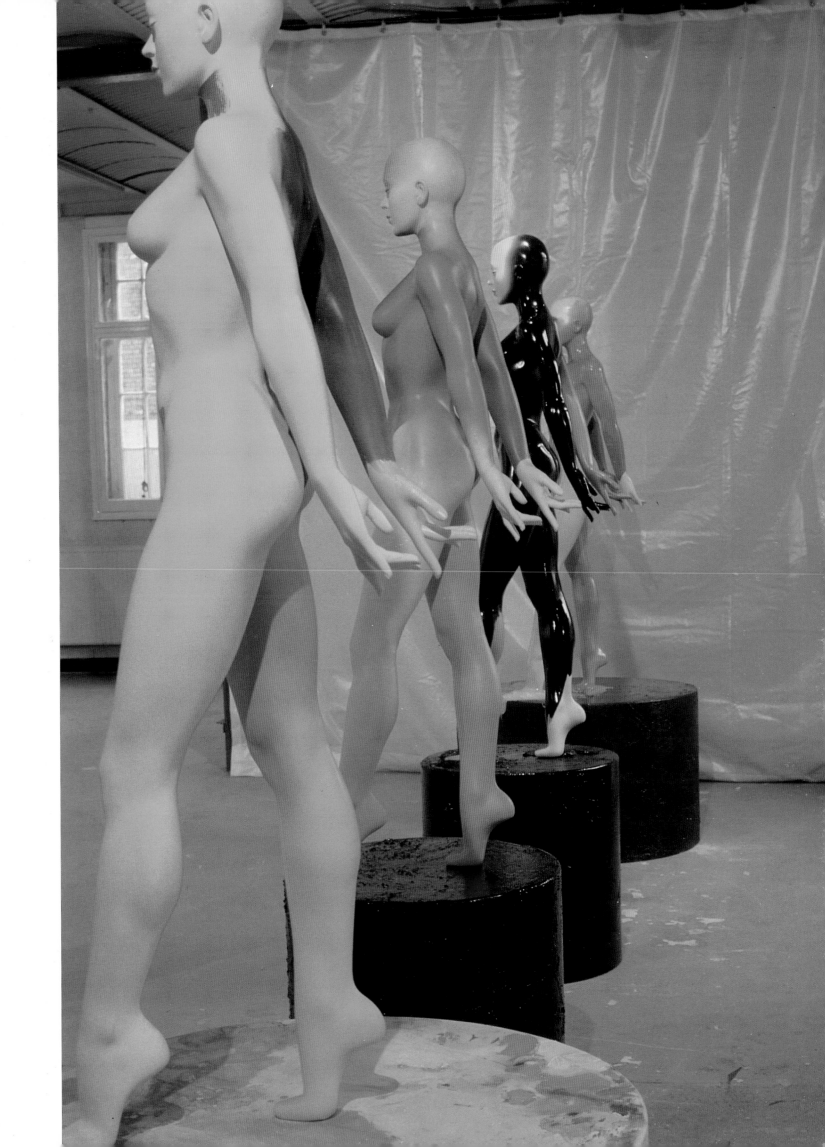

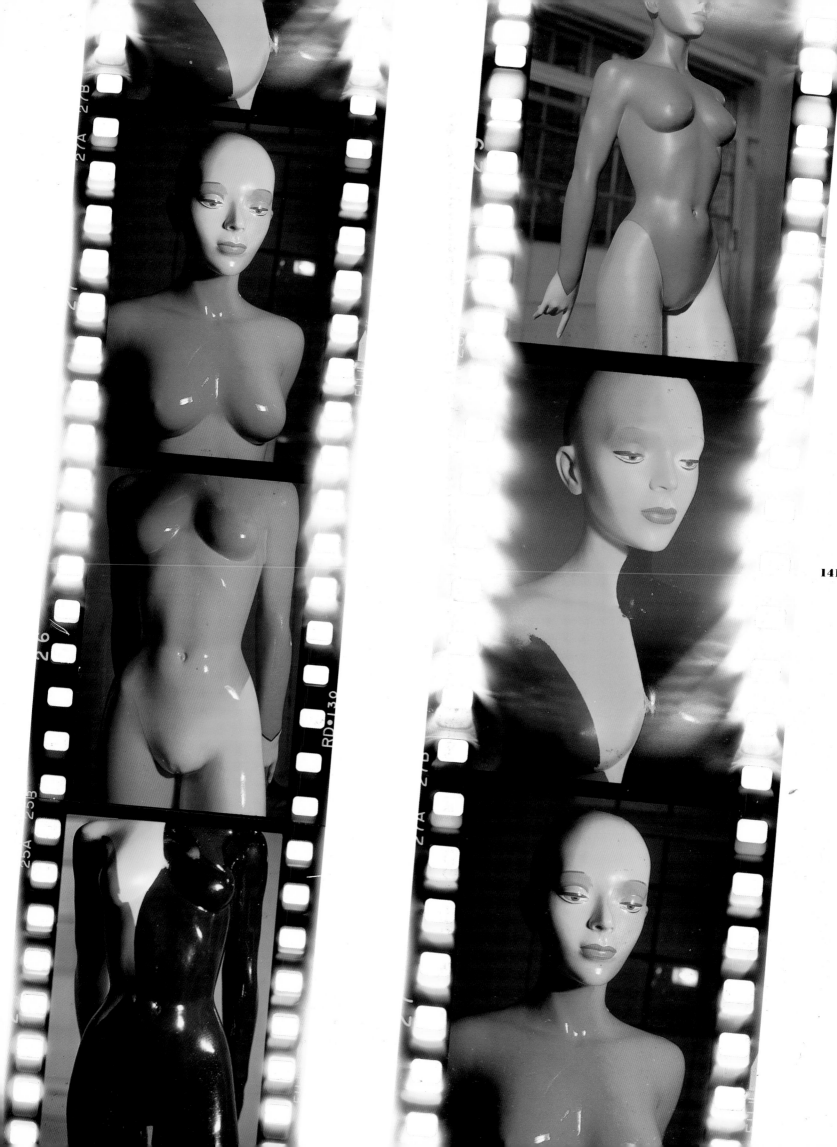

CAPTIONS • BIOGRAPHICAL DETAILS • PUBLIC COLLECTIONS

Captions (numbers refer to pages):

6 *Tales*, 1973, collage, 40.5 x 30.5cm

9 *Curious Woman*, 1964, oil on wood with epoxy filled plastic breasts, 122 x 102cm

10 *Encore*, 1977, oil on canvas, 182.9cm²

11 Untitled, *c*1970, mixed media and watercolour, 75.2 x 104.5cm

12 *Knife Thrower*, 1978, watercolour, 104.1 x 74.9cm

13 *Knife Thrower*, 1978, oil on canvas, 182.9cm²

14 *A Matter of Fact*, 1967-68, oil and black gloss paint on primed canvas, plus two tiled shelves and plastic sides, 183.5 x 153 x 14.5cm

15 *Barely There*, 1967-68, oil on canvas with tiled aluminium steps, 182.9 x 152.4cm

16 *Stand In*, 1975, oil on canvas, diptych, 182.9 x 91.4cm²

17 *A Proposition*, 1975, watercolour, 22.6 x 17cm

18 *Life Class*, 1968, lithograph, two part canvas, 50 x 60cm, from portfolio of seven lithographs and frontispiece, edition of 75

19 *Thrill Me*, 1969, offset and lithograph, 68 x 100cm, created with James Wedge, edition of 120

20 *Desire Me*, 1968, pencil and ball pen on paper with airbrushed photograph, 96.5 x 40cm

21 *Man Pleaser*, 1968, oil on canvas and retouched photograph, mounted on Masonite, 243.8 x 76.2cm

22 ABOVE: *Maitresse Study*, 1976, watercolour, 47 x 24cm; BELOW: *Maitresse Study*, 1976, watercolour, 47 x 24cm

23 *Maitresse*, 1976, oil on canvas, 182.9cm²

24 *Black Soft Aroma*, 1973, oil on canvas plus latex suit, 182.9 x 167.5cm

25 *Red Aroma*, 1973, oil and latex on linen, 121.9cm²

26-27 *Secretary*, 1972, fibreglass and leather, 99 x 58.4cm, edition of six variations

28 Allen Jones with *Hatstand*, 1991 (photograph by Magnum)

29 *Hatstand*, 1969, fibreglass mixed media, 190.5cm high (photograph by Erik Hesmerg)

30 *Chair*, 1969, mixed media, 77 x 100cm, one of six variations

31 *Table*, 1969, mixed media with 'metal flake' on fibreglass, 60.9 x 83.8 x 144.8cm, one of six variations (photograph by Erik Hesmerg)

32 LEFT: *Bronze Torso*, 1977, fibreglass with metal flake (photograph by Barry Ryan); RIGHT: *Black Breast Plate*, 1973, vacuum formed polyurethane, multiple, photograph for Pirelli Calendar (photograph by Brian Duffy)

33 ABOVE: *Woman*, 1965, lithograph, 70 x 56.5cm, edition of 75, printed by Urwin Hollander, New York City; BELOW: *Elizabeth Taylor*, 1964 (photograph by Bert Stern)

44 *The Kiss*, 1988, oil on canvas, 30.5cm²; BELOW: *Music Party*, oil on canvas, 1988, 35.5 x 30.5cm, 3rd variation

45 ABOVE: *Double Act*, 1980, oil on canvas, 152.4cm²

46-47 *Rhapsody*, 1982, oil on canvas, diptych, 182.9 x 243.8cm

48 *Vision in Pink*, 1976, watercolour, 75.2 x 104.5cm

49 ABOVE: *In the Mood*, 1989, watercolour, 101.6 x 68.6cm; BELOW: *Play on*, 1989, watercolour, 101.6 x 57.2cm

50-51 *Cellist*, 1989, watercolour, diptych, 152.4 x 203.2cm

52-53 *Focus*, 1991, oil on canvas, 61 x 101.6cm

54-55 *The Blues, in Red, Yellow and Green*, 1988-99, oil on canvas, diptych, 152.4 x 182.9cm

56 *Cue*, 1981, lithograph, 106.5 x 71.1cm, edition of 75

57 ABOVE: *Untitled*, 1982, watercolour, 74.9 x 104.1cm; BELOW: *Prompt*, 1981, lithograph, 24.1 x 30cm, edition of 35

58-59 *Fugue*, 1984, oil on canvas, 215 x 275cm

60 *Mirror, Mirror*, 1981, oil on canvas, 152.4 x 182.9cm, USA

61 *Question*, 1982, lithograph, at University of Huston, 76.2 x 57.2cm, edition of 35

62 *A Parable of Our Time IV*, 1981, oil on canvas, 152.4cm²

63 *A Parable of Our Time III*, 1981, oil on canvas, 152.4cm²

64 *Paso Doble*, 1983-84, oil on canvas, 182.9cm²

65 *A Question of Grammar*, 1986, oil on canvas, 152.4cm²

66 *Temptation*, 1986, oil on canvas, 152.4cm²

67 *Declamation*, 1986, oil on canvas, 152.4cm²

68 *Motivation*, 1990, watercolour on Hanji paper, 161 x 151cm

69 ABOVE: *Question and Answer*, 1986, oil on canvas, 30.5 x 35.5cm; BELOW: *Bunny*, 1986, bronze, 21.2 x 20.3 x 9.5cm, edition of nine

70 *The Sitter*, 1986, oil on canvas, 152.4cm²

71 ABOVE: *First Rapture*, 1988-89, watercolour, 38.1 x 55.9cm; BELOW: *A Little Ragtime – for Eric Satie*, 1989, watercolour, 38.1 x 55.9cm

72-73 *Enrapture*, 1989, watercolour, diptych, 152.4 x 203.2cm

74-75 *Ragtime*, 1989, oil on canvas, 152.4 x 182.9cm

76 *Tambourine Woman*, 1990, oil on canvas, 152.4cm²

77 *Voodoo Queen*, 1988, oil on canvas, 45.7 x 35.6cm

78-79 *Island Life*, 1986-87, oil on canvas, 101.6 x 152.4cm

80-81 Mural for The Ivy Restaurant, London, 1990, oil on marine ply, 459.7 x 143.5cm

82 *Endangered Species*, 1982, oil on canvas, 182.8 x 121.9cm

83 *ABOVE LEFT: Dancer 2*, 1981, watercolour, 36.8 x 34.6cm; *BELOW LEFT: Dancer 1*, 1981, watercolour, 37.4 x 36.1cm; *ABOVE RIGHT: Dancer 3*, 1981, watercolour, 36.8 x 34.2cm; *BELOW RIGHT: Dancer 4*, 1981, watercolour, 38.7 x 34.9cm

84 *Die Fledermaus*, 1991, oil on canvas, 45.7 x 35.6cm

85 *A Fan*, 1991, oil on canvas, 30.5 x 45.7cm

86-87 Billboard advertisement for Fogal, 1981, acrylic, 1,300cm wide, Zurich Railway Terminal

88-89 Advertisement for Fogal, 1979, acrylic, 2,100cm high, Basel Railway Terminal

90 *ABOVE: Daze*, 1986, oil on canvas, diptych, 182.9 x 213.4cm; *BELOW: Tropic*, 1986, oil on canvas, diptych, 182.9 x 213.4cm

91 *ABOVE LEFT: In the Wood*, 1986, watercolour, 22.2 x 30.2cm; *CENTRE LEFT:* Sketch for diptych, 1986, charcoal and synthetic paint on paper, 70.2 x 100cm; *BELOW LEFT:* Sketches for beach diptych, 1986, charcoal on paper, 70.2 x 100cm; *ABOVE RIGHT: The Serpent, c*1987, watercolour and pencil, 21.8 x 30.5cm; *CENTRE RIGHT:* Sketch for *Tropic*, 1986, watercolour and pencil, 21.9 x 30.5cm; *BELOW RIGHT: The Mermaid*, 1986, watercolour and pencil, 21.8 x 30.5cm

92 *Dance to Her Tune*, 1986, oil on canvas, 45.7 x 35.6cm

93 *ABOVE: Back to Basics*, 1992, water-colour, 38 x 28cm; *BELOW: Quicktime*, 1992, watercolour, 38 x 28cm

94 *Totem*, 1986-89, painted wood and steel, 168.9 x 76.2 x 60.9cm

98-99 *FOREGROUND: Sungoddess*, 1987-88, lacquered rusted steel 106.7 x 335.3 x 142.2cm; *ABOVE LEFT: Little Blue Goddess*, 1987-88, painted aluminium, 10.5 x 33 x 12.7cm; *ABOVE RIGHT: The Crab*, 1987, painted aluminium, approx 12 x 15cm

100-101 *BACKGROUND:* Maquette for recumbent figure, 1987, painted aluminium, approx 10 x 15cm; *LEFT: Odalisque*, 1983, painted metal, 101.5 x 131 x 106cm, one of five variations; *CENTRE: Sprawl*, 1988, painted steel, 109.2 x 223.5 x 152.4cm, one of five variations; *RIGHT: Odalisque with Blue Ball*, 1984, cardboard and resin, 107.3 x 158.7 x 106.7cm

102 *Artisan*, 1988, painted steel, 210.8 x 167.6 x 86.4cm, second variation; *INSET: Red Worker Maquette*, 1986, painted aluminium, 44.5cm high

103 *Red Worker*, 1986, painted mild steel, 396cm high, Perseverance Works, Hackney

104-105 *Vision in Pink and Blue*, 1982-83, enamel on wood, 196.2 x 158 x 102.5cm, one of two variations

106 *Man in a Hurry*, 1989, painted steel, 228.6 x 91.4 x 91.4cm, first variation

107 *Carefree Man*, 1991-92, painted steel, 260 x 91cm², one of five variations

108-109 *Little Vision*, No 1, 1982-83, oil enamel on wood, 66.5 x 52 32cm, one of five variations

110-111 *Small Fan Dancers*, 1982-83, painted plywood, 62 x 38 x 27cm, four variations

112-113 *LEFT & RIGHT: Red Fan Dance*, 1982, oil enamel on fibreglass, obverse and reverse, 200 x 99 x 78cm; *CENTRE: Passionate Fan Dance*, 1982, oil enamel on fibreglass, obverse and reverse, 200 x 99 x 78cm; *BACKGROUND:* Maquette for *Red Fan Dancer*, 1982, cardboard and tin, approx 35cm high

114 *Fascinating Rhythm in Yellow*, 1982-83, oil enamel on ply wood, 205.8 x 143.2 x 98.1cm, first of two variations; *INSET:* Maquette for *Fascinating Rhythms*, 1982-83, painted cardboard, approx 35cm high

115 *Fascinating Rhythm in Red*, 1982-87, enamel on ply wood, 205.5 x 143 x 98cm, second variation

116 *FOREGROUND: Red Ballerina*, 1982, 'hammerite' paint on fibreglass, 188cm high; *INSET, ABOVE TO BELOW: Light Moves*, 1984, watercolour, 76.5 x 57.5cm, forth variation of five; *Amazed Sculpture*, 1982, pencil on paper, 15.5 x 12.5cm; *Light Moves*, 1984, watercolour, 76.5 x 57.5cm, second variation of five; *Light Moves*, 1984, watercolour, 76.5 x 57.5cm, third variation of five; *BACKGROUND:* Sketches after *Red Dancer* – three figures, plus one, 1982, pencil and conté-crayon, 28 x 58cm

117 *Paper Dancer*, 1983, paper and resin, 95 x 51cm²; *BACKGROUND:* Sketches after *Red Dancer* – three figures, plus one, 1982, pencil and conté-crayon, 28 x 58cm

118 *LEFT: Blue Ballerina*, 1982, painted fibreglass, 188cm high; *INSET, ABOVE TO BELOW:* Study for painted object, 1982, watercolour and ink crayon, 20.3cm²; *Indignant Sculpture*, 1982, pencil on paper, 17 x 10.3cm; *Light Moves*, 1984, oil colour and watercolour, 76.5 x 57.5cm, fifth variation of five; *Light Moves*, 1984, oil and watercolour, 76.5 x 57.5cm, first variation of five; *BACKGROUND:* Sketches after *Red Dancer* – four figures, 1982, drawing, 28 x 58cm

119 *FOREGROUND: Little Ballerina*, 1983, oil on ply wood, 52 x 27 x 25cm, third variation of five; *BACKGROUND:* Sketches after *Red Dancer* – four figures, 1982, drawing, 28 x 58cm

120 *Headstand*, 1988, painted, rusted and lacquered mild steel, 246.4 x 121.9 x 109cm, second variation; *INSET: Headstand Maquette*, 1982, aluminium, 36.2 x 19.1 x 16.5cm

121 *LEFT: Man Losing his Head, and Hat*, 1988, painted steel, 25.4 x 24.1cm, second variation; *CENTRE: Hats Off*, 1989, painted steel, 120.7 x 26.7cm²; *RIGHT: Hats Off*, 1988, waxed rusted steel with painted elements, 118.1 x 26.7cm², second variation

122 *Dancing Couple*, 1987, painted steel, 732cm, Installation in Cottons Atrium, London Bridge City, for St Martin's Property Corporation (photograph by Chad Hall)

123 *Musical Chairs*, 1988, painted steel, 221 x 137.2cm², first variation; *INSET:* Maquette for *Musical Chairs*, 1988, aluminium, approx 15cm high

124 *Dancing Couple*, 1988, painted steel, 228.6 x 152.4 x 121.9cm, third variation

125 Studio, 1992 (photograph by Chad Hall)

126 *Dancers*, 1990, painted steel, 40 x 80cm², second variation maquette for Heathrow Hilton Hotel sculpture

127 *Dancers*, 1990, Heathrow Hilton Hotel (photograph by Chad Hall)

128 *Face*, 1989, stabile double thick cor ten steel, 289.6 x 396.2 x 228.6cm, for the Milton Keynes Development Corporation (photograph by Chad Hall)

129 *Face*, 1988, stainless steel, 66 x 86.4 x 50.8cm, edition of eight

130 Jones in *Acrobat*, Chelsea and Westminster Hospital, London (photograph by Chad Hall)

131 *Acrobat*, 1992-3, painted cor ten steel, 1,676.4cm high, commissioned by Riverside Health Authority for Chelsea and Westminster Hospital, London (photograph by Chad Hall)

132 *Painted Object*, 1982, oil on canvas, 152.4cm²

133 *Painted Silhouette*, 1987, mixed media sculpture, 215.9 x 60.9cm²

134 *Waiting on Table*, 1987, painted fibreglass on aluminium, 215.9 x 60.9cm²

135 *Waiting on Table*, 1987, fabrication in progress, Studio Dik Beech

136-137 *Artist's Studio*, 1991 (photograph by Magnum)

138 *Stand Out*, 1992, painted fibreglass and wood, 184.8 x 115.6 x 62.9cm

139 Studio, fibreglass figures, 1987-88 (photograph by Allen Jones)

140 *Stand In*, 1991-92, painted fibreglass and wood, 184.8cm² x 62.9cm

141 Photo strip, 1987-88 (photograph by Allen Jones)

Biographical Details

Allen Jones was born in Southampton in 1937, and studied at Hornsey College of Art, London, from 1955-59 and at the Royal College of Art from 1959-60. He took a teacher training course at Hornsey from 1960-61, and has taught in Germany, the United States and Canada, as well as in England. He has designed for the stage and for television.

Recent commissioned works include large-scale sculptures for the Liverpool International Garden Festival in 1984; Cottons Atrium, London Bridge City in 1987; The British Airport Authority, Heathrow Hilton Hotel, Terminal Four, 1991, and the Chelsea and Westminster Hospital, London, in 1992-93.

Allen Jones was elected to the Royal Academy in 1981 and is a trustee of the British Museum. He has resided for extended periods in the United States of America, and currently he lives and works in London.

There have been one-man exhibitions of Allen Jones' work worldwide since his first one-man show with Arthur Tooth and Sons, London, in 1963.

These include:
1964 Richard Feigen Gallery (also 1965 and 1970)
1967 Galerie der Spiegel, Cologne (also 1971)
1969 Galleria Milano, Milan (also 1972)
1973 Tolarno Galleries, Melbourne
1974 Seibu, Tokyo
1975 Welsh Arts Council, Oriel Gallery, Cardiff
1976 Waddington Galleries, London (also 1980, 1982, 1985, 1988)
1978 Retrospective of drawings, watercolours and prints (1958-1978), ICA London, touring to Cambridge
1980 Retrospective (1959-1979), Walker Art Gallery, Liverpool, touring to London, Sunderland, Baden-Baden and Bielefeld
1985 Galerie Patrice Trigano, Paris (also 1986, 1989)
1987 James Corcoran Gallery, Los Angeles
1989 Heland Wetterling Gallery, Stockholm
1992 Galerie Levy, Madrid and Hamburg, Glynn Vivian Museum and Art Gallery, Swansea

Allen Jones' work has been included in major group exhibitions throughout the world since 1960, most recently 'Forty Years of Modern Art 1945-1985' at the Tate Gallery, London in 1986, 'British Art in the Twentieth Century: The Modern Movement', at the Royal Academy, London in 1987, touring to the Staatsgalerie, Stuttgart and 'Pop Art' at the Royal Academy, London, 1991, touring in 1992 to Museum Ludwig, Cologne, Centro de Arte Reina Sofia, Madrid and the Montreal Museum of Fine Arts.

Five other books have been published on Allen Jones' work: *Figures*, Edizioni O, Milan, Galerie Mikro, Berlin, 1969; *Allen Jones Das Graphische Werk*, Verlag Galerie Der Spiegel, Cologne, 1969; *Projects*, Mathews Miller Dunbar, London, 1971; *Waitress*, Mathews Miller Dunbar, London, 1972; *Sheer Magic*, Thames & Hudson, London, Congreve Publishing Co Inc, 1979.

Public Collections

Arts Council of Great Britain; Arts Council of Northern Ireland; Art Gallery of Western Australia, Perth; Boymans van Beuningen Museum, Rotterdam; British Council; British Museum; Calouste Gulbenkian Foundation; Chicago Museum of Art; City Art Gallery, Birmingham; Contemporary Art Society; Ferens Gallery, Kingston-on-Hull; Fogg Art Museum, Cambridge, Massachusetts; Frederick R Weisman Foundation, Los Angeles; Glynn Vivian Art Gallery, Swansea; Hirshhorn Museum and Sculpture Garden, Washington DC; Ind Coope Collection; Konstmuseets Vanner, Gothenburg; Kunsthalle, Bielefeld; Kunsthalle, Hamburg; Kunstmuseum, Dusseldorf; Landesmuseum für Kunst und Kulturgeschichte Munster; Moderna Museet, Stockholm; Museum Aachen, West Germany; Museum Bochum, West Germany; Museum of Contemporary Art, Ghent; Museum of 20th Century Art, Vienna; Museum of Modern Art, New York; Nagaoke Museum, Japan; National Museum of Wales, Cardiff; National Portrait Gallery, London; Neue Galerie der Stadt, Linz; Oregon State University; Pasadena Art Museum; Peter Stuyvesant Collection; Power Gallery of Contemporary Art, University of Sydney; Regional Museum, Olinda Province, Brazil; Southampton Art Gallery; Stedelijk Museum, Amsterdam; Sunderland Art Gallery; Tate Gallery, London; Vancouver Art Gallery; Victoria and Albert Museum, London; Walker Art Gallery, Liverpool; Wallraf-Richartz Museum, Cologne; York City Art Gallery